What Life Was Like®

AMID SPLENDOR AND INTRIGUE

Byzantine Empire
AD 330 – 1453

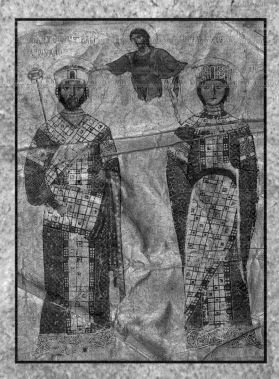

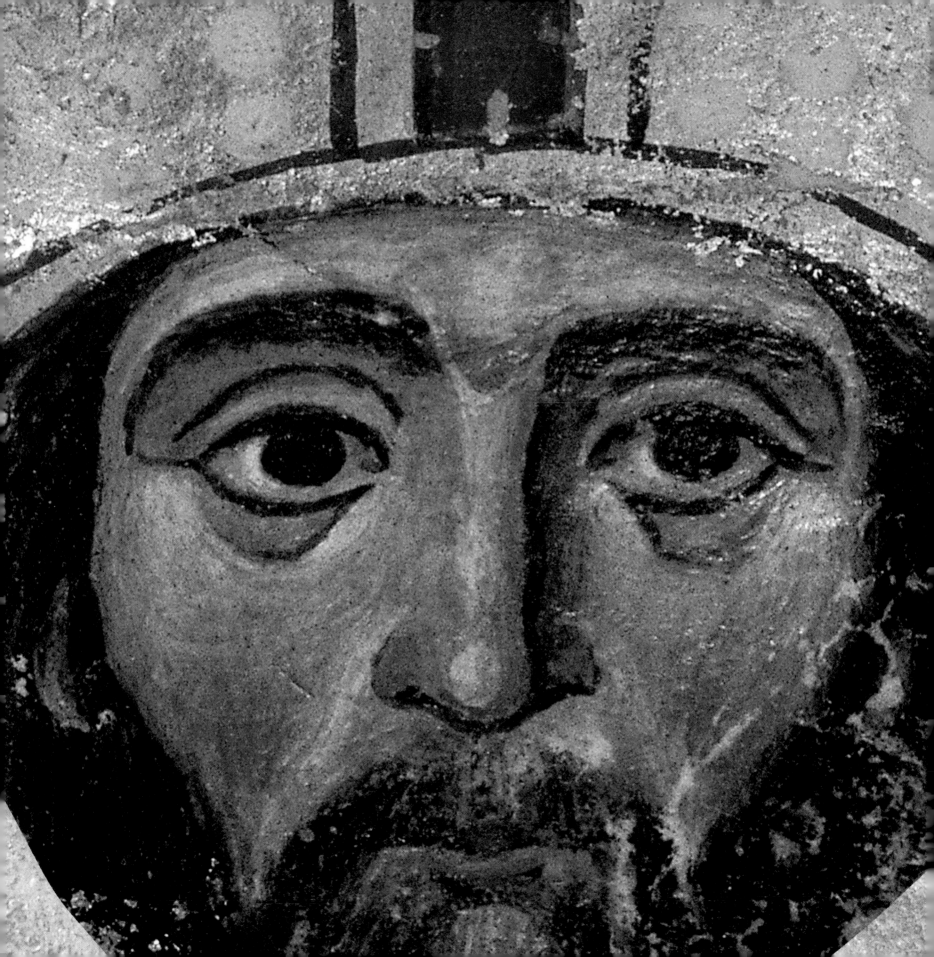

What Life Was Like

AMID SPLENDOR AND INTRIGUE

Byzantine Empire
AD 330 – 1453

BY THE EDITORS OF TIME-LIFE BOOKS, ALEXANDRIA, VIRGINIA

CONTENTS

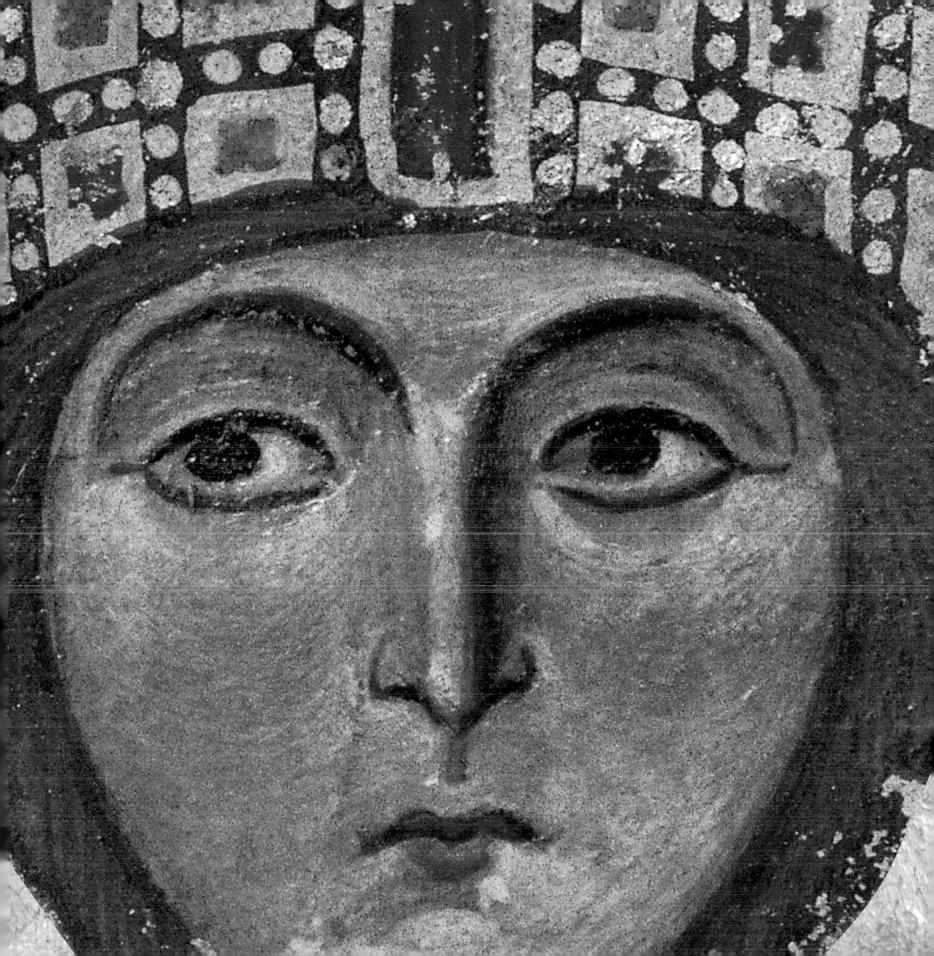

AMID SPLENDOR
AND INTRIGUE

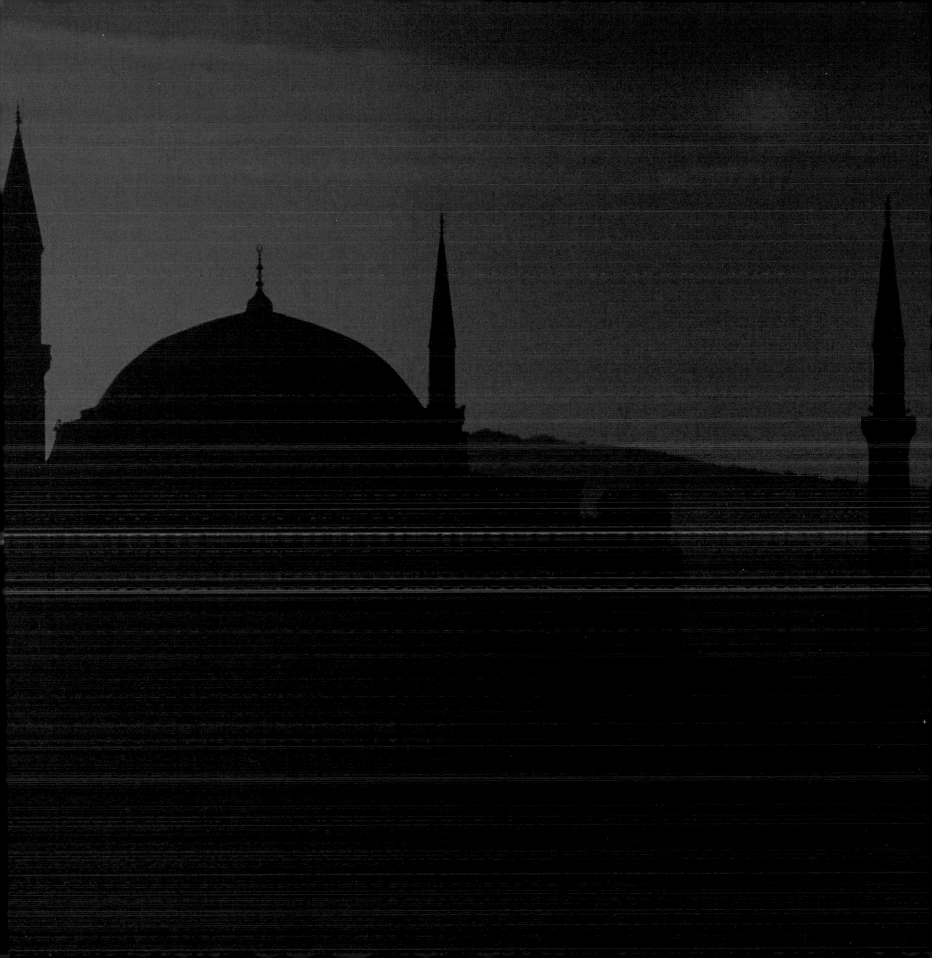

BETWEEN EAST AND WEST

Soon after he became sole Roman emperor in AD 324, Constantine the Great made two decisions that would change the history of the world for the next thousand years and more: He established a new imperial capital, and he endorsed Christianity as the official religion of the empire.

For a location for his new capital, Constantine looked east. Several possible sites were considered, including that of ancient Troy, on the coast of Asia Minor, and Jerusalem, scene of Christ's death and resurrection. But finally he selected a Greek fortress-city called Byzantium, on the western side of the Bosporos, the narrow strait that divides the Balkan Peninsula of southeastern Europe from Asia. The city would give its name to the so-called Byzantine Empire based there, and Constantine would give his own name to the city: Constantinople.

After the city's inauguration on Monday, May 11, in the year 330, the emperor set about turning Constantinople into a fitting imperial capital. He commissioned defensive walls, a palace complex, public squares, and churches. Foremost among these early buildings was the domed cathedral of Hagia Sophia, a work finished by one of Constantine's successors, the emperor Justinian. "Thanks be to God," Justinian is said to have proclaimed, "who has found me worthy to complete so great a work and to surpass even thee, O Solomon."

The city known as the New Rome retained much that was Roman in ideology, government, and law, but Latin remained the official language only until it was eclipsed by Greek at the end of the sixth century. The Orthodox, or Eastern, rite of Christianity that developed in Byzantium also

330	395	476	528
Constantine the Great transfers the seat of the Roman Empire to the city of Byzantium, which he renames Constantinople	The Roman Empire is divided into eastern and western halves	The last of the Western emperors, Romulus Augustulus, is deposed	Emperor Justinian I commissions a revision of the Roman legal code, which would be republished as the *Codex Justinianus*

overtook the Roman, or Latin, rite; its patriarch in Constantinople became a rival of the pope in Rome. "Between us and the Latins is set the widest gulf," one Byzantine commentator would declare. "We tread them down by the might of Christ, who giveth unto us the power to trample upon the adder and upon the scorpion."

When the Latins in the western part of the empire fell to tribes of invaders from northern Europe in the fifth century, the Eastern Empire continued to thrive. Yet warfare was a constant fact of life for them as well, and throughout Byzantium's existence its fortunes and boundaries were in a constant state of flux. By the early 600s it entered its first period of decline. Barbaric European tribes conquered Byzantium's territories in Spain and Italy. From the north, the Slavs began to threaten the Byzantine provinces of Macedonia and Thrace, as well as large areas of mainland Greece. And the Persians conquered Syria, Palestine, and Egypt, capturing the holy city

of Jerusalem in 614. Things were so bad, in fact, that the Byzantines even considered moving their capital from Constantinople to Carthage in North Africa.

The Byzantines eventually recaptured Syria, Palestine, and Egypt from the Persians. But soon a powerful new enemy appeared on the empire's borders: Arab invaders from the south. The Arabs conquered Syria and Palestine in 636, Persia the following year, and Egypt three years after that. These territories were forever lost to Byzantium. Meanwhile, the Bulgarians, a Slavic people recently arrived in the Balkans from the Eurasian steppes, posed an additional threat. For the next two centuries the Byzantines would have to fight off Arab invasions from the south and east, and Slavic aggression from the north.

Byzantium's troubles were compounded by a string of ineffective rulers who reigned around the end of the eighth century. The most notable of these were Empress Irene (797–802),

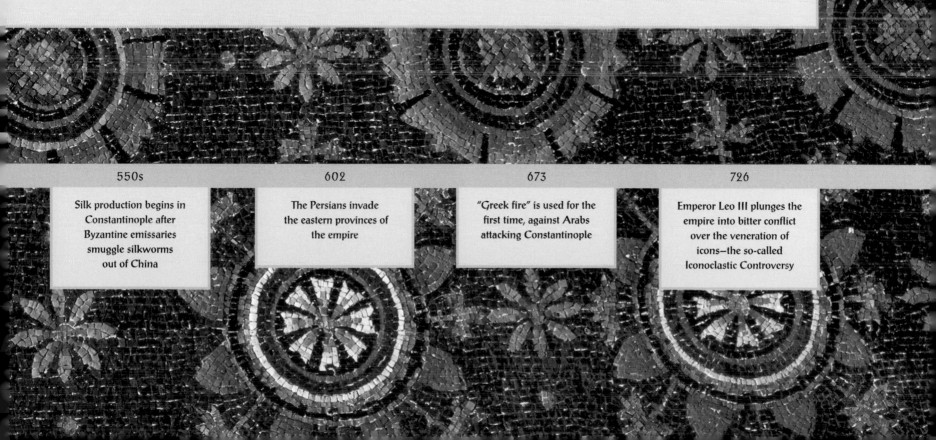

550s	602	673	726
Silk production begins in Constantinople after Byzantine emissaries smuggle silkworms out of China	The Persians invade the eastern provinces of the empire	"Greek fire" is used for the first time, against Arabs attacking Constantinople	Emperor Leo III plunges the empire into bitter conflict over the veneration of icons—the so-called Iconoclastic Controversy

who became the first sole empress after blinding her son, the rightful heir; and Emperor Nikephoros I (802-811), who was killed in battle fighting the Bulgarians and whose skull was then turned into a drinking mug for the Bulgarian leader.

But in the mid-ninth century there emerged a number of strong, visionary rulers, and Byzantine fortunes began to improve. The empire, in fact, entered a golden age, which corresponded roughly with the reign of the Macedonian dynasty founded by Basil I. Byzantium peaked in terms of military, political, and commercial strength, and also in cultural brilliance. Its army and navy were strong, trade was booming, scholarship and the arts were flourishing, and the Orthodox Church was extending its influence to the Slavic countries of Europe. To the Byzantines, it seemed that theirs was not just the strongest empire on earth, but the *only* empire on earth. And under Basil II, it would attain a territorial size not seen since the early days, under Constantine and Justinian.

Cracks in the Byzantine armor again began to appear after the death of Basil II in 1025. No longer held in check by watchful rulers, powerful provincial aristocrats accumulated more and more land, and the centralized system of government from Constantinople weakened. And while the 11th century continued to be a time of great intellectual and cultural activity, it was also a period during which inept emperors paved the way for future troubles by neglecting the frontiers, running down the military, and depleting the imperial treasury. Byzantium was like a royal palace whose foundations had rotted; all that was needed was another push by an invader to topple the whole edifice.

Those invaders were quick to appear. Indeed, they seemed to emerge on every front: central Asian nomads to the north, Normans to the west, Turks to the east. And at the Battle of Mantzikert in 1071 Byzantium suffered the most staggering defeat in its history, losing to the Turks much of Asia Minor.

800	843	863	867
Charlemagne is crowned emperor of the Western Holy Roman Empire	Icons are officially restored to Hagia Sophia on March 11, a day still celebrated annually as the Feast of Orthodoxy	The Byzantine missionaries Cyril and Methodios begin their mission to convert the Slavs to Orthodox Christianity	Emperor Basil I founds the Macedonian dynasty, which rules Byzantium for most of its 200-year golden age

Further setbacks were to come. Before the century was out, the knights of the First Crusade were permitted to cross Byzantine territory in order to help oust the Turks from Asia Minor. The crusaders, having seen the riches of the empire, would return in 1203 to conquer and loot Constantinople, which for the first time in its history was occupied by foreigners. Byzantine rule was restored to the capital only in 1261, when Michael VIII took the throne.

There followed another period of great productivity in art, theology, and literature. But the advance of the Turks was relentless: By the early 1400s they had reduced the Byzantine Empire to little more than a small Greek city-state. And with the terrible inevitability of a Greek tragedy, Byzantium's end drew near. In the spring of 1453 the Turks laid siege to Constantinople and, after a heroic defense on the part of its residents, conquered the city. On Tuesday, May 29—1,123 years and 18 days after the inauguration of Constantinople—Sultan Mehmed II knelt in prayer on the floor of Justinian's Hagia Sophia. The history of Byzantium was over.

And so ended an empire its citizens believed would endure until the Second Coming of Christ. Constantinople would become Istanbul, Hagia Sophia a mosque. But Byzantium bequeathed to the world the spiritual benefaction of Orthodoxy, the form of Christianity practiced by some 250 million people today. Physical evidence of that legacy can be seen in the monasteries and monuments dotting the land around the Mediterranean and in the Slavic countries of eastern Europe.

In the chapters ahead we will look at the lives of the Byzantines, at their achievements and their follies, their machinations and their murders, and their struggles against heretics, infidels, barbarians, and the devil. We will see why the word *byzantine* has come to suggest deception, deviousness, and cunning—and just what life was like amid the splendor and intrigue that was Byzantium.

1019	1054	1204	1453
Emperor Basil II completes his conquest of the Bulgarian kingdom and annexes its territories	Final and decisive schism between the Eastern and Western Churches	The warriors of the Fourth Crusade conquer Constantinople	Constantinople falls to the Ottoman Turks

At its peak, the Byzantine Empire extended from Spain in the west to the mountains of Armenia in the east, and from the Black Sea and the Danube in the north to the coastal fringe of Africa in the south. The heart of the empire, though, would always be Greece, adjacent parts of southeastern Europe, and Asia Minor, also known as Anatolia. Together these regions formed a protective band around the city Constantine the Great chose as his capital, Constantinople.

Perched between Europe and Asia, astride the routes of east-west trade, Constantinople's site was an inspired choice. As shown below, it was located on a peninsula washed on three sides by the waters of the Bosporos, the Sea of Marmara, and the Golden Horn. And on the fourth side, formidable land walls protected the approaches to a city whose cathedrals and palaces boasted more wealth than the world had ever seen.

While barbarians plunged much of Europe into the Dark Ages and Islam conquered substantial segments of Asia and Africa, Constantinople served as a bulwark for Christianity. Within its walls the ancient learning of Greece and Rome was maintained and extended. It was a melting pot of cultures, a city of nearly a million souls, a place where, according to one sixth-century visitor, all 72 languages of the world could be heard on any given day.

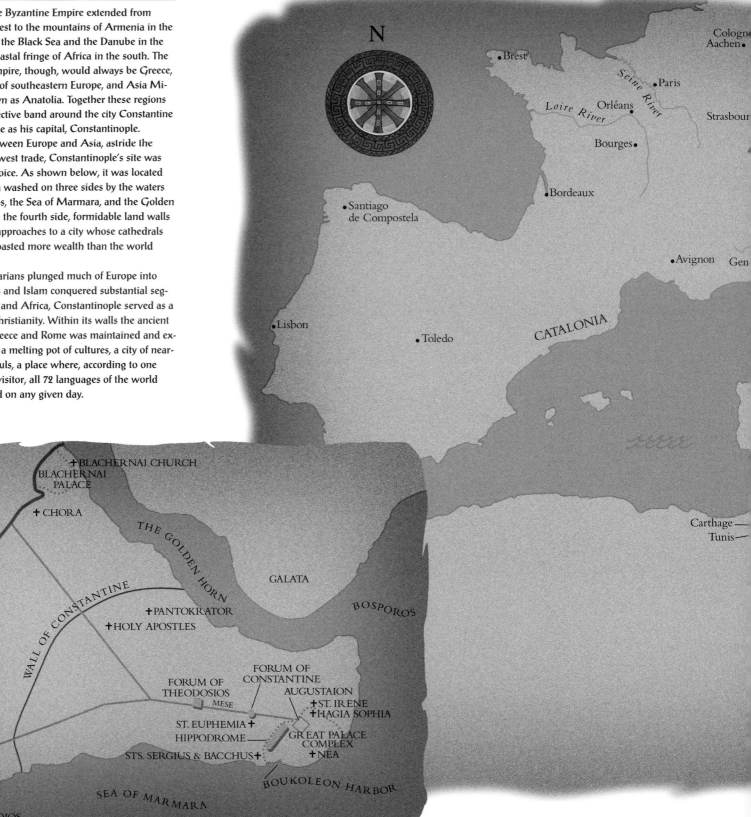

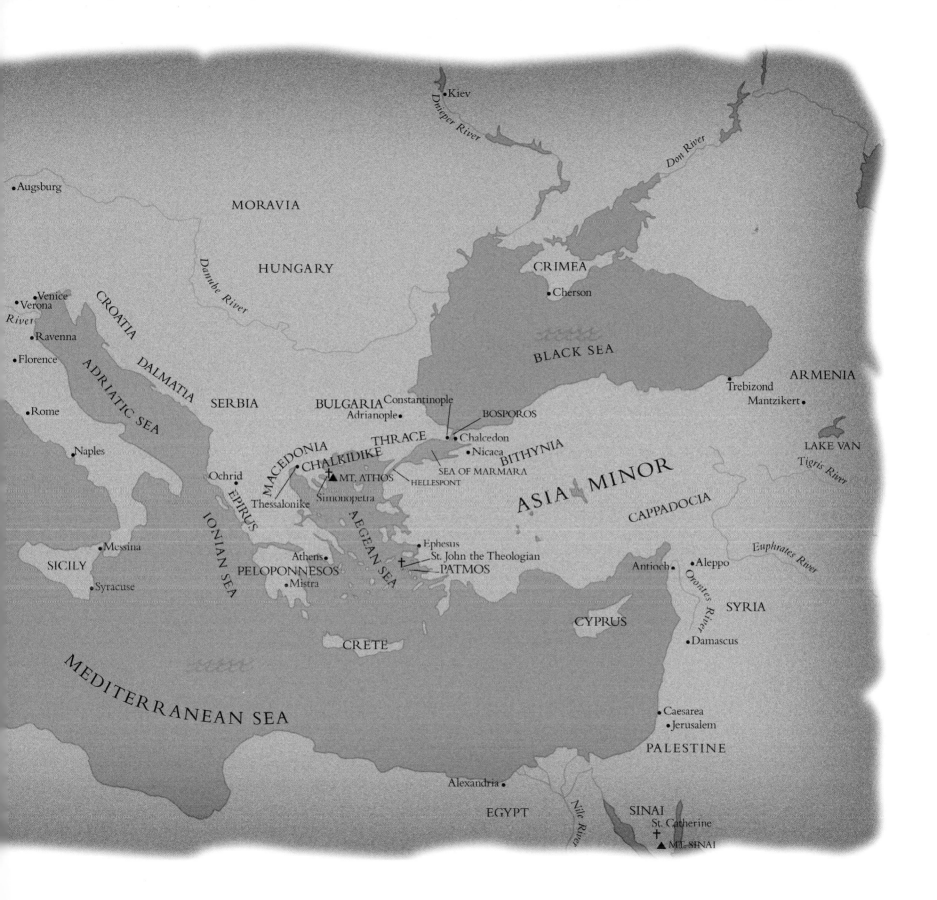

THE FATHERS OF BYZANTIUM

Of the 88 emperors who ruled Byzantium during its thousand years of glory, two will be remembered as having bequeathed lasting gifts to the world. Constantine broke with the Roman Empire's traditions by granting religious freedom to Christians, and 200 years later, Justinian codified Roman law, perpetuating the empire's great legal heritage.

In his famous Edict of Milan in AD 313, Constantine granted "both to the Christians and to all men freedom to follow the religion which they choose." In doing so, he led the way to the spiritual conversion of all of Europe. In the temporal realm, Justinian formed the numerous Roman laws into a coherent whole, producing a code used by European nations for centuries. He also rebuilt cities, walls, and churches, including Hagia Sophia in Constantinople.

The two emperors were immortalized as Byzantium's founding fathers in the 10th-century mosaic at right. In it, Justinian (left) presents a model of Hagia Sophia to the Virgin, the protector of Constantinople, while Constantine (right) offers a model of the city he built.

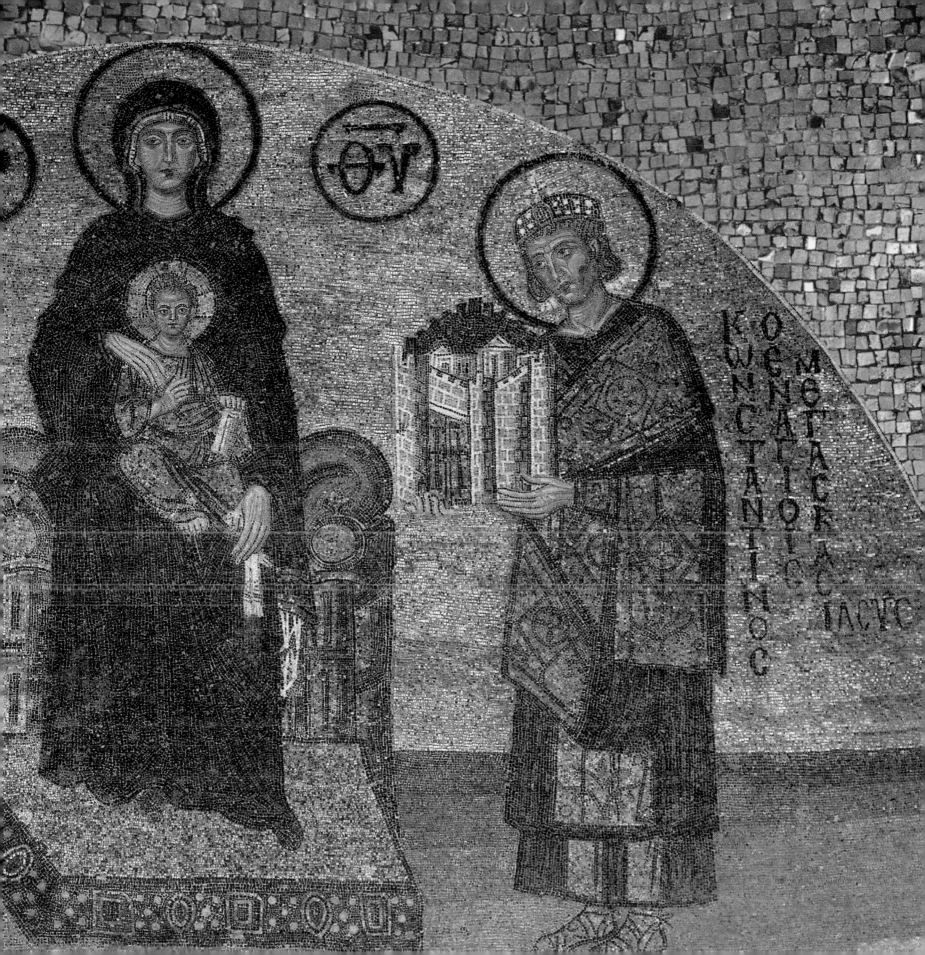

A SIGN FROM THE HEAVENS

Some scholars attribute Constantine's edict allowing Christianity to political motives, but he may have experienced something that changed his way of thinking. According to the version of the story told by Eusebios, bishop of Caesarea and Constantine's contemporary biographer, it all began with a vision.

One day, Eusebios wrote, at "about noon, when the day was already beginning to decline, he saw with his own eyes the trophy of a cross of light in the heavens, above the sun, and bearing the inscription, CONQUER BY THIS." Later, when Constantine was asleep, "the Christ of God appeared to him with the same sign which he had seen in the heavens, and commanded him to make a likeness of that sign which he had seen in the heavens, and to use it as a safeguard in all engagements with his enemies."

Constantine obeyed, ordering a gold-and-jeweled standard of the shape and commanding that it be carried at the head of all his armies. He then marched to Rome to fight Maxentius, coruler of the Roman Empire and his chief adversary. "Trusting more in his magic arts than

in the affection of his subjects," wrote Eusebios, Maxentius advanced beyond the walls of the city to the Milvian Bridge. During the ensuing battle, Maxentius's army fled back across the bridge, and their leader fell into the Tiber River and "went down into the depths like a stone." Constantine subsequently "entered the imperial city in triumph."

Constantine needed no further proof of the power of the Christian God. He became a strong supporter of Christians and credited all his subsequent victories to Christ. After defeating Licinius, another coemperor, and becoming sole emperor of the entire Roman Empire, he promoted and defended Christianity throughout the realm.

Constantine was not baptized until the eve of his death. At that time, it was not unusual for converts to delay baptism, so that they could die with all past sins forgiven. The emperor died on May 22, 337, wearing the white garments of a Christian, forsaking the imperial purple forever.

This colossal head of Constantine, measuring six feet across, adorned the emperor's basilica in Constantinople. After his conversion, Constantine decreed that all portraits should show his eyes gazing heavenward.

In these miniatures depicting Constantine's dream and conversion, an angel appears to Constantine and points to the cross in the sky, Constantine's army routs Maxentius, and Constantine is baptized by Eusebios.

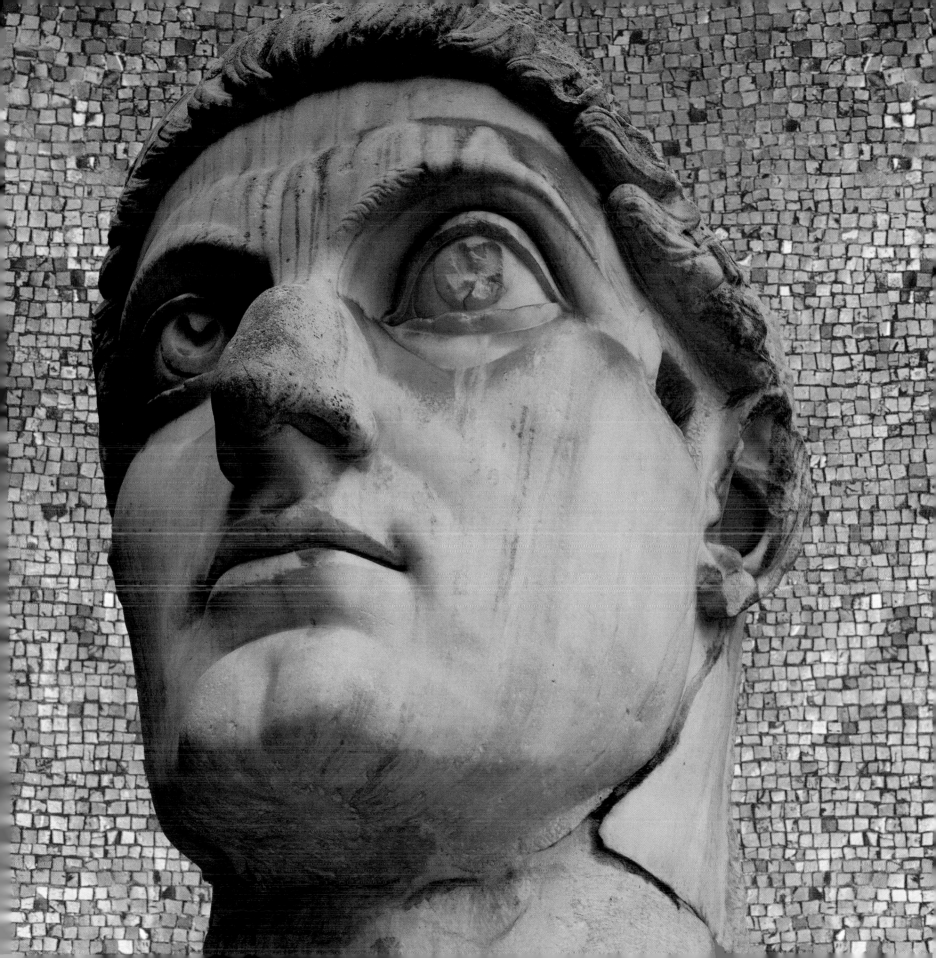

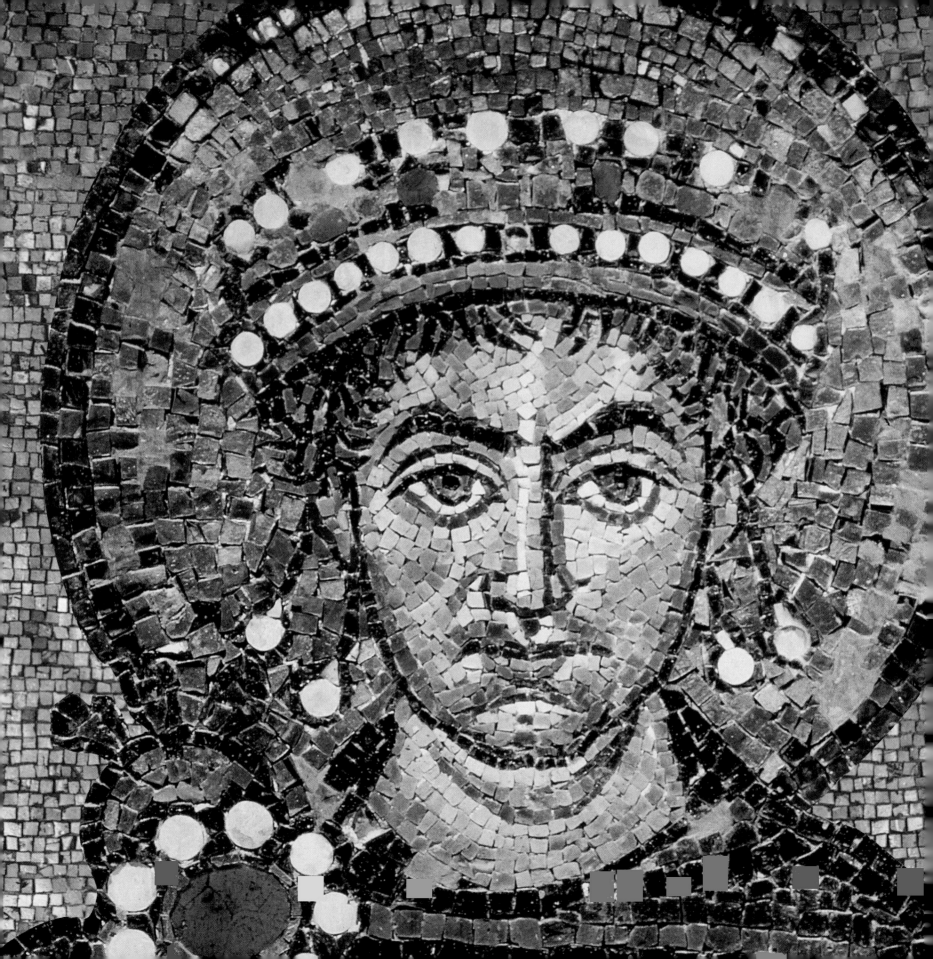

ONE EMPIRE, ONE LAW, ONE CHURCH

When Justinian ascended the imperial throne in 527, he inherited an empire in disarray. Portions of the Western Empire had been lost to conquerors, the Christian church was becoming divided and other religions were taking hold, and the laws of the land were archaic and contradictory. Though he met with little success with most of these challenges, he did succeed in uniting his people under one clear and understandable body of law—a lasting accomplishment.

The Romans had long prided themselves on their legal system, which in scope and logic surpassed any other in the ancient world. But by Justinian's time the laws had become so numerous, redundant, contradictory, and in some cases outdated that he determined to reform the system. He announced the project in 528, stating in an edict, "What many previous emperors saw must needs be rectified, but none has ventured to put into effect, we have decided to grant now to the world, with the help of Almighty God."

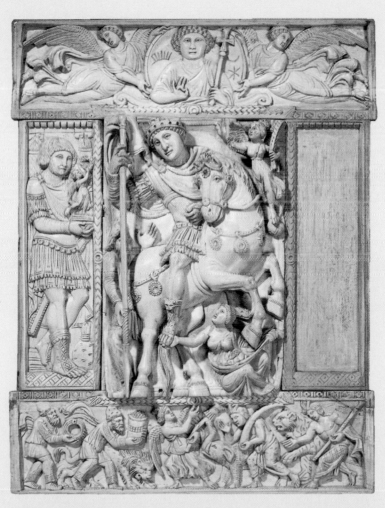

To begin, Justinian appointed a commission to compile all the valid imperial statutes, pruning repetitions and contradictions as they went along. In April 529, this work, known as the *Codex Justinianus,* was complete, and copies were distributed to all the provinces in the empire. The codex constituted the law of the land, and no other statutes or enactments were to be cited in court.

The second stage of reform involved compiling all the responses of the great jurists of the classical period and arranging them by subject matter into a set of 50 books known as the *Digest.* In the course of their work, the commission read some 2,000 books by 39 authors, totaling three million lines—and by judicious editing, reduced them to 150,000 lines. In 534, Justinian commissioned a revised edition of the codex, and it is this body of laws that we still possess today and on which most European nations later built their own legal system.

A halo symbolizing spiritual authority and a crown representing earthly powers frame the emperor Justinian's face in this mosaic from San Vitale, a church he built in Ravenna, Italy.

In this ivory diptych, Christ blesses a Roman emperor—probably Justinian. A general bears a trophy of Victory, Earth supports the emperor's foot, and conquered peoples offer tribute.

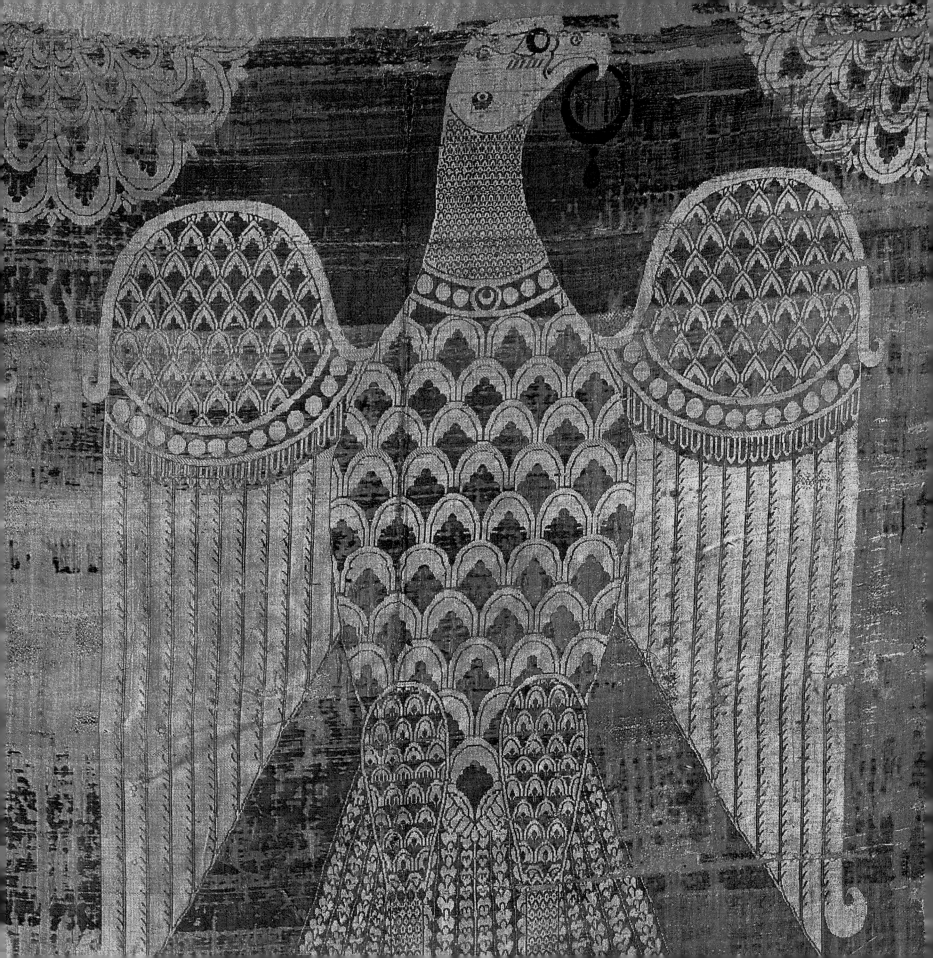

THE TWO HALVES OF GOD

To the Byzantines and their Roman predecessors, the eagle was a symbol of both imperial might and divine will. The posture and raised wings of the eagle on the silk textile at left emphatically signify military power, but the majestic bird's role as an instrument of God assured the victory of good over evil. Byzantine silks such as this royal one were highly prized and were considered as valuable as gold.

wo suns rose over Constantinople, it was said, on the day that a new emperor was crowned. The individual who reached this pinnacle of earthly power would shine as radiantly as the celestial orb. To witness such an event on Sunday, May 28, in AD 866, the residents of Constantinople spilled out of their houses onto a tangle of narrow, winding alleys and made their way to the larger avenues that led to the ceremonial heart of their glorious, gold-domed city. Folks who tarried would not find a place to stand in the marble-paved, colonnaded Augustaion, Constantinople's main public square. Even imperial officials and bureaucrats had to hurry in order to secure their seats in Hagia Sophia, the magnificent cathedral of Holy Wisdom, where they would participate in the coronation of Basil the Macedonian as coemperor and heir to Michael III, the reigning monarch.

Those who could rode mules or horses or were borne in brightly decorated, mule-drawn carriages, thereby avoiding the refuse and animal droppings that littered the streets. Most, however, walked. Many emerged from the harbor districts along the great estuary known as the Golden Horn. Some trudged beside the immense aqueduct built 500 years earlier by the emperor Valens. This imposing structure was

part of a system that brought water from Thrace, more than 30 miles away, to feed Constantinople's baths and fountains and replenish its vast underground reservoirs.

Before long both riders and pedestrians reached one of the two branches of the Mese, or Middle Street, the thoroughfare that ran from the city's land walls to the Augustaion. Shaded by arcades and punctuated by forums, cathedrals, and statue-filled squares, the Mese today was strewn with rosemary and perfumed matting in honor of the occasion. Some of the strollers stopped to refresh themselves at the huge fountain in front of the Forum of Theodosios before passing through the bazaar district. Here, rows of shops displayed a selection of meats, cheeses, vegetables, fruits, and honey, while other establishments were crammed with such luxuries as silks, jewels, golden plates and utensils, glass vessels, leather, and fragrant perfumes.

Although the gathering crowds stood ready to stamp their approval upon the coronation of Basil as Michael's heir, it was only a short time ago that they had railed in the streets against Michael for the brutal events leading up to this coronation, denouncing him for shedding the blood of his own kin. But now, under the spell of tradition, most chose to forget the murderous plots that had spurred Basil's rise. It was more important to them that Michael, who had no offspring, ensure a stable government after his death by choosing a successor. No matter what Basil had done to reach this position, palace intrigue was better than civil war, and the people, the army, and God himself would sanction his ascension to the throne.

In the meantime, the man upon whom the masses had fixed their hopes prepared for his day of glory. With large, powerful hands, Basil

Seen here giving a public audience, Byzantine emperor Basil I proved himself an adept and attentive ruler. During Lent he was said to visit the imperial tax office every day to settle disputes between citizens and tax collectors.

A reigning emperor crowns his successor while both men are raised on a large shield before a cheering crowd. Choosing an heir before a ruler's death helped to ease the transition from one monarch to the next.

adjusted the white silk tunic that barely seemed to contain his muscular physique. The servants fanning him from the heat of the Mediterranean sun could not keep the sweat from gathering on his alert, handsome face, set off by a mass of curls. This emperor-to-be could neither read nor write, and often, amid the stylized manners of the court, he revealed the crude customs of the humble farm family into which he had been born. A power-hungry opportunist, he had plotted and murdered his way to the crown. Yet his cleverness, ability to take decisive action, and lack of ties to any single faction would serve him well as emperor. Indeed, Basil was to prove an adroit and worthy ruler who would usher in an era hailed as the most glorious of the Byzantine Empire.

Flanked by guards and attendants, Basil and Michael left the extensive complex of administrative buildings, living quarters, and churches known as the Great Palace and proceeded toward the Hagia Sophia, greeting the dignitaries who lined their path and acknowledging the praise of the crowds. Before reaching the cathedral, they stopped at a pavilion in the Augustaion to participate in an ancient ritual practiced by the Romans when lauding their caesars: Surrounded by units of the imperial armed forces, the two emperors stepped upon a large circular shield that was then hoisted onto the shoulders of a group of soldiers. The throng roared its approval.

Next, the royal party entered Hagia Sophia. Just inside the church, Photios, patriarch of Constantinople, assisted by several eunuchs, dressed Basil in elaborate ceremonial robes, throwing over his clothing another white silk tunic so that only the embroidered cuffs of his original garment were visible. On Basil's shoulders he placed the chlamys, a jeweled mantle dyed in royal purple and embroidered in gold with animals and constellations. And on his feet he set a pair of jeweled scarlet leather shoes.

Then, taking Basil by the hand, the patriarch led the two emperors deeper into the church. They were watched by rows of elegantly clad officials, courtiers, and clergy, some of whom revealed their occupations by their traditional garments: philosophers in gray robes, physicians in blue. Foreign dignitaries were bedecked in strange, brightly colored outfits with exotic

Sculpted in marble, a Byzantine emperor in regal garb radiates a power as brilliant as the sun to which he was likened. He holds a military standard in one hand and a globe surmounted by a cross in the other, emblems of his command over the Christian world.

headdresses. Women of high status sat, as was customary, in the gallery, having taken no part in the public procession; on top of their flowing tunics they wore gold- and silver-embroidered mantles with patterns woven in shades of blue green.

Basil lit several candles and knelt in prayer. With satisfaction he noted the two thrones set side by side in the spot where the emperor's chair usually stood alone. While Michael climbed to the top of Hagia Sophia's three-tiered marble pulpit, Basil stepped onto the middle level. An imperial official, standing on the lowest tier, read the emperor's proclamation: "It is my will that Basil, the High Chamberlain, who is loyal to me, who has delivered me from my enemy and who holds me in great affection, should be the guardian and manager of my Empire and should be proclaimed by all as emperor." Basil, either genuinely moved by the proclamation or recognizing the need to make a display of emotion, promptly burst into tears.

Now Michael removed his crown, a golden, jewel-encrusted skullcap, and passed it to the patriarch. Photios blessed the glittering hemisphere and returned it to Michael, who would himself crown his successor. But even as Michael placed this regal symbol upon Basil's head, the wily new emperor may have been thinking of the day when he would reign alone and conjuring up a plan for hastening it. But all thoughts were drowned out by the congregation's cheers: "Long live the emperors, Michael and Basil," and the thrice-repeated, "Holy, Holy, Holy, Glory to God in the highest and peace on earth."

A Byzantine crown of solid gold sparkles with pearls, gems, and jeweled pendants. Its enameled plaques show the 11th-century emperor Michael VII in the company of Christ and various saints of the church.

Pleased to be performing their part in the mystique of divine investiture, the congregation continued their laudatory chanting for several hours, led by the cathedral's choristers, each of whom would afterward receive gold coins for their efforts. At the altar, woven into a red curtain, the radiant figure of Christ, wearing a shimmering golden robe, pointed the fingers of his right hand as if confirming Basil as God's chosen viceroy. The participants' sense of awe was heightened by the immense dome of the cathedral, 107 feet in diameter and 180 feet above them, where a huge cross stood out from a background of gold mosaic. The ring of 42 arched windows surrounding the dome flooded the building with sunlight and made it appear as if the dome were, in the words of one observer, "suspended from heaven." In this brilliance, the polished marbles of pillars and floors glistened green, pink, violet, black and white, silver veined, or gold flecked. Mosaics in the form of humans, angels, and animals, real and mythological, told thrilling tales upon the pavements and walls. It was hardly surprising that one observer had suggested that God "must love to dwell in this place."

The ordinary people, massed outside Hagia Sophia, were also given a chance to acclaim the new emperor. As the royal entourage emerged from the cathedral, the citizens chanted their praises along the route of the procession, which next made its way to the hippodrome, an ellipse 1,300 feet long and some 500 feet wide, built for chariot racing. This was the people's domain, a place where luck and accomplishment, rather than birth, held

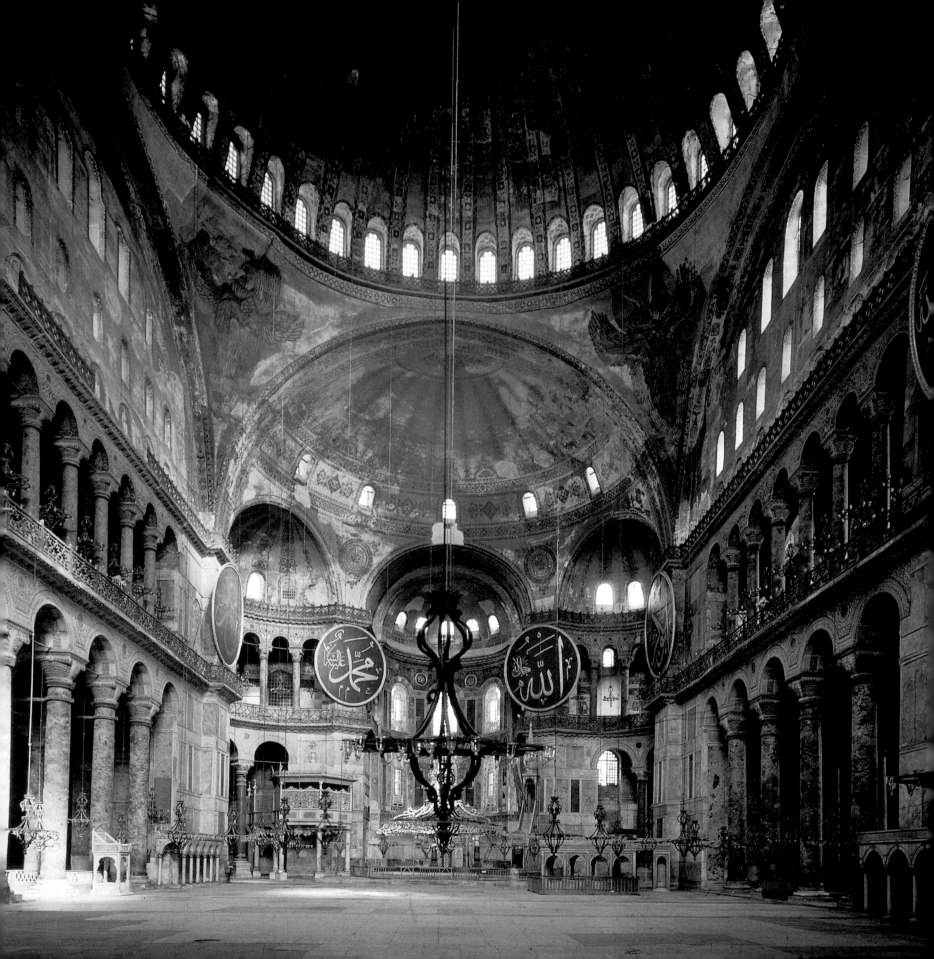

For almost a thousand years the religious and ceremonial life of the Byzantine state centered on the great cathedral of Hagia Sophia, or Holy Wisdom *(below)*. The building, which was later converted into a mosque and then a museum, remains an unparalleled architectural wonder. Its interior nave *(left)* is over twice as wide as and notably taller than that of Chartres or any other Gothic cathedral. Its dome is supported by an extraordinary system of interlocking main piers, secondary piers, buttress piers, and spanning arches. The effect, wrote one visitor to the church, is that one's "mind is lifted up to God, feeling that He cannot be far away."

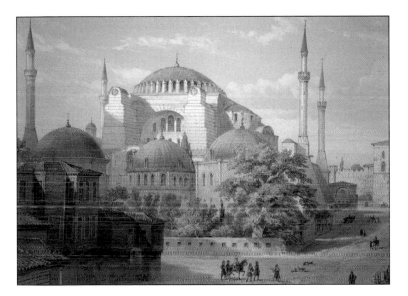

sway, and where the men of the city were always admitted without charge to choose from among the unoccupied marble seats of the 60,000-capacity arena.

The imperial party advanced to the royal box at the northeast end of the hippodrome, abutting the Augustaion. There, at a nod from the emperor, a group of attendants distributed 10,000 loaves of bread to the delighted populace; inside each loaf had been baked three gold coins bearing the new emperor's image. Then Michael dropped a white handkerchief as a signal for the races to begin.

To the cheers of the crowd, four-horse chariots thundered along one side of a low wall down the center of the hippodrome, turning at the stones marking the upper and lower ends of the course. If anyone in the audience lost track of a race's progress, they could look up at the seven ostrich eggs set upon a stand: Every time one of the seven laps was completed, an egg was removed. Race winners were presented with gold emblems and silver helmets, and during intervals between races, hosts of performers—musicians, actors, singers, jugglers, mimes, dancers, and acrobats—entered the arena and entertained the crowd.

Many of the spectators preferred to fill the time between races by exchanging gossip, all of which today focused on the new coemperor, Basil. Some alluded slyly to his role in the brutal murder of Michael's popular uncle, Bardas. But to the wellborn, the man's lowly origins were reason enough for scorn.

Basil's family, which was of Armenian origin, had eked out a living from a hardscrabble farm in Thrace. When he was a young boy, though, he and the other members of his family were taken captive with thousands of others by an army of invading Bulgarians. A few years later they were released by the Bulgarian ruler and sent to occupy a patch of farmland in an area north of Greece called Macedonia. So it was that Basil—who spoke Greek only with a heavy Armenian accent—would become known as "the Macedonian."

When he grew to young manhood, Basil left farming and worked for a short while for the governor of his province. But the time came when he set his sights higher, and he trudged off to the imperial capital, with little more to his name than the pack he carried on his back. Arriving in Constantinople on a Sunday evening, he rested on the steps of the monastery of Saint Diomedes, just inside the city walls. That night the saint himself is said to have appeared to the abbot in his sleep, bidding him to open the door

for the man who would one day be emperor. Groggily the abbot rose, but all he saw on the doorsteps of his monastery was a shabbily dressed young man. However, when he went back to sleep, a voice again commanded him to "rise and bring in the man who lies before the door. He is the emperor."

Whatever the circumstances of Basil's arrival, the abbot soon arranged for the introduction of Basil to Theophilitzes, a distant relation of the royal family. Pleased with the youth's size and strength, Theophilitzes hired him to groom his horses, a job at which he worked ably for several years. His master's high regard for his abilities would advance Basil further, eventually catapulting him to the attention of none other than Michael III, emperor of Byzantium.

Michael was the son of Theodora, who had reigned as regent for him throughout his childhood and had been reluctant to give up control of state matters when her son came of age. Supporting Theodora in her rule over the empire was her chief adviser and loyal friend, Theoktistos, and also Bardas, her brother. But Bardas, seeking greater power, arranged for the murder of Theoktistos, and after the loss of her key supporter, Theodora was forced to retire from the government. Bardas became, in effect, ruler of Byzantium. His intelligent administration of the bureaucracy won him a reputation as an incorruptible official, and he was esteemed by the army and adored by the populace. The soldiers were also devoted to the young emperor Michael, for he was a brave fighter and leader of his troops. At home, however, he was content to leave the running of Byzantium to his uncle while he indulged in his favorite pursuits: wining, dining, and above all, horse racing.

This was the situation at the palace when Basil appeared at its fringes, through his job with the courtier Theophilitzes. Already Basil had come a long way from his humble beginnings. But to rise from where he stood to the stature of even a minor court official would be a giant leap forward. Two stories of mythical proportions are told to explain his subsequent advance.

One evening Bardas's son, Antigonos, gave a banquet in honor of his father, filling his hall with dignitaries and friends, including Theophilitzes, as well as a delegation of Bulgarians new to the city. After dinner, as custom demanded, a central area was cleared and sprinkled with sand, and a group of wrestlers entertained the guests with their feats of strength. The Bulgarians boasted that one of their men could throw any wrestler, and indeed the man was able to defeat all challengers, shaming his Byzantine hosts.

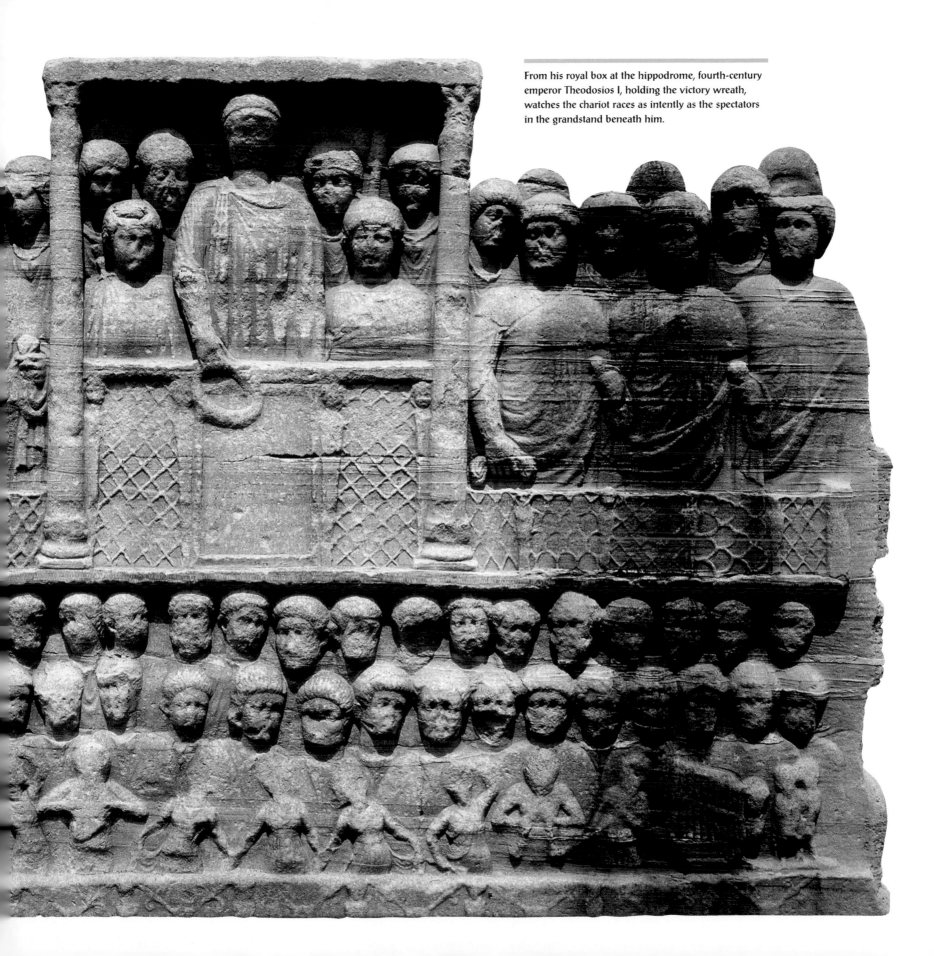

From his royal box at the hippodrome, fourth-century emperor Theodosios I, holding the victory wreath, watches the chariot races as intently as the spectators in the grandstand beneath him.

Resentful of the Bulgarian taunts, Theophilitzes at last reacted. "There's a man in my service who can equal your Bulgarian," he declared, and sent for Basil, who agreed to take on the foreigner. Swelled with his successes, the Bulgarian champion came at Basil and tried to throw him. But Basil lifted him into the air and tossed him clear across the room.

Michael was delighted by news of this strong and capable youth, and even more so a short time later, when the emperor received as a gift a beautiful but wild horse that none of his grooms were able to manage. Once again Theophilitzes brought Basil along to show off his skills. Taking the bridle in one hand, Basil whispered to the magnificent animal, all the while stroking its head. Before long the beast allowed him on its back, and soon Basil was able to turn over to the emperor a well-behaved animal. But Michael would not settle for the horse alone. He persuaded Theophilitzes to allow the brawny young trainer to come and work for him.

Michael and Basil were drawn to each other from the start. "Come and see the splendid creature I've discovered," the emperor enthused to his mother. But when he introduced his new favorite to Theodora, apparently she did not like the ambition she saw in him. "Would to heaven," she later said, "I had never set eyes upon this man, for he will destroy our house!"

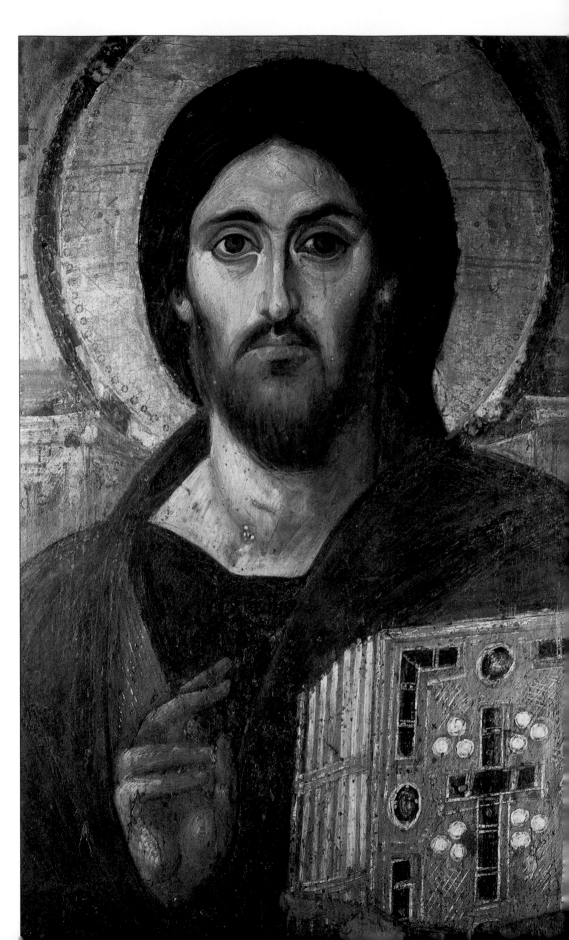

WINDOWS ON HEAVEN

To their opponents, they were a form of idolatry that violated the Old Testament prohibition against "graven images." But to their supporters, icons were nothing less than windows on heaven, a vehicle for their prayers, and a way to get close to God.

Derived from the Greek word for image, icons were depictions of holy people and events. Most were painted on wood, but they could also be crafted out of enamel, ivory, and precious metals, or made as mosaics; some were small and portable, others great paintings decorating churches.

From the fourth century on, these sacred objects became key to Byzantine public and private worship. On special occasions they were brought out for veneration and paraded around the city walls to protect the inhabitants. Inside churches and private homes, the faithful lit candles and burned incense before their icons, and through them made their petitions to God.

Like all icon painters, the artist sitting at his easel *(above)* was expected to spend considerable time in prayer before beginning his day's work.

An Iconoclast uses a sponge dipped in whitewash to destroy a circular icon of Christ in this illustration from a ninth-century copy of the Psalms.

Holding a jewel-covered gospel, Christ calmly gazes at the viewer in the typically Byzantine style of this sixth-century icon.

31

By the early eighth century the so-called Iconoclasts—or image destroyers—took control. After an earthquake and a series of attacks on Constantinople by the Muslims, Emperor Leo III became convinced that God was angry over the use of icons and ordered them taken out of churches.

In 726 the systematic destruction of icons began: All images of Christ, the Virgin, and the saints were to be ripped from the walls of churches and replaced with simple crosses or nonreligious figurative art. Leo's moves met resistance, though: When his soldiers tried to take down a great mosaic icon of Christ over the Chalke gate, the main entrance to the Great Palace, a group of angry women attacked them, and in the ensuing fracas one soldier was killed.

The assault on icons and on those who believed in them would rage, on and off, for more than a century. Finally, the regent empress Theodora—mother of Michael III—ended the dispute by installing a pro-icon monk named Methodios as patriarch. In 843 the church celebrated the restoration of icons with the Feast of Orthodoxy, during which the holy objects were carried through the streets of Constantinople to the cathedral of Hagia Sophia. The event is still celebrated each year by the Eastern Church.

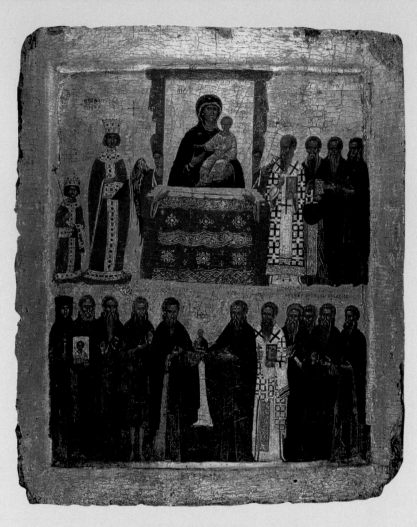

In *The Triumph of Orthodoxy,* an icon celebrating Iconoclasm's defeat, Theodora, Michael III, and Methodios are among those standing before a famous Byzantine icon.

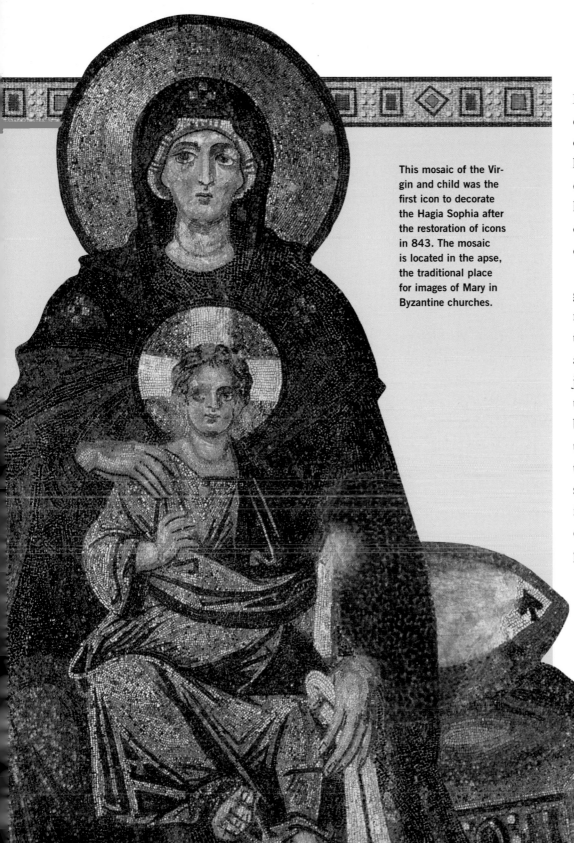

This mosaic of the Virgin and child was the first icon to decorate the Hagia Sophia after the restoration of icons in 843. The mosaic is located in the apse, the traditional place for images of Mary in Byzantine churches.

Such warnings could not dislodge Basil from Michael's favor, however. Indeed, the carping of those around him only caused Michael to cling more firmly to the Macedonian, as Basil was now called, and he made him his "master of the horse." Given Michael's extravagant love of horses and of racing, it was a post of optimum influence.

Michael's uncle Bardas, who was still governing Byzantium in the emperor's name, also distrusted Basil. When in 862 the high chamberlain was dismissed after a quarrel with Bardas, Michael gave the job to Basil. Among other responsibilities, the chamberlain slept in the emperor's bedchamber. Since this official was traditionally a eunuch, Basil's appointment led to suggestions of a homosexual relationship between Michael and Basil, whose friendship deepened through the inevitable closeness fostered by Basil's new position. Perceiving hidden ruthless ambition in the outwardly compliant chamberlain, Bardas added his misgivings to those of Theodora, observing that in the highest reaches of government there was "a lion who will end by devouring us all."

The former stable hand was now declared a patrician, and Michael determined that he would se-

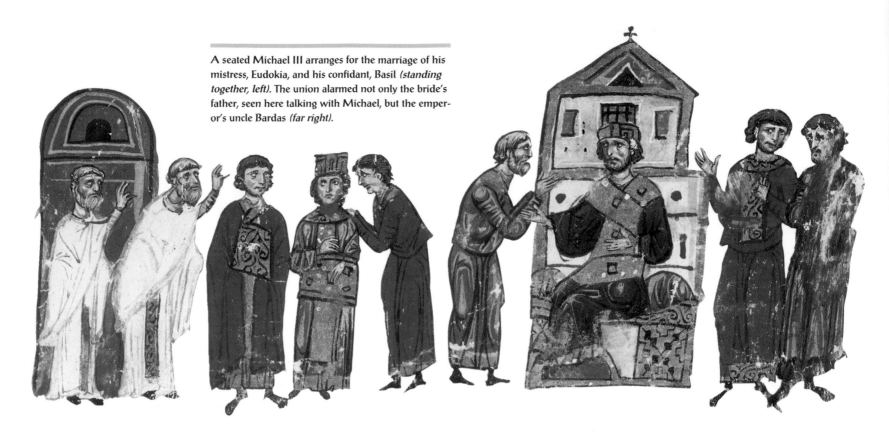

A seated Michael III arranges for the marriage of his mistress, Eudokia, and his confidant, Basil *(standing together, left)*. The union alarmed not only the bride's father, seen here talking with Michael, but the emperor's uncle Bardas *(far right)*.

cure his friend's rise into this class with a suitable marriage. Basil, in fact, already had a wife. Sometime in his youth, probably before his arrival in Constantinople, he had wed a Macedonian woman named Maria, who had recently borne him a son, Constantine. Nevertheless, Michael had a new candidate in mind. Since his early manhood, the emperor had loved a beautiful half-Swedish woman named Eudokia Ingerina. It was, however, the duty of the emperor's mother to choose a wife for her son, and Theodora had selected an aristocratic young woman from a family named Dekapolitissa ("Ten Cities"), whom she foisted upon her reluctant offspring. Although Michael eventually would rid himself of the unwanted spouse, he never ended his liaison with Eudokia. And, it was rumored, to ensure her position in court Michael had made a contract with Basil: Eudokia would wed Basil, but the marriage would remain unconsummated, and she would continue as Michael's mistress.

While this bizarre arrangement raised Basil considerably higher in his relationship to the emperor, it added to the gossip about the upstart. Carrying out the humiliating agreement must have been emotionally wrenching, for Basil had to divorce Maria and send her back to her native Macedonia, a richer, if perhaps disillusioned, woman. Basil's new wife, Eudokia, remained Michael's mistress and therefore untouchable, so Basil decided to make do by making love to Thekla, the emperor's sister, who was very attracted to the handsome, robust Macedonian. Thus far Michael had trusted Basil with two of the three elements of his life he valued most, his horses and the women he loved; the third would be his empire.

Michael now had Basil to counter his powerful uncle Bardas, and these two top advisers began to contend for control over the emperor. Basil set about convincing Michael that Bardas was plotting to kill him and rule alone. To back up his claims, Basil enlisted the help of Symbatios, Bardas's son-in-law, after convincing the young man that Bardas had blocked his advance within the bureaucracy. Feeling betrayed, Symbatios followed Basil's lead in warning Michael of a conspiracy on the part of his

father-in-law. Reluctant at first to believe their stories, Michael gradually came to accept them as true—and realized the need to get rid of Bardas before his uncle got rid of him.

Bardas quickly learned of Basil's plotting. In Constantinople, where his son Antigonos commanded the guard, Bardas was well protected. But in early 866 the conspirators hit upon a plan to lure Bardas elsewhere. That March, Michael and Basil decided to join their troops in an expedition to Crete, which had lately fallen to the Arabs, and asked Bardas to accompany them. The shrewd Bardas refused to go, however; without some guarantee of his safety, he dared not leave the capital. To soothe his anxieties, Michael and Basil escorted him to the church of Saint Mary in the copper market, located on the site of a former synagogue that once had been used by Jewish coppersmiths. Patriarch Photios, the most important priest in the land, awaited them there, and he bore witness as the emperor and his right-hand man swore an oath, supposedly signed in the blood of Christ, that they harbored no plan to harm the emperor's uncle. Bardas was

left with little choice but to travel abroad along with the court.

Shortly after arriving in Crete, Bardas donned his most elegant clothes and rode to the imperial tent to see the emperor. While Bardas was meeting with Michael and Basil, Symbatios admitted into the tent a group of sword-bearing men, who advanced on Bardas. The older man, unarmed and separated from his supporters, threw himself at Michael's feet, begging for protection. Unmoved, his nephew watched as Bardas was cut to pieces.

Upon returning to the capital, Michael and Basil asserted that the murderers had been defending the emperor against the alleged treachery of Bardas. And Photios, taking a second step in complicity, publicly hailed the emperor for his narrow escape and denied the veracity of the assassination stories inundating the city. The people would have none of it: "Woe unto you!" they shouted in the streets, cursing Michael for his uncle's death.

The killing left the weak ruler even more susceptible to the

On a litter borne by slaves, a wealthy woman from Patras, in southern Greece, arrives in the imperial capital. She made the long trip to offer tribute to her newly powerful friend, Basil.

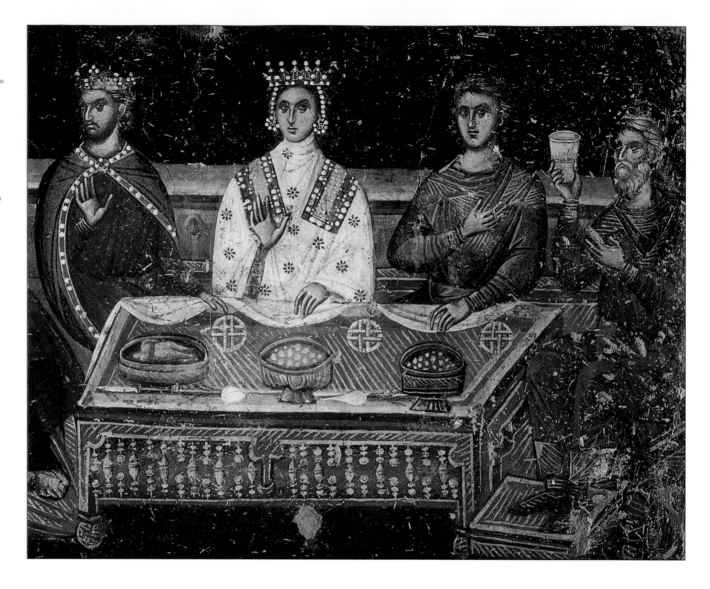

A pair of royal newlyweds celebrate their wedding at a matrimonial banquet in a wall painting from the 1300s. When a Byzantine emperor took a bride, a banquet was held in the Hall of the Nineteen Tables, the Great Palace's most formal dining room. There, guests reclined on embroidered couches, dined on plates of solid gold, and—though knives and spoons had long been in use—ate with their fingers.

influence of Basil, whom he now perceived as his only true friend. Since Michael had no children, Basil was able to persuade the emperor to adopt him as his heir. And so Basil was crowned co-emperor in May 866. But a man could grow impatient with waiting; indeed, he might just seek to hasten the day when he would succeed the reigning emperor and take the crown for himself.

In September 866, in the Great Palace, Basil's wife, Eudokia, gave birth to a son. The event was duly announced in the hippodrome, where the crowds roared their acclaim for a child that many at court suspected was actually Michael's offspring. The boy was named Leo.

Not long afterward, however, Michael began having second thoughts about the man he had made his heir. He even fixed upon a new favorite, a patrician gentleman named Basiliskianos, whom he had recently appointed chamberlain. One night, after a palace dinner, Michael got drunk. Turning to Basiliskianos, he ordered, "Take off my scarlet shoes and put them on yourself." Then to Basil he remarked, "I think they look better on him than on you." Basil's wife Eudokia, with whom Michael, as usu-

al, had been openly flirting, tearfully reminded the emperor not to dishonor "the imperial dignity." "Don't you worry about that, my dear," he answered her. "It amuses me to make Basiliskianos emperor."

Basil made no reply, but he was nothing if not a man of action. He called again upon Bardas's assassins and awaited his chance to strike. The opportunity arose in the Palace of Saint Mamas, across the Golden Horn from Constantinople, where the emperor kept a private racetrack to practice for the races at the hippodrome. During a banquet there on the evening of September 23, 867, Michael once more became deeply intoxicated. Seeing this, Basil slipped out of the hall and headed for the imperial bedchamber. With his own strong hands, he bent the bolts of the door so it could not be locked. Returning to the hall, he watched Michael sink deeper into his cups, and after the guests had departed, insisted on helping him to his bed. He left the sleeping emperor guarded by his chamberlain and another servant.

Later that night, Basil reentered the room with eight assassins and quickly overwhelmed the guard. Michael awoke, and one of the conspirators cut off his hands. The room rang with the emperor's curses as another ran him through with a sword. The brutal crew left the emperor's mutilated, lifeless body wrapped in a horse blanket, taking with them the royal diadem and other trappings of power. Led by Basil, they raced to the Golden Horn, where they had stashed a boat. After crossing the channel, they made their way through the darkened city streets to the Great Palace. Basil, now sole emperor, retired to the imperial bedchamber in which Michael had slept the night before.

But Basil might never sleep soundly again, knowing as he did that holding on

These two objects, a goblet of agate and gold set with precious gems and a silver toothpick and ear cleaner, are splendid enough to have graced an imperial banquet table. According to one 11th-century courtier, were the emperor to share a drink with guests, he would first "put to his own lips the cup," thus relieving his guests "of any suspicion of poison."

to his new post would require constant vigilance as well as strength. Michael was neither the first nor the last emperor to suffer such a fate; 13 of his predecessors had died a violent death, as would 15 emperors who would follow him—a third of the 88 rulers, beginning with Constantine, who governed Byzantium. The very nature of Byzantine imperial rule tempted adventurers to regicide, for it was not any one man, but the supreme office itself, that received divine favor and approbation. Although Basil had been a mere peasant, his coronation had transformed him into one who was *deo coronatus,* "crowned by God"; only with the Lord's backing, the people reasoned, could he have reached this holy position. And while this thinking would not protect Basil from assassination, it did ensure that his ascent to the throne, along with the demise of Michael, would be accepted as the divine will.

The next several days would be difficult, but Basil could ease the transition from Michael's reign to his own by meticulously following the daily palace routine expected of the emperor. This began each morning as the early light bounced along the marble walls of the palace halls and gleamed upon the silver door of the emperor's bedchamber. At six o'clock, a few days after the assassination, the servant

Recently unearthed in Maca in Slovakia, this early-10th-century bronze cross testifies to Byzantine missionary work in Moravia.

Cyril and Methodios, portrayed here in a 14th-century Macedonian church fresco, were canonized by both the Roman and Orthodox Churches for their work with the Slavs.

MEN WITH A MISSION

When in 862 Prince Rastislav of Moravia asked Constantinople to send him teachers "who can explain to us in our language the true Christian faith," Emperor Michael III jumped at the chance. Here was an opportunity not just to spread the values of Orthodox Christianity but also to extend Byzantine political influence to the lands of the Slavs. Moreover, Michael knew the perfect men for the job: a pair of brothers, both brilliant young scholars, theologians,

and linguists, known to history as Saints Cyril and Methodios.

The brothers had already distinguished themselves on an imperial embassy to the Khazars, a people who lived in a region northeast of the Black Sea; Cyril and Methodios had combined diplomacy with religious conversion and had reestablished friendly relations between Khazaria and Byzantium. They were also qualified for the Slavic mission because they had grown up

in Thessalonike, in northeastern Greece, and said Michael, "all Thessalonians speak pure Slavic." But the Slavs had no written language of their own. Undaunted, Cyril, after whom the modern Cyrillic alphabet is named, invented for them a largely Greek-based script, thereby bringing to the Slavs literacy as well as Christianity.

Rastislav and his people welcomed the Byzantine brothers, who began preaching in what is today the Czech Republic and

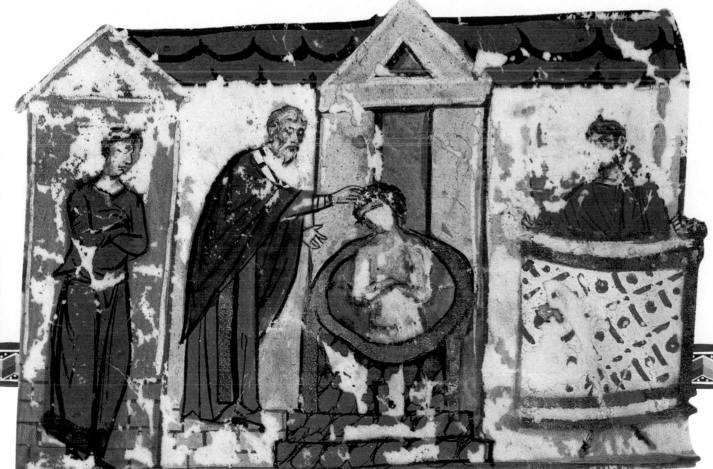

King Boris of Bulgaria's acceptance of Christian baptism in 864 meant a new faith for his country and valuable trade privileges with the Byzantine world.

Slovakia, building churches and schools and translating the Bible into Slavic. Not everyone was happy about their success, though. Missionaries from Germany had been trying for years to convert the Slavs of southeastern Europe, but disdained to use their "barbarous language," preaching only in a Latin unintelligible to the Moravians. The Germans complained that the two Byzantine missionaries were not using one of the three approved languages—Hebrew, Greek, or Latin—to spread the gospel. The complaint brought a defiant response from Cyril: "Does not God's rain fall upon all equally? And does not the sun shine also upon all?" he demanded. "Are you not ashamed to mention only three tongues, and to command all other nations and tribes to be blind and deaf?"

Among the Moravians, Cyril and Methodios continued to celebrate Mass in Slavic and train native priests, defending their actions successfully before the pope in Rome in 868; so impressed was the pope with their accomplishments, in fact, that he allowed them to celebrate the Slavonic liturgy in Saint Peter's. Cyril died the next year, and his brother returned to missionary work in Moravia for another 16 years. When Methodios died in 885, however, his followers were expelled from that country by Rastislav's successor. But they moved easily into neighboring Bulgaria, where the ruler, Boris, "thirsted after such men." The Bulgarians embraced the Slavic literary tradition Cyril and Methodios had begun, and through it exported Byzantine Christianity to other Slavic lands, including Bohemia, Serbia, Macedonia, and the emerging state of Kievan Russia.

Prince Vladimir of Kiev sent emissaries abroad to report on Judaism, Christianity, and Islam before choosing Orthodoxy for the Russian people.

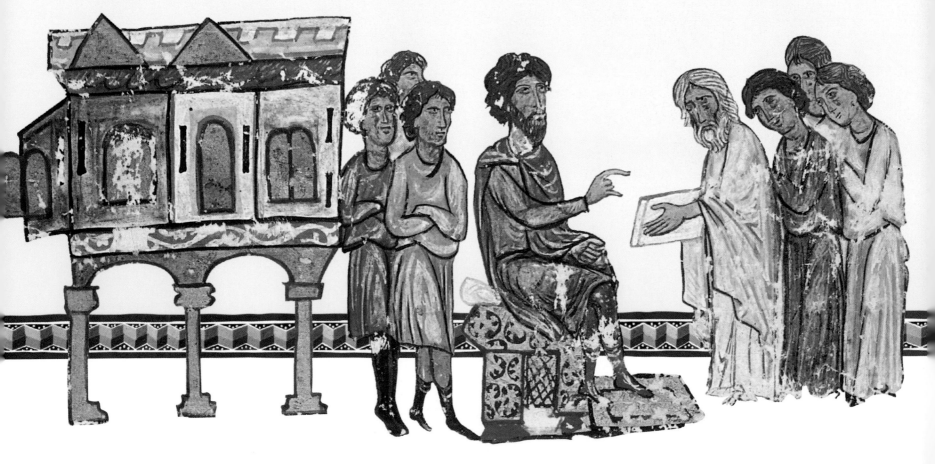

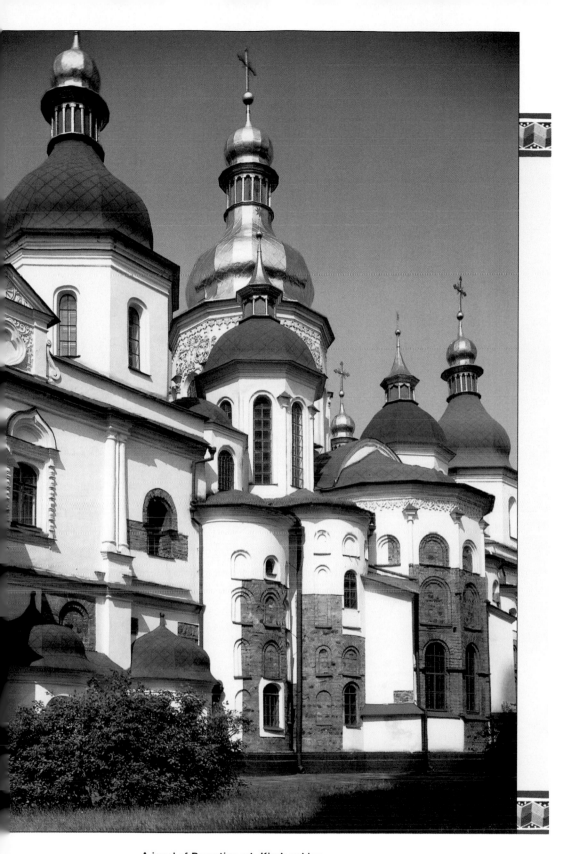

A jewel of Byzantine art, Kiev's golden-domed Hagia Sophia cathedral was built in 1036 to match the splendor of Hagia Sophia in Constantinople.

on duty outside that room knocked three times, as he did every morning at this time, regardless of the identity of the current occupant. Still in his bed, its golden frame reflecting the morning sun, Basil stirred and sat up. He conducted a lengthy toilet of washing and combing that sometimes included removing wax from his ears with a tiny golden spoon.

Eunuchs dressed the emperor on ceremonial occasions, but on other days he dressed himself. After pulling on his long, tight-sleeved, close-fitting, white silk tunic, embroidered with jewels around the neck and down the front, he threw over his shoulders the chlamys worn when performing his official duties, a purple cape adorned with squares of gold cloth and bordered with jewel pendants hanging from gold chains. After placing the gem-studded royal diadem on his head, he absently ran his hand across the back of his neck, where a fringe of jewels hung from the crown. Finally he pulled onto his feet the imperial scarlet shoes and emerged from the bedchamber.

A number of attendants appeared at Basil's side. Like most of the servants and bureaucrats who would attend the emperor throughout the day, these men were eunuchs. Unable by their nature to found dynasties of hereditary successors, eunuchs could never become rulers themselves, and they were therefore con-

BYZANTIUM'S THIRD SEX

On bended knee, a 10th-century state treasurer named Leo the Patrician presents his Bible to the Virgin Mary, who beckons Christ to accept the offering. The treasurer's gray hair and beardless face identify him as a eunuch, a member of Byzantium's so-called third sex. Because such individuals were barred from the throne, they were deemed particularly worthy of the emperor's trust.

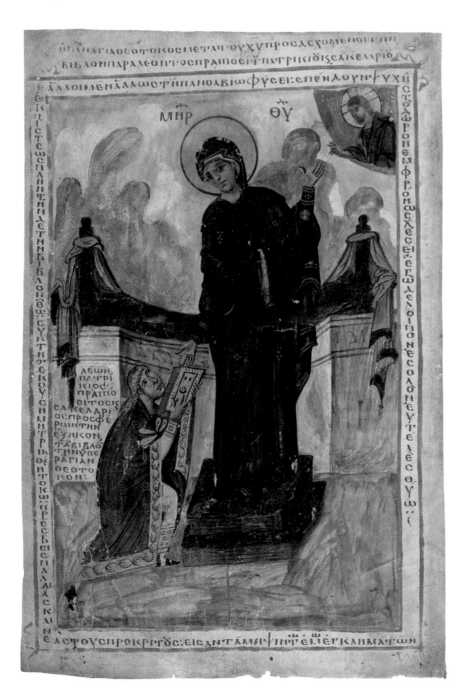

sidered to be exceptionally loyal to the reigning emperor. Some noble families, in fact, went so far as to have their youngest sons castrated in hopes of placing them in the imperial entourage.

Basil headed for the Golden Hall, the throne room where the emperor's business was conducted. Guardsmen now loyal to Basil stood erect at the doorways, with their gleaming swords unsheathed, red plumes bursting from their golden helmets. As the emperor entered the stately, domed hall, his first official act was a private one: He knelt and prayed before an icon of Christ suffering upon a cross sparkling with jewels.

Basil would need God's help; his new responsibilities were overwhelming. He was in charge of the imperial treasury, in command of the army, and overseer of a large empire where he was final arbiter on a multitude of thorny questions. From now on, his actions would be dictated by a detailed, highly ceremonial set of protocols, orchestrated by a huge bureaucracy. The daily rituals of the palace embodied a divine symbolism; they were the signs of a man through whom the Lord was working his will. The power of heaven was manifest even in the sumptuous gold and jewels that surrounded the emperor, for the more splendid his visible lifestyle, the greater evidence offered of the exalted life that every Christian could expect in the hereafter.

Rising slowly from prayer, Basil walked toward the golden throne and ascended three porphyry steps leading to the pedestal on which it was placed. The long hall had the solemn grandeur of a cathedral and indeed was built in the shape of a church, with the emperor seated where the altar would have been. One awe-struck visitor would later describe the gilded bronze tree that stood before the throne: "There were birds of different kinds in its branches, and they also were made of gilded bronze; each sang its own kind of song, and together they formed a chorus." Gilded lions flanked the emperor, and according to

Imperial decrees were issued as chryso-
bulls, documents sealed with a gold disk
portraying Christ on one side—in this case
Christ and the Virgin—and the emperor
on the other.

the visitor, these mechanical beasts "opened their mouths and roared, moving their tongues and beating the ground with their tails."

The throne was a cushioned, canopied double seat, with half of it always empty. On Sundays and during festivals, the right half of the throne was said to be occupied by Christ himself, and the emperor sat on the left. During the rest of the week the emperor, as Christ's representative, sat on the right side. Basil, seated on the right this morning, was served breakfast at a glistening golden table, using bowls, trays, plates, and utensils made of pure gold.

Like any busy executive, the emperor spent the morning in a series of meetings. Having risen through the palace ranks, Basil must have known how his ministers felt as they waited, restless and somewhat fearful, in an anteroom outside the hall. He could use this knowledge to his advantage, making them wait—and worry—when it suited him. He did not, however, keep his chief logothete, or minister, waiting this morning. The logothete entered the throne room wearing his purple and gold ceremonial robe, embroidered with peacocks and shellfish, mandated for

imperial audiences. At the appropriate moment, a pair of eunuchs appeared. Leaning on the arms of the two servants, the logothete came toward the throne, which was curtained off by magnificent purple silk hangings, adorned with jewels. The mechanical lions roared and the birds in the gilded tree sang a variety of songs as the logothete neared the throne, and then the curtains were pulled back to reveal the seated emperor.

The logothete immediately knelt upon a circle of purple marble, prostrating himself in a gesture known as *proskynesis*. The extent of this exercise varied with rank. While senior government officials were entitled to kiss the right side of the emperor's breast, junior ministers had to throw themselves to the ground with their arms over their heads and kiss the emperor's feet. Foreign ambassadors made the proskynesis in a kneeling position.

Everyone except the patriarch was required to stand throughout an audience with the emperor. And so, at Basil's signal, the logothete rose and remained standing. Like all imperial subjects, the logothete addressed the emperor in the appropriate court phrases, such as "Your Serenity," "Your Outstandingness," "Your Sublime and Wonderful Splendor." The two men had much to discuss, and an imperial stenographer took notes while white-robed eunuchs fanned the heavily garbed group.

Although his rule was still insecure, Basil was full of plans for the empire's future. To raise his standing among the soldiers, he would vigorously pursue the military campaign being waged in southern Italy against the Arabs. And in the ecclesiastical realm he would do all he could to improve relations with the pope, which would also bring Western backing for his Italian campaign.

The curtain was lowered in order to provide privacy for the emperor and his minister while they discussed these delicate matters of state. After Basil unfolded his strategy for handling Rome, the logothete excused himself to prepare the necessary papers. Before leaving, however, he brought to Basil's attention some minor issues that were awaiting the emperor's decision. When the logothete departed, Basil quickly came to a decision on these matters and had the stenographer record his verdict along with the minutes of the meeting. Perhaps then he met with the court architects to explore the possibilities for refurbishing Hagia Sophia: Like the majority of his predecessors, he wanted to leave his mark upon the great cathedral. After Basil had fully reviewed the work of these artisans, he made the sign of the cross, a signal of dismissal. The architects backed out of the hall, hands folded across their chests, as another courtier, the master of ceremonies, chanted, "So be it, so be it, so be it."

Escorted by guards, the emperor next proceeded to another room in order to sign the documents that had been prepared by the logothete. As with all court activities, there was an elaborate procedure for the signing, which took place in a chamber set aside precisely for that purpose. Basil probably made a simple cross on the papers, since he could not write. The emperor was assisted in this task by the "keeper of the imperial writing materials," a high-ranking official who supplied him with a pen, papyrus, and special purple ink. Documents then had to be sealed, the lesser papers with a ring seal. Important letters, which were known as *chrysobulls,* carried a gold seal, the size and weight of which varied according to the significance of the correspondence.

A very large gold seal probably accompanied Basil's letters to the pope, which respectfully began, "Spiritual Father and Divinely Reverend Pontiff." After dispensing

with various other official papers, the emperor was ready for his midday meal. Today he would lunch with the man who would be most affected by the changes under way between Byzantium and Rome, Photios, the patriarch of Constantinople.

Five patriarchs divided the duties of Christendom: the bishops of Constantinople, Jerusalem, Antioch, and Alexandria, as well as the bishop of Rome, the pope. Of these, the pope had primacy of honor, but his position as symbolic head of a unified church had been eroding. Bardas, for example, had elevated Photios to the patriarchate without first obtaining papal permission, and when Photios finally did write to Pope Nicholas I about his new post, it was only to notify him and to seek his formal recognition. Nicholas resented this slight and had refused to accept Photios's legitimacy.

In Hagia Sophia, Photios, like Basil, had worked hard throughout the morning. After celebrating Mass garbed in his ecclesiastical robes and omophorion, a scarf embroidered with crosses, he too probably had dictated correspondence and had met with various church officials. Now the patriarch walked across the Augustaion and through the bronze gates of the Great Palace. As he passed through various marbled vestibules crammed with Greek statues, Photios must have wondered what role he would have in the new emperor's regime.

Emperor and patriarch together guided the affairs of Byzantium. Sometimes contending, often in accord, the two leaders were considered holy and appointed by divine sanction, "the two halves of God," as they were known in the Eastern Church. Indeed, after greeting one another, both men laid aside their ceremonial robes, indicating that, at least in the eyes of God, they were peers. Yet they were far from equal in power. While the emperor could elevate a man to the patri-

Byzantines wore jewelry as both ornament and amulet. The lady who adorned herself with this gold necklace sought the protection of the Virgin Mary, who appears in the central enamel plaque as well as on the pendant hanging below it.

THE BYZANTINE ART OF DIPLOMACY

Byzantines were masters of diplomacy, as any ambassador to the imperial court soon found out. When visiting the empire, an ambassador was greeted by a reception committee and escorted to Constantinople, where he was provided accommodation and attended by servants. On the day of the royal audience, mounted guards in full-dress uniform would bring him a horse from the imperial stables to ride through streets bedecked gaily in his honor.

The diplomat presented to the emperor his credentials and the greetings of his own sovereign. Later, they would discuss affairs of state. And the ambassador would be given a banquet to which other dignitaries were invited. Then, laden with gifts—gold, perhaps, or Byzantine silks—the envoy would depart, his mission completed.

It was not always thus, however, as Liutprand of Cremona learned when he visited Constantinople in 968 on behalf of Italy's King Otto I. At that time relations were strained between Otto and Emperor Nikephoros II Phokas *(left)*. As a result, Liutprand would be exposed to another side of Byzantine diplomacy: the abuse of a diplomat as a way of showing displeasure with the king he represented.

Upon his arrival Liutprand was taken to what he described as a "detestable, waterless, marble house open to all the winds of heaven." While there, he was attended by an incompetent servant whose equal "you would not find on earth, though you might perhaps in hell." On the day of his visit to the palace, he found that he had to walk there. And he was given a farewell banquet that also proved an occasion of insult: Liutprand was seated at the lower end of the table, while the Bulgarian ambassador dined next to the emperor. Finally, when he was leaving the city, officials confiscated from him five silk robes he had bought.

But the ambassador would have his revenge. Writing about the visit later, he characterized Nikephoros as "a man of strange aspect, with eyes as small as a mole's and hair [that] makes him resemble a pig." He was, concluded Liutprand, "Not at all the sort of man you would like to meet unexpectedly at midnight."

archate, the patriarch had no way of blocking the rise of an emperor. And though Photios had presided at Basil's coronation, when governmental and religious matters overlapped or conflicted, the emperor's will prevailed.

The backgrounds of the two men who sat down to lunch together—likely a simple meal, caviar, perhaps, with olives, fish, and salad—could not have been more unlike. Photios, an aristocrat with ties by marriage to the royal family, was a renowned scholar and a prodigious author of many texts. Basil, an illiterate, had come to Constantinople as an impoverished peasant. In the past Photios may have snubbed the uncouth Macedonian. And now, searching the emperor's countenance for clues to his thinking, he no doubt found reason for concern; Basil's expression may have lacked warmth. Maybe the emperor reminded him, a little too often, of the pope's hostility to Photios.

As the lunch concluded, the patriarch kissed the emperor, as was customary, donned his mantle, and departed for Hagia Sophia, his fears for the future if anything greater than before. An hour later the palace gates were locked, as they were every afternoon at three o'clock, not to be opened again until dawn the next day.

Throughout his patriarchate, Photios had expended his considerable energies on increasing the territory of his diocese. When the king of Bulgaria had consented to his nation's conversion to Christianity in the year 863, both Constantinople and Rome had positioned themselves so as to gain ecclesiastical dominance over the Bulgarians.

This competition developed into an acrimonious power struggle between patriarch and pope that became known as the Photian schism. Whoever controlled these new Christians would eventually oversee the religious activities of all the Slavs. Temporal influence would follow, ensuring the Slavs' allegiance either to the Byzantines or to the rulers of Western Europe. Pope Nicholas was furious when Photios finally succeeded in adding the Bulgarians to the diocese of Constantinople. Then Photios widened the gulf still further: A few weeks before the death of Emperor Michael, Photios had agreed to recognize King Louis of Italy as emperor of Western Europe; in return Louis would denounce Pope Nicholas and support the independence of the Eastern Church.

The clever patriarch seemed to have outmaneuvered the pope, but Photios had lost sight of the sensitivities of his own people: The Byzantines were deeply offended at granting the imperial title to a Western king; they considered their monarch heir to all that Rome once ruled, and thus believed him to be sole emperor in Europe. The deal was probably unacceptable to Basil as well, who was growing wary of Photios's increasing power. Within days of assuming the throne Basil decided to dismiss Photios. And to further placate Nicholas and the Byzantine people, the emperor would call to the patriarchate a man by the name of Ignatios, who was popular with the public and more acceptable to Rome.

Letters were dispatched from Constantinople to inform the pope of the ouster of Photios and to acknowledge Rome's influence in the affairs of the Orthodox Church. The news was too late to benefit Pope Nicholas, however: By the time the letters reached Italy, Nicholas had died.

The deposition of Photios was formalized at a church council held in Constantinople in the autumn of 869. Basil had invited papal delegates to attend the council, but much to their annoyance the emperor himself presided over the session. In an effort to maintain an appearance of neutrality, Basil invited Photios to testify on his own behalf.

There was much the cleric could have said. He had served Michael loyally and had been prepared to serve Basil in a similar fashion. And surely it was with great bitterness that he recalled how he had aided the pair in the murder of his patron, Bardas. But to avoid a further quarrel with the emperor, Photios

remained silent. On November 5, 869, he was officially excommunicated and went quietly into exile, leaving Ignatios to take up the all-important post of patriarch of Constantinople.

In the aftermath of Michael's death, his mistress—Basil's wife—had fared better than his patriarch, though she too had endured many worries. The day after the assassination of Michael, Basil had moved Eudokia into the empress's royal apartments. Anxiously she had paced their mosaic floors as she considered her future. Feeling confined within the white marble walls, she may have strolled from one room to another through silver doors until she was outside, overlooking from her terrace a series of flower gardens that extended down to the sapphire waters of the Bosporos. Her ladies-in-waiting, women of the upper class, fluttered about her, dressed informally, as was their empress, in long, sleeveless tunics of thin silk and sandals with gold-braided straps. Here in her own quarters, she was free of the jeweled headdresses, heavy gold necklaces, pearl earrings, and snaking armlets that she wore in public.

Eudokia pondered her position. She would be at the emper-

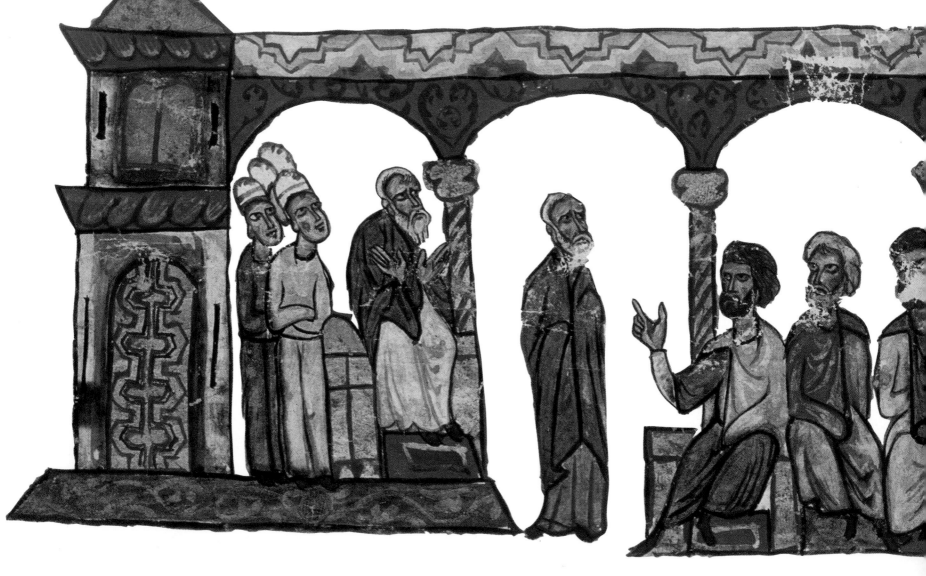

or's side on all important state occasions, give audiences and conduct her own court, and exercise substantial authority throughout the palace. Should anything happen to Basil before his heir was old enough to succeed him, she herself would reign for a time as regent. Although Basil had tried to reassure her of his loyalty, Eudokia probably took little comfort from his words, given his deceitful past. But in fact Basil would retain her as his wife, and she would bear him a half-dozen more children.

In the years ahead, Basil continued to surprise others with his astute actions. His military triumphs placed him among the

At the behest of Emperor Leo VI, church elders depose Photios *(third from left)* as patriarch of Constantinople. In Photios's place, Leo installed his own teenage brother, Stephen.

greatest of the Byzantine monarchs. He made advances against the Arabs in Asia Minor, establishing strongholds in the Euphrates Valley, and he recovered the full length of the Dalmatian coast and much of southern Italy. After building the Byzantine navy into an effective force, he sent it out to rid the coasts of piracy and protect his territories from seaborne attack.

During this period, the church converted the Slavic tribes of southeastern Europe. But in 877 Patriarch Ignatios died, at a time when the enormous work of assimilating these new Christians required experienced leadership. Needed was someone like Ignatios's predecessor, Photios, who had recently been allowed to come back from exile.

Photios had returned to Constantinople under mysterious circumstances. It was said that he had engineered his recall by planting a phony document in the royal library, to be uncovered by one of his followers. The paper, duly brought to the emperor's attention, indicated that Basil was descended from a dynasty of Parthians, an ancient people who had ruled Persia. Basil was intrigued by the opportunity to elevate his ancestry and was told by Photios's henchmen that only the former patriarch had the knowledge to interpret the document. Basil appointed Photios to the helm of the capital's Magnaura University and made him tutor to his sons, of which there were now four. And when Ignatios died, Basil restored Photios as patriarch of Constantinople, a choice acceptable to the new pope now ruling in Rome.

Of the emperor's sons, his eldest, Constantine, born of his first wife, Maria, was dearest to his heart. In fact, Constantine may have been the only person that Basil ever truly loved. The handsome boy had inherited his father's powerful physique and accompanied him everywhere, even on his Arab campaigns, where, reportedly clad in golden armor, the youth rode a milk-white steed. When Constantine died unexpectedly in 879 at the age of 20, Basil was devastated: Interpreting his son's death as God's retribution for Michael's murder, he sank into a deep depression and

at times seemed mad with grief. To appease the emperor, Photios canonized Constantine and had an archbishop conduct a séance in which the lad supposedly appeared to his father, an apparition on a white charger that faded as Basil drew close.

Unlike his older brother, Basil's second son, Leo, was a cerebral and studious young man. Basil despised him, perhaps because, like most of his palace attendants, he believed that the youth was really Michael's offspring. It was widely known that, at the time of his conception, Leo's mother had been mistress of the former emperor. Now Leo, at age 16, had a mistress of his own, the beautiful Zoe, but at Basil's insistence Leo grudgingly agreed to marry someone else.

His mother, Eudokia, as was customary, sponsored a beauty contest in which the loveliest women in the empire vied to become empress. A royal commission scoured the country for contenders, checking out such attributes as waist measurements and shoe sizes, but also charm, wit, and speaking ability. Young women who were outstanding in these requisites would not be ruled out because of class or wealth. Eudokia chose 12 from among them to compete in various contests. One such event had the contestants seated on the floor, barefoot. Each was required to slip into her shoes, rise, and gracefully curtsy. The speediest won, and her name was Theophano. Finally the girls paraded before Leo, who indicated his choice of wife in the traditional manner—by offering her an apple. Again, the winner was Theophano. After his marriage, however, Leo refused to give up Zoe. Furious, his father beat him severely with his own hands and married off Zoe to a man living far from the capital. Maybe he recalled the humiliating marital arrangements that Michael, in clinging to Eudokia, had forced upon him.

Basil was encouraged in his antipathy against Leo by Photios, and when the latter suggested that Leo was plotting against his father, Basil had his son thrown in jail. The heir apparent remained popular, however, and public pressure soon led to his release.

Not long after, Basil fell victim to a strange hunting accident near his country palace of Apameia, outside Constantinople. The emperor, now in his midfifties, had ridden away from his tired companions and encountered a stag drinking at a stream. Suddenly the stag charged at him and managed to catch its antlers on Basil's belt, draw him from his horse, and drag him 16 miles into the forest before his bodyguard caught up with him. Circling the stag, the men closed in slowly until one of them was able to cut the emperor free with his sword. Barely conscious, Basil ordered the man executed on the spot: The guardsman had committed the crime of raising his sword against the emperor. Basil's own death was not far behind: Little over a week later he died of a stomach hemorrhage.

Although he ended his days crazed with grief for his son, Basil strove, even in his last years, to achieve great things for his people. He restored to their former grandeur many of the older churches of Constantinople and built a magnificent new one called the Nea Ekklesia, with shining domes visible even upon the high seas. And despite having risen to his position by acts of extreme lawlessness, Basil threw his prodigious energies into a revision of the Roman law. Aided by the learned Photios, he produced the *Procheiron,* a summary of the state's most important legislation, and he began expanding this codification in the *Epanagoge,* a task completed by his successor.

The exact circumstances behind Basil's death remain shrouded in mystery. It has been speculated that somehow Photios contrived his murder or even that Leo arranged the so-called accident, since the group that rescued the emperor was led by the father of Leo's mistress, Zoe, a man who would later become the empire's most powerful imperial adviser. The truth may never be known. In the summer of 886, Basil's son was duly crowned Leo VI, and one of his first actions was to depose Photios. Contrary to the expectations of his father and his patriarch, he became known, because of his able and judicious reign, as Leo the Wise.

IMPERIAL WOMEN OF BYZANTIUM

Rarely have women had more influence over affairs of church and state than the empresses of Byzantium. Often chosen for great beauty, political acumen, or intelligence rather than high birth, a future empress was crowned before her marriage—a fine distinction that invested her with her own sovereign, God-given powers. Byzantine empresses ruled a vast apparatus from within the *gynaikeion,* a wing of the Great Palace decorated with precious white marble and rare porphyry. She commanded her own staff, managed her own estates, and even coined money bearing her own image.

Some empresses, such as Saint Helena of the True Cross, were pious and revered for their charity and goodness. Others were preoccupied with affairs of state—and of the heart. Several empresses, including the notoriously passionate Zoe *(right),* engineered the downfall of an emperor and installed a favorite—often a lover—in his place. Others ruled on their own or were power-brokers of the careers of their sons.

But through all this, the empress seemed to reign supreme in the hearts of her subjects. She took part in ceremonies, festivals, and special days at the hippodrome, where she was hailed as "Joy of the World, Glory of the Purple."

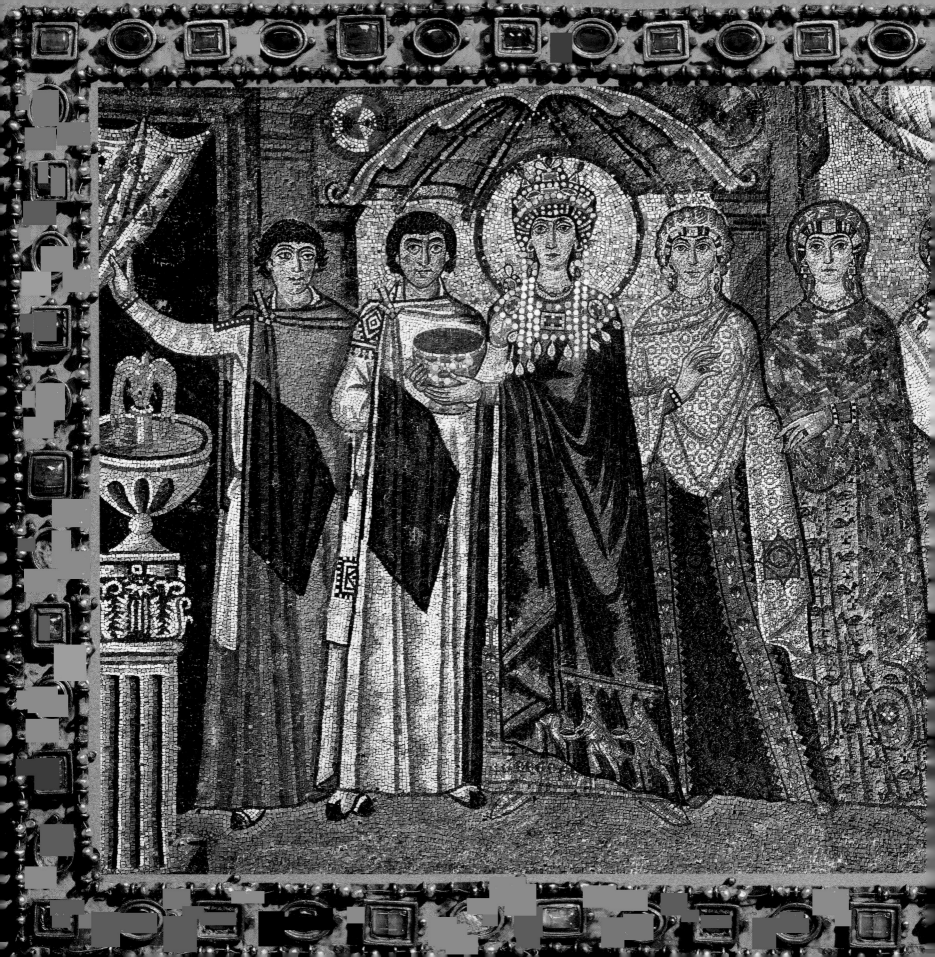

AN UNLIKELY HEROINE

Little in Empress Theodora's past could have foretold her ascension to the throne in 527 as the wife and trusted adviser of Emperor Justinian I. Although the most detailed account of her life was penned by her sworn enemy, the sixth-century historian Prokopios, most scholars agree that Theodora's beginnings were not only humble but also somewhat less than respectable.

Theodora was said to be the daughter of a hippodrome bear keeper and his actress wife. She followed in her mother's footsteps at a time when acting was held in low esteem. A high-spirited young woman, she apparently removed her clothing onstage, baring fully the beauty for which she was renowned. She is also said to have been intelligent and clever, thus possessing a powerful combination of attributes that apparently proved irresistible to a number of men.

Just how she and Justinian met is not known, but by that time Theodora had abandoned the stage and begun to lead a quieter life. The two married when Theodora was close to 30 years old.

If anyone in Justinian's court thought Theodora would confine her attentions to running her household, they were wrong. Before long—and with her husband's support—she had gained a seat on the imperial court and openly inserted herself into the diplomatic, political, and religious affairs of the empire.

Theodora proved a worthy statesman. Perhaps most telling is the story of her courage during the Nika Revolt, which shook Constantinople in 532. As mobs of angry citizens battered down the palace gates, Justinian and his ministers prepared to flee. Only the empress remained calm. Theodora scornfully told the men of the court to run if they must, but declared, "Never will I see the day that I am not hailed as Empress. I shall stay. . . . For I love the old proverb that says, 'The purple is the noblest shroud.'"

Theodora saved Justinian's throne that day. But not only was she strong, she was also compassionate. Perhaps because of her allegedly colorful past, the empress showed particular concern for impoverished girls forced into prostitution. On her orders, brothels were outlawed and their owners expelled from the city as "corrupters of public morals." She then gave each young woman some money and a new dress, and sent her home to her parents.

This mosaic of Empress Theodora and her attendants resides in the Church of San Vitale in Ravenna, Italy. Some historians claim that it fails to capture Theodora's true beauty.

O, MOST PIOUS AUGUSTA

Some Byzantine women are remembered more for their great acts of piety and charity than for the kind of political cunning that characterized the reigns of Theodora and others. The 12th-century empress Irene, shown at right in a detail from a mosaic in Hagia Sophia, took very seriously her imperial title of Most Pious Augusta and became the benefactor of various religious institutions. The wife of Emperor John II, she founded the great Pantokrator Monastery, the site of Constantinople's first public hospital and the burial place of many Byzantine rulers.

One of the first recorded Christian pilgrims was Helena, mother of Constantine the Great. The daughter of a humble innkeeper from Bithynia, she married Constantine's father when he was a Roman official. He later deserted her, but Helena went on to become the most venerated woman in the empire when her son became emperor.

Honored by the church as the inspiration for her son's decision to adopt Christianity as the official religion of the empire, Helena was such an enthusiastic convert that at the age of 72 she made a pilgrimage to the Holy Land. During that trip, it is said, she found the true cross of Christ, a relic that assured her sainthood.

Women also did their part to Christianize pagan peoples on the empire's outskirts. In 989 Princess Anna, sister of Basil II, was married to Prince Vladimir of Kiev as part of an agreement under which he brought Christianity to Russia. And during the 13th and 14th centuries, several emperors married their daughters into the Mongol royal family to ensure continued tolerance toward the Christian church.

A mosaic rendering of Maria, daughter of Andronikos II, in the church of the Chora Monastery in Constantinople portrays her as "the lady of the Mongols."

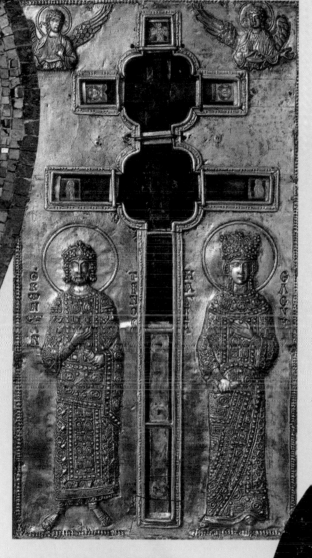

A gold reliquary, designed to hold a fragment of the true cross, dates from 11th-century Constantinople. Constantine the Great and Saint Helena are depicted in gold repoussé on its cover.

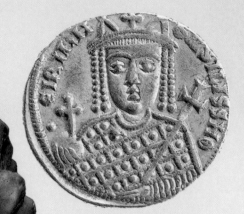

This gold coin bears the image of the eighth-century empress Irene, who for five years ruled the empire after taking the throne by force from her only son.

Empress Ariadne *(left)*, the daughter, wife, and mother of emperors, acted swiftly to exact revenge: Ariadne had an imperial guardsman slice off a man's ear for mistreating her mother.

Dignitaries approach Theophano *(far right)* and her sons Basil II and Constantine VIII. When her sons assumed the throne in 976 after the death of John Tzimiskes, the empress was recalled from exile but never took part in governing again.

UNBRIDLED IMPERIAL AMBITION

Adultery, murder, revenge—none of these acts were beyond the most unscrupulous and ambitious of Byzantium's imperial women. Enamored of power and unafraid to wield it, many empresses stopped at nothing to assert their authority.

The beautiful and elegant Theophano began her life as empress in the usual way, by ascending to the throne with her hus-band, Romanos II. But when he died pre-maturely, she took his place as regent. In the face of threats to her rule, she quickly de-cided to marry Nikephoros Phokas, a pop-ular but unattractive 51-year-old military hero. Within a few years, she was plotting his downfall. She had fallen in love with her husband's nephew, John Tzimiskes, who visited her in the Great Palace nightly.

Tzimiskes, too, was ambitious, and in the winter of 969, with Theophano's help, Tzimiskes and other enemies of the em-peror ambushed Nikephoros in his cham-bers and brutally stabbed and decapitated him. Theophano's expected marriage to Tzimiskes did not occur, however. He denied all involvement in the murder of his uncle and put the blame on his accom-

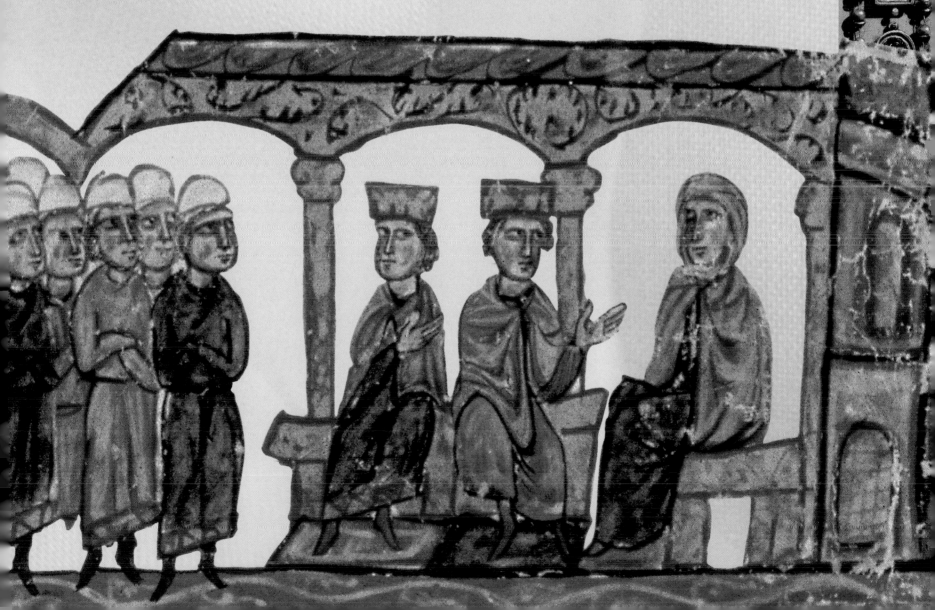

plices—including Theophano. After exiling the former empress, Tzimiskes was crowned emperor on Christmas Day 969, and he reigned for seven years.

Empress Zoe, granddaughter of Theophano and daughter of Constantine VIII, exhibited the same traits as her willful predecessors. Unmarried until age 50, when her father betrothed her to Romanos III, Zoe soon shocked the realm. She strayed into the bed of Michael the Paphlagonian, a teenager who had been brought into court by his powerful brother, the eunuch John. "He behaved as lovers do," wrote chronicler Constantine Psellos, describing Michael's seduction of Zoe. "Taking her in his arms, he gave her quick kisses, he touched her neck and hands, following the instructions of his brother."

Some historians believe that Zoe and Michael then set out to rid themselves of her husband by slowly poisoning him. When that took too long, the pair allegedly enlisted the aid of servants to drown him in his bath. She and Michael were quickly married, and he was crowned Michael IV. When Michael died of epilepsy in 1041, Zoe was persuaded by the eunuch John to adopt and crown another young man of his family. Alas, Emperor Michael V met an unfortunate fate at the hands of a Constantinople mob when he tried to depose the popular Zoe. For a while, she ruled with her sister Theodora, but Zoe later married Constantine IX, who in turn left her for a younger woman.

Romanos III, first husband of Zoe, is drowned in his bath in this illustration by John Scylitzes. Some believe Zoe and her lover, Michael IV, ordered the murder.

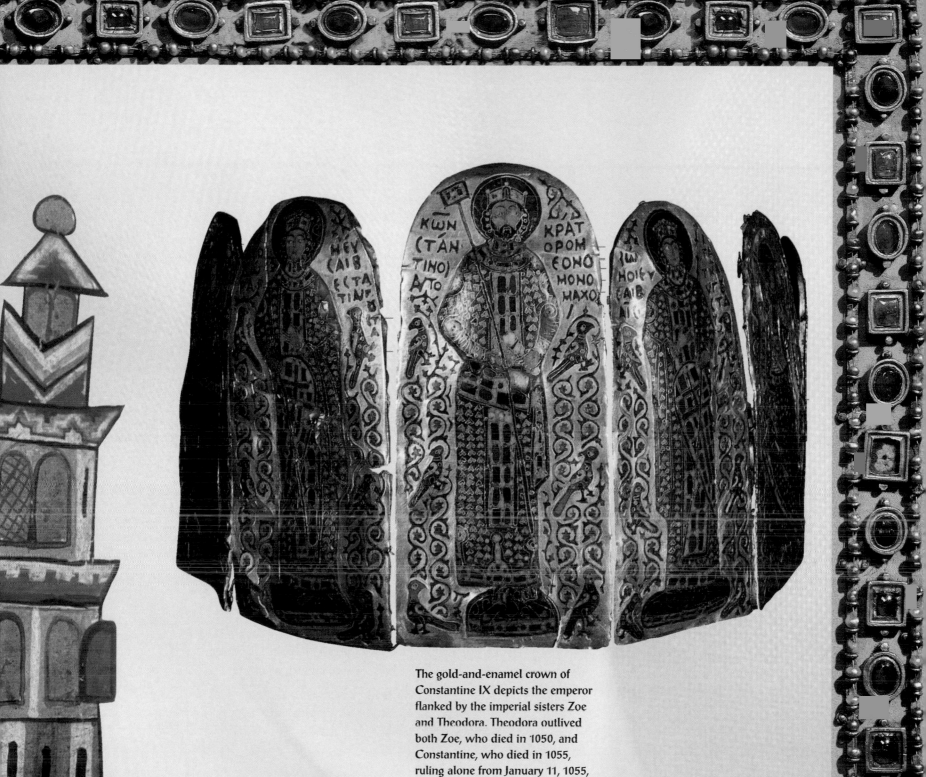

The gold-and-enamel crown of Constantine IX depicts the emperor flanked by the imperial sisters Zoe and Theodora. Theodora outlived both Zoe, who died in 1050, and Constantine, who died in 1055, ruling alone from January 11, 1055, until her death on August 31, 1056.

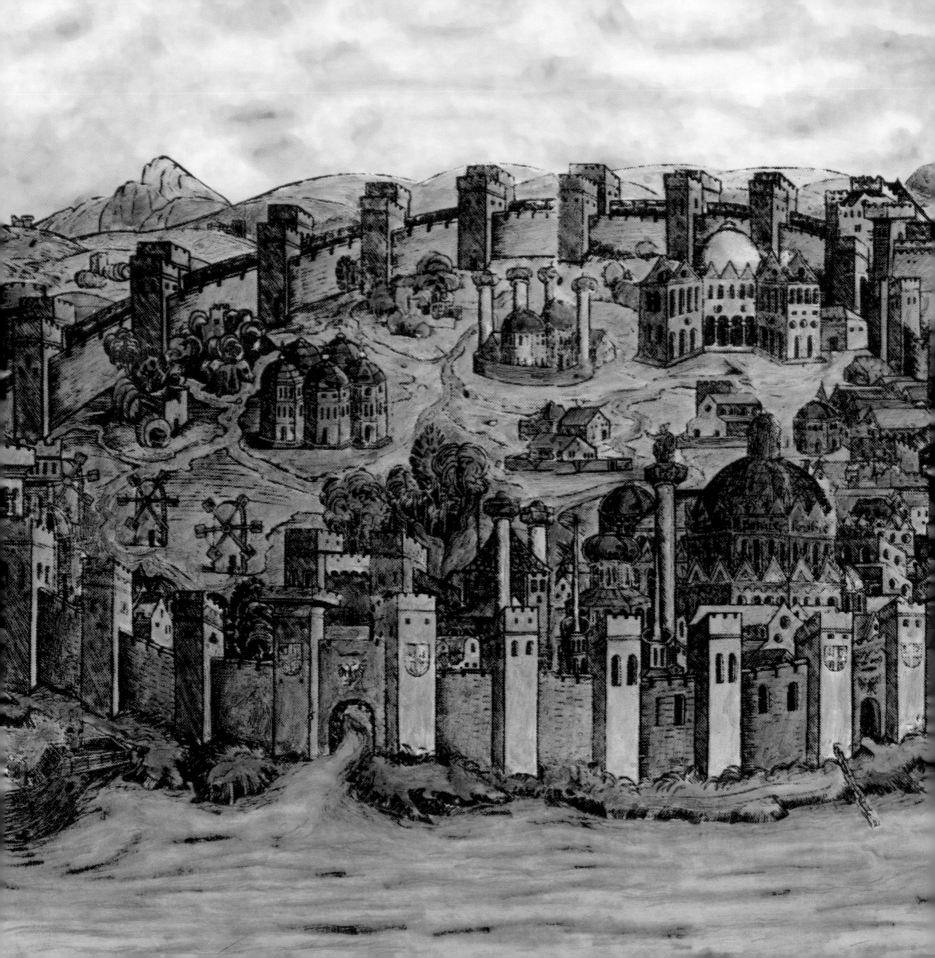

CHAPTER TWO

"ALL THESE BLESSINGS"

Seat of empire and heart of the Orthodox Church, the city of Constantinople—fancifully depicted at left—inspired one 11th-century visitor to declare, "Oh, how great is that city, how noble, how pleasant! and how full of wonderfully built churches and palaces. What a spectacle, what miracles of bronze and marble one finds there!"

For more than an hour, the elders of the clan had been arguing. Seated in a small gallery on the second floor of a three-story brick house belonging to the Psellos family, they raised their voices and gestured with their hands to underscore their views. They paid little attention to Theodota Psellos, who sat silently among them, clenching her fingers into fists as she listened intently to their words. The men had gathered to discuss the future of her son, Constantine, and until this moment Theodota had not believed that her plans for the boy would be thwarted.

Slender of figure and radiant of complexion, Theodota would one day be remembered by Constantine as being "like a rose that has no need of borrowed beauty." Now, however, the rose was all thorns; her state of mind had turned prickly when the debate took an unexpected shift, and she was determined to puncture their arguments, if necessary, to protect Constantine's interests.

At issue was whether Constantine would be permitted to continue his education. When it came to matters concerning the children's welfare, their father had always deferred to her. Even so, Theodota took care never to flaunt her influence over her spouse. Instead, she man-

61

aged, through subtlety and charm, to lull her husband into thinking that it was he who made the key decisions at home.

If Theodota was a good wife, she was a devoted mother, especially since the birth of Constantine in 1018. As the only male child in a family twice increased by daughters, the lad was so precious that Theodota had determined early on that he would have the best education the family could provide. One day, she imagined, her son would be counted among the finest scholars in Byzantium. Indeed, as the boy grew he had proved to be more partial to study than to play, starting school when he was five, mastering Homer and the Bible, and completing his elementary education by the age of eight. It seemed obvious to her that he should take the next step in his studies.

Among families in the upper classes, to whom a good education was taken as a right, such a decision would have gone uncontested. But to a middle-class family like this one, education was a costly privilege. And while it might well prepare Constantine for a successful career as a government bureaucrat, schooling would strain the income that Psellos earned from his small shop. As in many such households, this step could not be taken until the family's elders had met in council.

But the debate was not proceeding as

Theodota had anticipated. The boy would be better off learning a trade, the more outspoken of her relatives were insisting, rather than wasting any more time and money on books and tutors. He should become a goldsmith or a carpenter, a tradesman like his father, whose shop lay in the shadow of the imperial palace.

For Theodota it was unthinkable to remain silent in the face of such a threat to her beloved son's future. Adjusting the scarf covering her head, her gold earrings gleaming through its filmy fabric, Theodota rose to her feet. The folds of her tunic swayed gently above her sandals, where her eyes were fixed. In glove-soft, measured speech, she recounted a dream that had recently come to her: She had witnessed this very meeting, even the elders' inclination to end her son's studies. Then suddenly, she said, the sainted John Chrysostom had appeared before her and had implored her to do all that she could to ensure that Constantine devoted himself to learning. "Like a teacher I will fill him with knowledge," the saint had promised.

The murmurs of surprise that filled the room stilled as Theodota went on to share a second dream, some nights later. She had seen herself surrounded by people, in the Church of the Holy Apostles, when a beautiful woman approached Theodota with two men at her side. "Fill this woman's son with learning," she told her companions, smiling and nodding in Theodota's direction, "for you see how she loves me." With that, the mysterious maiden was gone, and the two men with her. Not until they were out of sight, Theodota explained, did she realize who they were. The woman was none other than the Virgin Mary, and the men were the apostles Peter and Paul.

As she sat down, Theodota could tell from the stir in the room and from a sideways glance into her husband's eyes that her story had made a powerful impact upon the men. There wasn't a person in Byzantium, not even the priests, who gave short shrift to visions.

Attired in finely woven shawls and tunics that covered most of their bodies, these wealthy young Byzantine women would have spent most of their lives confined within the family home, venturing out only for such things as religious ceremonies or visits to city baths reserved for females. Poor women were seen more often in public, where they shopped at the marketplace or even ran their own businesses.

Dreams were believed to be glimpses of the future. There were those in Constantinople who earned their bread by consulting the stars on behalf of clients or by divining the significance of particular events. Byzantine Christians routinely wore amulets to ward off the evil eye, sought miracles in the touch of an icon or the mere glimpse of a saint's relics, and blamed many a disease or derangement on some demon that had tunneled into the unfortunate victim's body. The church, when occasionally it showed skepticism, ran into opposition from members of its own clergy who could not separate popular superstition from religious notions of the supernatural.

Theodota herself had no trouble accepting an invisible world. She saw her dreams as a window on this other reality. Few in the Psellos family would dismiss these visions as irrelevant, least

try, arithmetic, and music—in addition to delving into more complex literature, rhetoric, and philosophy, all in preparation for his further studies at the University of Constantinople.

Although none present at the fateful family meeting could foresee it, the outcome of their debate would affect the future of not only the Psellos family, but also, to a certain degree, the empire itself. For the youngster whose education was at stake would play a substantial role in the destiny of Byzantium.

In carrying the candle of knowledge for her son, Theodota may well have been trying to compensate for her own deprivations. Like most Byzantine women of her time and class, she had been denied the kind of education that Constantine enjoyed, receiving instead only enough instruction in reading and writing to be

"If he gets the chance, he will make love to your wife . . ."

of all her husband, who was standing now and addressing the group. Happily for Theodota, no one rose to disagree with the message she had so effectively conveyed: Constantine would continue his studies.

Following the decision of the family council, Constantine was enrolled in a school at the local monastery and later would proceed under a tutor who would further the youngster's command of grammar and literature and teach him the intricacies of rhetoric. By his own account he was an excellent student. At the age of 10 or 11 he could recite the *Iliad* from memory, even as his peers were still struggling through animal fables. He breezed through the curriculum typical for a boy of his age, and by 14 he was tackling the daunting quadrivium—astronomy, geome-

considered literate before being schooled in the household duties that would occupy her days as an adult; the emphasis was on such skills as spinning, weaving, and embroidery.

Perhaps it was her desire for more learning that had inclined Theodota, during adolescence, to become enamored of religion, with its appeal to the mind and spirit. Indeed, she seemed more attracted to the rites of the church, which she attended often, than to any of her suitors. After she had turned away a succession of persistent young men, her father gave her an ultimatum: She must marry or bear his curse, no doubt a frightening prospect to a devout young woman. So Theodota relented and accepted Psellos's proposal.

On her wedding day, the guests assembled at Theodota's

house dressed in white, as was the bride in her delicately embroidered tunic and brocaded skirt. Her shining face, enhanced by heavy makeup, was not visible until Psellos arrived to lift her veil. Accompanied by musicians and singers, the party proceeded to the church, where a contract was signed that would bind them for life. Standing under marriage crowns, held over their heads by relatives, they exchanged rings and then sat down to a banquet, men and women at separate tables. Afterward the guests escorted the couple to their chamber, returning the next morning to rouse them with song.

Marriage, however, seemed not to have entirely banished Theodota's doubts about her choice of lifestyle. More than once she suggested to her husband that they both enter the religious life when the children were on their own—a step not uncommon in Byzantium, where many of the city's 300 convents and monasteries welcomed the married individual who was prepared to live apart from his or her spouse. So far, though, Psellos would hear none of it. "Separation from my wife," he insisted, "would be worse even than separation from God."

In her zeal for the Eastern Church, Theodota was linked emotionally to a powerful institution that had made itself the guardian of hearts and minds the length and breadth of the empire. Its authority was evident in a wide range of activities, from its dispensation of the sacraments to its management of the schools. No house, field, or fishing fleet

A storklike bird decorates this redware pottery bowl that dates from the 12th century and probably came from a humble Byzantine home, where vegetables, vinegar, olive oil, and a barley or flour gruel would have been the normal fare. Eating utensils consisted of knives and spoons, and for the elite, small gilt forks, with which they ate sweetmeats.

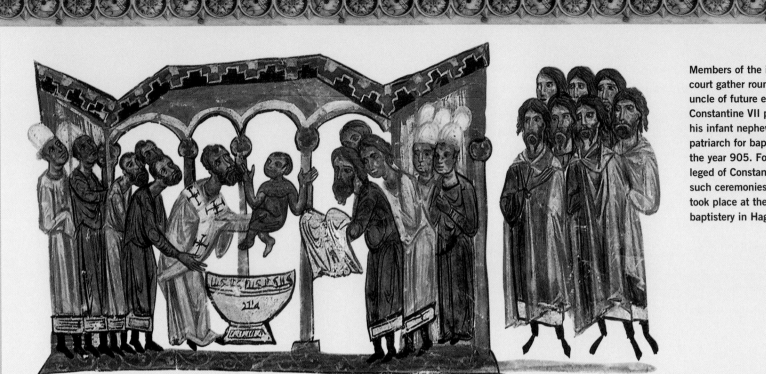

Members of the imperial court gather round as the uncle of future emperor Constantine VII presents his infant nephew to the patriarch for baptism in the year 905. For the privileged of Constantinople, such ceremonies typically took place at the great baptistery in Hagia Sophia.

LIFE'S RITES OF PASSAGE

For all its imperial associations, the Orthodox Church played a central role in the lives of ordinary Byzantines, marking the major events in a Christian's life with ceremonies and rites from cradle to grave.

Soon after they were born, all Byzantine infants were baptized—immersed three times in a font of holy water—as an initiation into the church of Christ. After the ceremony, the entire congregation took Communion, and a procession of friends and family, holding lighted candles and singing hymns, carried the infant back home.

Unless a person took monastic vows, marriage rites constituted the next religious passage in life. On their wedding day, the groom and his veiled bride received an ecclesiastical blessing from a priest, donned marriage crowns, and exchanged rings. Then a musical torchlight procession accompanied the couple to the groom's house, where the bride removed her veil and guests were entertained at a banquet before the couple retired to the bridal chamber.

Christian funerals marked the last rite of passage for the Byzantines and had the twofold purpose of bidding farewell to the departed and helping the soul on its journey to heaven. After women prepared the body for burial, it was displayed on a couch in the family home, facing east toward Jerusalem and clutching a holy icon. At this time mourners grieved and lamented and sang psalms over the deceased to protect the soul from demons. When the visitation period was over, the body embarked on its final earthly procession, borne aloft to the cemetery along a route lined with lamps and burning incense.

This carved ivory plaque portrays Christ placing the marriage crowns on 11th-century emperor Romanos IV and his wife, Eudokia.

In this miniature the prophet Micah is pushed off a cliff to his death, then buried by his followers. The quiet dignity of his burial contrasts with the wailing, tears, and chest beating typical of Byzantine funerals.

Byzantine wedding rings like the one above often depict marriage scenes in which Christ stands between bride and groom to bring them together.

went unblessed so long as there was a priest nearby. So pervasive was the church's influence that the average person was hard pressed even to find a bolt of cloth without lead seals attached bearing images of Christ or the Holy Virgin.

Once she was married and a mother, Theodota energetically pursued the daily routine of a typical housewife and added to it special tasks that she took upon herself. On any morning of the week, she rose early to dress in her everyday woolen tunic topped by a robe whose long side panel could be pulled over her head to hide much of her face in public. She parted her hair in the center and coiled it on either side of her head, as was the fashion. A little makeup may have completed the picture.

Marriage had done little to dim her piety, and soon she was off to Mass, making her way there with head veiled and eyes dutifully avoiding contact with those of passersby. Later, as the day wore on, she occasionally would retreat to the shrine that was tucked into a corner of her family's living quarters, and there she would pray to her favorite icon or read the Bible.

Like other Byzantine Christians, Theodota believed that the salvation of her soul depended not only on the depth of her faith, but also upon the sincerity of her good works. As a result, she took seriously Christ's admonition to look to the least among them. She often invited the poor into her own home; while her children watched, she washed the feet of her impoverished visi-

EDUCATION IN BYZANTIUM

Education was highly prized in Byzantium, and for young boys fortunate enough to be schooled, learning was divided into three stages: elementary, grammar, and rhetoric. Elementary education usually began around the age of six and took place in the family home, where mothers or pedagogues taught reading, writing, and simple arithmetic. While many boys' education came to an end by age nine or 10, the more privileged would go on to be tutored by a grammarian, studying the Bible and the literature of classical Greece. From the ages of 14 to 18, top scholars would continue their studies in a classroom setting, as shown at right, where they would learn how to express their ideas through writing and speaking, and perhaps begin training for law, medicine, or one of the other professions.

For girls, the opportunities for education were limited. From age six or seven they also were taught by tutors or parents, learning to read and write and study passages of Scripture, all in the seclusion of the home. But much more emphasis was placed on the acquisition of domestic skills, such as spinning and weaving, in preparation for the running of a household.

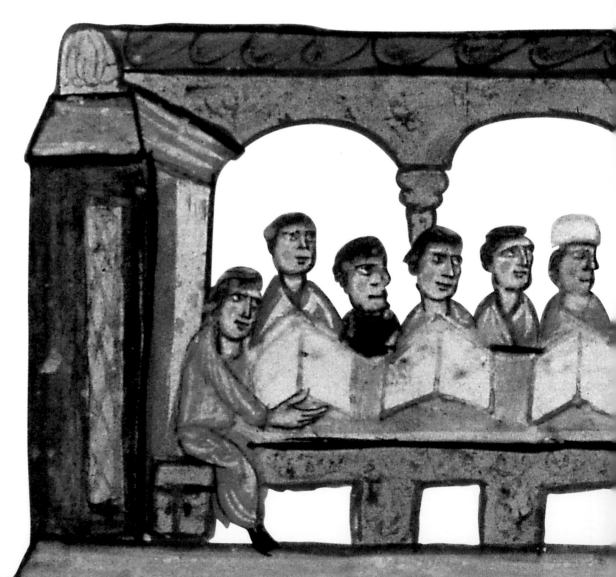

tors and fed them at her table "as if they were great lords," her son would later write. The Byzantine Church had long ago taken the lead in establishing hospitals, poorhouses, and orphanages. Even so, with poverty and disease rampant in Constantinople, Theodota and other compassionate souls did not have to search far to find those who needed help. When it came to extending her good works to the ailing elderly, Theodota looked no further than her own household, where she tenderly cared for her aging, homebound parents.

Aside from her regular walk to church, Theodota spent a good deal of her time at home, spinning and weaving. Often she picked up needle and thread to mend the frayed hem of one of her husband's tunics or sat down with her daughters to coach them in the finer points of embroidery. Occasionally she ventured outdoors to participate in one of Byzantium's religious festivals or in family celebrations.

Above all, she looked after her children with a dedication that seemed to surpass her peers. She could be affectionate with her offspring, who adored her, yet she was a stern disciplinarian, and her family called her "the living law." Continuing to take an active role in her son's education, Theodota devoted many evenings to ensuring that his studies were maintained at a high level. She quizzed him late into the night on the content of the day's lessons, perhaps gaining, in the process,

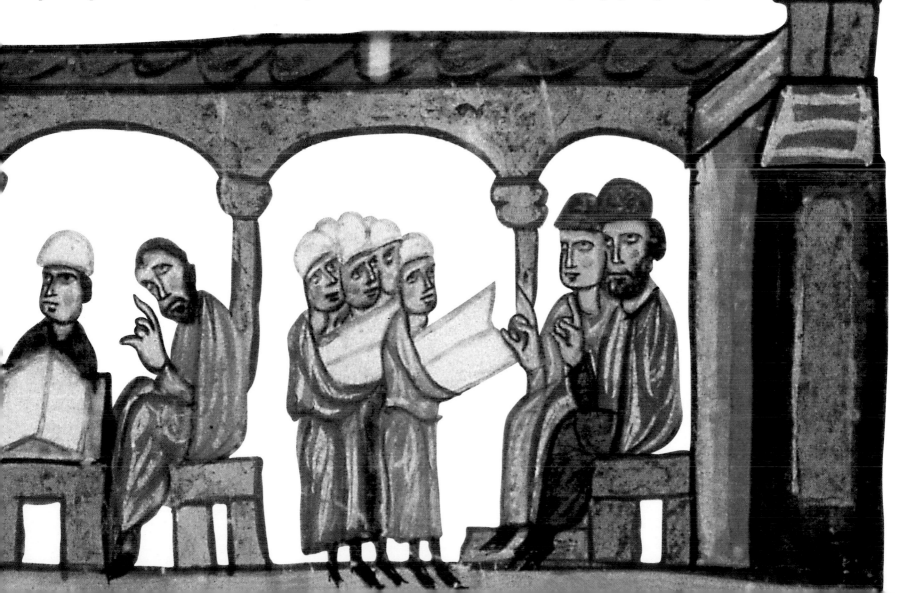

a small portion of the education she had been denied. When she was unable to help Constantine with a passage that bewildered him, she would, her son recalled, raise her "hands to God" and, beating her breast, "invoke Heaven to remove my difficulties." Constantine never resented his mother's attention. On the contrary, he later acknowledged, "I owe you a double debt, for not only did you bring me into the world, but you also enlightened me with the splendor of learning; you were not willing to depend upon teachers, but desired to light it yourself in my heart."

Theodota would have spent a portion of her day chatting with her relatives. Like many extended families, her kinfolk probably lived together in a small brick housing compound that shared a common courtyard, where a bathhouse stood. Indeed, bathing twice a day was not unusual. As was customary, the living quarters were situated on the upper stories, while on the street level were the storerooms and stables. The windows, narrow on the first floor, wider on the second and third, looked out on the inner courtyard. To the street, the building presented a blank wall.

Inside, a central hall served as a reception room, where columns of wood rose from the foundation to secure the upper stories. Curtains divided the upstairs living space into rooms, also stemming drafts. Cushions, carpets, and hangings were as decorative as the murals that covered the plaster walls. The house was equipped with such up-to-date conveniences as terra-cotta pipes to funnel away sewage, charcoal braziers for heating and cooking, and a lavatory that drained through pipes, flowing eventually to the sea. At night, light came from smoky lamps fed by olive oil or grease. Fresh water was available, as it was to all the residents of Constantinople, from an extensive system of aqueducts and cisterns.

On the top floor was the *gynaikeion,* or women's quarters, to which Theodota and her daughters were sometimes confined, listening to the voices of men and the echo of their footsteps as they entertained their friends. For when men other than relatives entered the house, the women had no choice but to make themselves invisible. This custom of sexual segregation was not always stringently followed, however, leading one 11th-century nobleman to advise his male readers of the dire consequences that would arise from allowing their wives or daughters to appear in company: "Your friend will stare at them, and, while pretending to lower his eyes, will study their appearance, their clothes and their faces, and, in short, will examine them from head to foot." And there was worse to come. "If he gets the chance, he will make love to your wife, pursue her with insolent looks, and do his best to seduce her, or at least will boast of having

done so." Daughters warranted more extreme measures, and it was best to keep them "under lock and key," to guarantee their marketable value.

Theodota's husband was prosperous enough to have purchased their house, even though many people of more modest means had no choice but to rent apartments. These were located in tenements that were perennially overcrowded and too often the scenes of murders and thefts. Conditions were even worse for the poorest of the poor, who roamed the streets by day, sleeping outdoors by night and huddling in inclement weather under the porticoes of the city's churches.

Life for the Psellos family was eased by the presence of two servants, who handled the day-to-day drudgery of cooking, cleaning, and grocery shopping. A day rarely passed, in fact, that Theodota didn't dispatch one of her housemaids to fetch fruit, bread, fish, vegetables, and meat for the family's meals. This young girl tripped through the courtyard and out into the street, her long hair, unbound in the manner of maidservants, flowing past her shoulders in the stiff Constantinople breeze. Threading her way through the crowded streets, the hubbub of the throng flooding her ears, the maid perhaps glanced shamelessly into the eyes of others, as a servant might. Once in the marketplace, she mixed freely with other shoppers and rubbed elbows with the working-class women who operated many of the food stalls. The air in the market was heady with the aromas of grilled duck and gakos, the pungent sauce that went with fish dishes. There

would be figs to sample, freshly baked bread to buy, melons to test, and cheeses to nibble. When her errand was finished, she would hurry home laden with groceries, her cheeks crimson from the wind and sun, ready to display her purchases for Theodota's approval.

Theodota thrived in her small realm, as did her husband in the wider world of business, where Psellos was so at ease that, as his son later put it, "he went through life lightly, without making a false step, at an even pace, like oil flowing noiselessly"—so lightly indeed that he left no record of his first name. His physical presence was not insubstantial, however, for he was, in the words of his son, a tower of a man, tall "as a well-grown cypress," and recognized as much for the strength of his character as for his even temper. Such traits must have served him well in his work, the nature of which was not reported, only that he was active in commerce. Psellos may well have been a perfumer, and if so, such a man would have built his small perfumery into the shop of choice for the most discriminating of buyers.

Each morning, bolstered by a breakfast of bread and olives—or when he had more time, a rich onion omelet—he would set out for the shop, eager to put his hands and his nose to work. First, however, Psellos had to endure the insult of the city's smells as he made his way toward the wide, straight thoroughfare known as the Mese. The stench was always worse in the tangle of trash-strewn lanes that led from his own house to the broad boulevard, and it was no easy task to hurry through these alleys.

They were choked with peddlers, porters, and horse-drawn carts, while the ubiquitous slime of fish blood, rotting vegetables, and animal droppings ruined shoes and made footing precarious. At times the odor was so bad that the more well-to-do residents were forced to keep cauldrons of aromatic herbs bubbling in their halls or had their servants sprinkle rose water throughout their homes. The emperor took the more drastic measure of fronting his palace with a wall of fragrance, decreeing that every perfume vendor must sell his wares within a stone's throw of the palace gate.

Psellos no doubt navigated this labyrinth without mishap, perhaps taking heart when he finally caught sight of the statue of Apollo, perched on its 117-foot column in the Forum of Constantine. In a few minutes his steps would fall on the Mese's solid pavement, and he could move more quickly through its commodious width. There the city's noise increased, even this early in the morning. Scores of vendors raised their strident voices in entreaty; heavily laden carts rumbled by, their metal wheels clattering over the huge paving blocks; church bells pealed overhead.

A glance at the public clock in the Forum of Constantine might tell Psellos that he had to hurry. Yet even as he quickened his pace, he would relish the scene unfolding around him. Everywhere along the Mese,

strains of Arabic, Russian, Italian, French, or even choruses of odd-sounding Anglo-Saxon could be heard against the background symphony of everyday Greek. Camels laden with Mongolian silk and Russian furs were led carefully through the throngs of pedestrians. Merchants from Africa and Venice, their colorful robes contrasting with his plain linen tunic, hurried by, engaged in conversation about their business ventures. Burly sailors from ships anchored in Constantinople's bustling harbor pushed their way through the crowds, the Vikings from the Slavic hinterlands wearing strange-looking trousers. Many of these foreigners, like Psellos, had long hair. While some foreign faces were clean shaven, most Byzantine men sported neatly trimmed beards, considered a sign of masculinity. A few had let their whiskers grow to their waist—a throwback to the seventh century, when fashion dictated that men braid their beards or even sleep with curlers in them.

Near the public square known as the Augustaion, which also served as a busy marketplace, the Mese grew more congested. Along this stretch of the avenue, lined on both sides by shops sheltered by colonnades, customers could be seen fingering the silks and brocades of the cloth vendors and holding the handiwork of the goldsmiths up in the low morning light. Goats headed to market were prodded along by their owners, as were slaves destined for

Glass perfume bottles, like the one above from the 12th century, held fragrances made from incense, myrrh, spices, and aloe.

their own market, a place known to all as the *koilas klaphthmonos,* the "valley of weeping." By midday, this section of the lively boulevard would be swarming with jugglers and street musicians, and with astrologers, magicians, and fortunetellers. By this time, too, the city's wealthier residents would be up and about, the routes of their gilt-trimmed carriages cleared by whole phalanxes of eunuchs.

In the open courtyard of the Augustaion, with its dark marble pavement, lay the Milion, the initial milestone from which the distance to any point in the empire was stepped off. Passing it, Psellos may have shuddered, remembering the heads of rebels that hung there during times of civil disturbance. The hippodrome, its entrance just to his

right, brought pleasanter memories, for on racing days he was usually one of the viewers. Under the colonnades that lined the square, the booksellers set up shop. As Psellos passed, he would nod in the direction of the one or two he knew. Above them loomed the domed splendor of Hagia Sophia, the most beautiful of the more than 500 churches that collectively underscored Constantinople's reputation as "the God-guarded city." His own shop might have been right around the corner, in a row of perfume booths situated to "make pleasant the porches of the palace."

On one particular morning, as Psellos unfastened the intricate set of locks on the door to his shop and stepped inside, he may have felt uneasy, recalling that he would be interviewed that afternoon by two agents of the eparch of Constantinople. Next to the emperor, the eparch was the most powerful man in the city and the most intrusive in the lives of its citizens. As the top local official, he served as chief magistrate, chief of police, supervisor of immigration, and trade commissioner. The eparch and his army of civil servants tracked down criminals and dutifully carried out scourgings, blindings, and executions.

The eparch's headquarters were in the Praetorion, which also housed the city jail and was located on the Mese, midway between the Augustaion and the Forum of Constantine. From there the eparch also governed the trade that had made Constantinople the commercial crossroads of three continents, a home away from home for some 60,000 foreign merchants, and an unparal-leled clearinghouse for fish, honey, wax, furs, caviar, silk, wine, and spices.

Imports and exports were strictly controlled by the eparch and his men, duties were imposed and collected, trading privileges were granted and revoked. No foreign merchant could escape the scrutiny of the eparch: To a man, they had to report to his office upon arriving in Constantinople, and once registered, they could stay in the city for just three months at a time. Moreover, they could not close any transactions without the eparch's express permission.

Equally vigilant when it came to domestic production, the eparch assigned each trade to a particular quarter of the city, fixed wages and the prices of most goods, regulated profits, and set exchange rates. He also kept a tight rein on the guilds, guaranteeing each a monopoly of its trade on the one hand, but imposing all manner of regulations on the other. Accordingly, each guild could sell only goods of its own manufacture, and no craftsman could belong to more than one guild. It was the eparch's duty to ensure that linen merchants sold linen and not silk, that leather-workers worked leather but didn't tan hides, that silk spinners spun silk but didn't weave it. Sons were encouraged, and sometimes required, to ply their fathers' trades, and once a man had established himself in one field, he was all but prohibited from trying another.

It may be that one of Psellos's apprentices had attracted the eparch's attention. Perhaps an investigation had exposed the young man as a fraud, who had lied about his background when

HOLY MEN ON HIGH

Perhaps the most amazing scene to be glimpsed by a visitor along the busy streets of Constantinople was the sight of holy men perched atop pillars 30 or 40 feet high. Such men, known as stylites, sought separation from the sinful world and a life of prayer, penance, austerity, and devotion to God.

The first stylite was Saint Symeon the Elder, a fifth-century ascetic from Syria. In order to fly to "heaven and escape from this terrestrial existence," Symeon ascended a column about 50 feet high. There, for more than 20 years, he spent his days, unprotected from wind and weather and accepting gifts of food for sustenance, fulfilling his calling as a priest and healer. At right the saint, in monastic hood, stands atop his column with hands raised in prayer, admired by turbaned non-Christians and cloaked monk alike.

he first apprenticed himself to Psellos, an act that could well invite a flogging. Although Psellos himself was in no way party to his assistant's indiscretion, he would have worried all day about the impending visit of the investigators. In the end, however, the interview with the eparch's agents was probably not as difficult as he had imagined beforehand. Questions were asked and answers given, with Psellos absolved from responsibility and thanked for his cooperation.

Still, Psellos no doubt would have been rattled after the interrogators left, and he looked forward to the end of the workday. But his days were often long and busy, overseeing the blending of herbs for his scents, as well as the distillation and bottling of them, selling his perfumes, and filling orders for export. It was probably just turning twilight when he made his way home through the darkening side streets and lonely alleys. At that time of day Psellos must have appreciated the long reach of the eparch. For it was then that the official, as chief of police, deployed patrols to man the guard posts and to enforce the nightly curfew on the major thoroughfares. Even God-guarded Constantinople was a city rife with crime. When apprehended, common criminals were flogged on the spot, as were curfew violators if they had no good excuse for being out on the main thoroughfares after dark. There was little protection, however, on the narrow side alleys, along which Psellos would trek homeward.

On such a tension-filled day, Psellos would often stop at his favorite tavern. Many saloons were places of ill repute, the trawling grounds of prostitutes and the scenes of drunken brawls. Some were less unsavory than others, however, and it was to one of these, on a street just off the Mese, that Psellos might repair for a glass of wine. He would have frequented the same tavern for years, perhaps because the wine was good, not watered down as in so many other saloons, but mostly because that was where his friends assembled.

On this evening, the buzz of conversation might be about

tomorrow's races at the hippodrome, an event long anticipated. Nursing his wine in the tavern after work, at ease among his comrades, Psellos could feel the day's tension drain away with every sip. After paying for his drink with a copper coin, he would step out into the twilit streets and head home to Theodota.

Though able to surmount the small stresses of his workday, Psellos was about to face, in 1033, a major crisis at home: He and Theodota could not provide a dowry for their daughter while continuing to finance an education for their son. Constantine was 15 at the time and still excelling at his studies, but he had already been given years of schooling, while their daughter might never again have so fortunate an opportunity to marry. Accordingly,

they decided that the daughter would have her dowry and that Constantine would enter the work force. Shortly thereafter, he secured a position as a clerk to a provincial judge whose far-flung jurisdiction included Mesopotamia, Thrace, and Macedonia.

Constantine bore his sister no ill will for having shortened his academic career. On the contrary, he loved this older sister and she him, their mutual affection having grown all the stronger since the death of their middle sister some years before. She was, as he wrote of her later, "all to me and more than mine own soul." But it was this deep affection that made even more acute a family tragedy that occurred a year later. While away in the provinces, Constantine was absorbed in his duties as a law clerk. But as much as he liked the work, he was nonetheless delighted when a letter arrived from his parents informing him that he could return to the capital and renew his studies. The letter also mentioned that his sister was thriving.

Nothing could have been further from the truth, for Constantine's sister had in fact become ill and, within a few days, had died. Mindful of the closeness of brother and sister, the well-meaning parents had sought to bring him home under a ruse. They feared that the truth would crush the boy and that to read it in a letter would only worsen the blow.

By the time Constantine reached the city on horseback, it was several days after the funeral, a day on which, according to Byzantine tradition, the deceased's family gathered at the tomb for prayer and lamentations. Encountering his relatives, Constantine greeted them and asked about his parents. "Your father is making the funeral laments at your sister's tomb," he was told, "and your mother is with him, inconsolable, as you know, from grief."

A girl dances to the tune of a lyre-playing centaur, a creature from Greek mythology, in this scene from a Byzantine carved relief. Music was an integral part of church services and was also an important part of the secular life of the empire. Musicians and dancers often performed at court ceremonies as well as at the hippodrome.

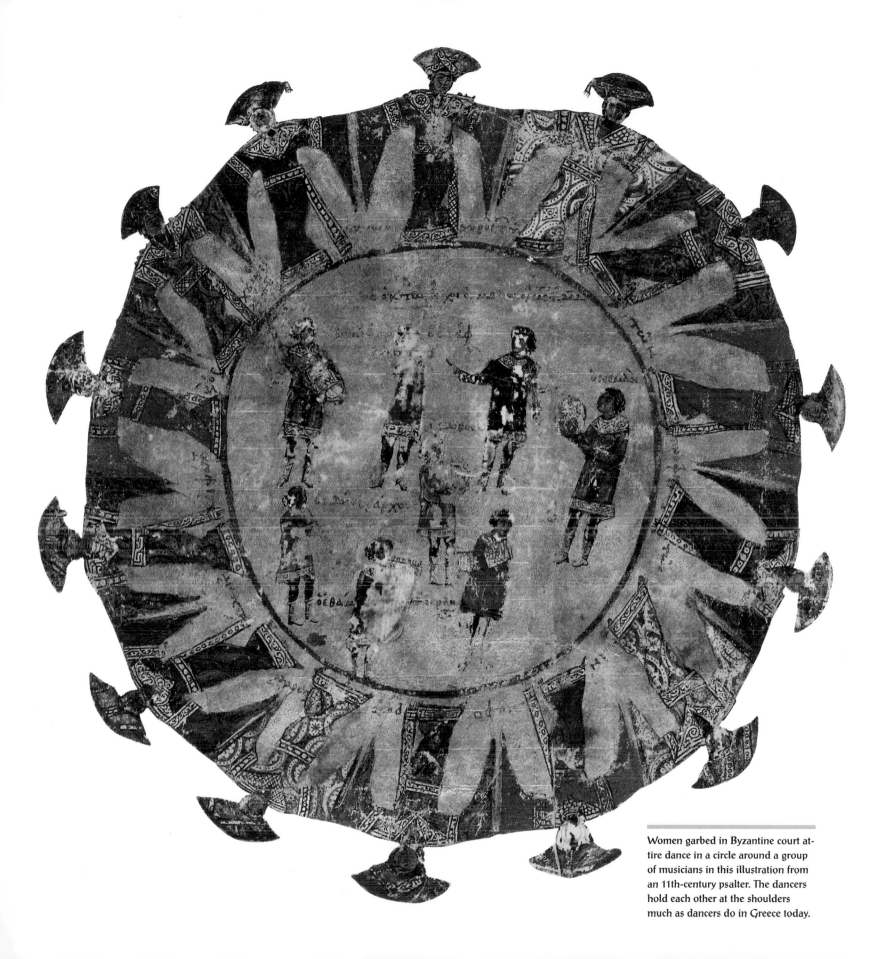

Women garbed in Byzantine court attire dance in a circle around a group of musicians in this illustration from an 11th-century psalter. The dancers hold each other at the shoulders much as dancers do in Greece today.

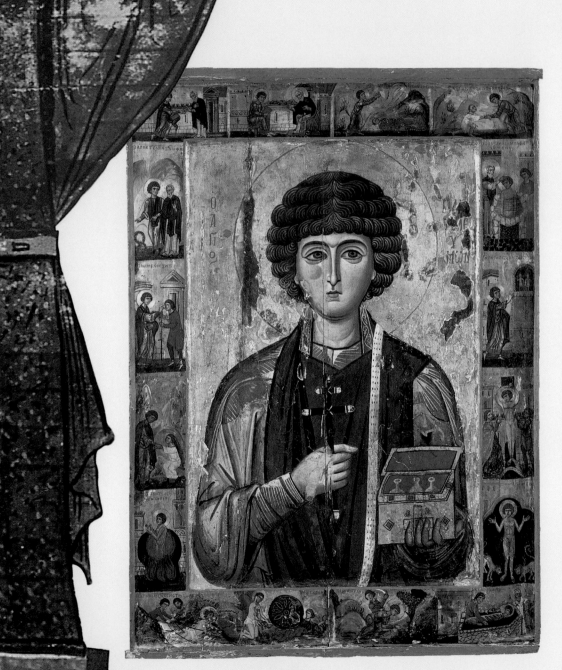

Surrounded by scenes from his life, Saint Panteleemon holds a cross and a medicine box, symbols of his power to heal the sick with miraculous cures.

CARING FOR THE SICK

In Byzantium, healthcare was the responsibility of the church, whose monastic orders ran hospitals throughout the empire. Among the most famous of these was the hospital of the Pantokrator Monastery in Constantinople. By the 12th century it boasted 50 beds divided into separate wards for surgical cases, medical cases, and women. The staff consisted of 10 male doctors and one female doctor; male and female assistants; an herbalist; a professor of medicine for the instruction of new doctors; and a kitchen staff to prepare the mostly vegetarian meals served to patients.

By the standards of the day, the practice of medicine in such hospitals was highly developed, for the Byzantines were inheritors not only of the rich Greco-Roman medical tradition but also of Arab expertise. Drugs were given for digestive, heart, and chest ailments. Autopsies and dissections were done to improve surgical techniques. And doctors specialized in such fields as ophthalmology, gynecology, and dentistry.

But in this Christian empire, sickness was often believed to have supernatural causes that only religious remedies could cure. As a result, patients were often directed to pray to particular saints for healing: Saint Nicaise for smallpox, Saint Blaise for upper respiratory infections, and Saint Roch for the plague.

Pulling on ropes, two doctors raise and lower their patient against the rungs of a ladder in hopes that the stretching and massage will heal his dislocated vertebra.

The device below measures the amount of blood taken from a patient during bloodletting, a common medical procedure in Byzantium. The two mechanical figures on top record the level of the blood as it flows into the basin at bottom. The gauge was invented by the Arabs, who were revered as great medical authorities and whose methods were studied throughout Europe.

These illustrations from a 10th century Byzantine medical textbook accompany instructions on how to bandage the head, "helmet style."

"Voiceless and lifeless, as if struck by fire from heaven, I fell down off my horse," Constantine later recalled. His parents, inside the nearby cemetery, heard their relatives cry out, and they raced to their son. Lifting her veil in public, Theodota revealed a face undone by grief. Keening anew, this time over their son, the distraught parents, clad in black, lifted him up and carried him to the graveside. "When I opened my eyes and beheld my sister's tomb," wrote Constantine, "I understood the full extent of my sorrow, and, coming to my senses, I poured upon her ashes, as if it had been a funeral libation, the rivulets of my tears."

Yet another shock awaited the youth. For Constantine now noticed what he had earlier overlooked: His mother's beautiful hair was cropped close to her skull, and she was dressed in a nun's habit. Theodota had resolved at the moment of her daughter's death to devote what remained of her own life to God. And Psellos, yielding to his wife's wishes, had agreed to do likewise. Only days earlier, she had entered a convent and he a monastery.

As Constantine was to discover, his mother had taken to the ascetic life with abandon—fasting, sleeping on bare ground, and devoting hour after hour to prayer—her denial of the flesh nurturing an ecstasy of the spirit. His father, on the other hand, was a more reluctant novitiate. In this regard he was akin to many of his fellows, who had for one reason or another sought temporary refuge from the world, and his prayers centered mostly on his wife's swift return to her senses.

Psellos's prayers were to go unanswered. Not long after resuming his studies in the city, Constantine was called to the monastery. He found his father gravely ill and his mother at his bedside. "My child," the father told his son, "I am about to set forth upon the great journey. I charge you not to weep too much for me, but rather to assuage your mother's grief." Constantine tried, but his mother's sorrow was beyond comforting. After her husband's death, she surrendered herself completely to her religious fervor, denying every consolation, forgoing meals and giving her food to passing beggars. She soon grew so feeble that she had to be helped into church and supported during prayer.

All this time, Theodota had refused to take her final vows, having convinced herself that she could never be worthy of the veil. Then a fellow postulant talked to her about a vision she had experienced in which the emperor called Theodota to occupy a throne. As her friend spoke, Theodota saw in the woman's face what she already knew—that the end was near. She decided to take her final vows, receiving the sandals, ring, and cross that marked her as a nun. Overcome by emotion, Constantine prostrated himself at his mother's feet, and she said to him softly, "May you one day also experience all these blessings, my son." Suddenly feeling weak, Theodota was helped to a bench. Her strength failing her, she whispered her son's name with her last breath.

Since returning to the city, Constantine had been under the tutelage of a renowned scholar. He now devoted himself to his studies and reveled in the company of his fellow students, among them John Xiphilinos, later the patriarch of Constantinople, and Constantine Doukas, who would one day become known to

In this 12th-century miniature, former courtier Michael Psellos appears as a monk with graying hair and beard. It was not unusual for men and women to enter a monastery in their later years. The contemplative life furnished them with the security of a ready-made community where they could play a vital role and be cared for when illness and death approached.

Nuns from a Constantinople convent reach out their hands, perhaps in supplication during a worship service. Whether they took up the cloistered life as 16-year-old girls or as elderly widows, all nuns followed one of two paths within the convent: The literate utilized their skills as choir sisters, while the illiterate performed more mundane housekeeping tasks.

FEAR AND TREMBLING

Religious services of the Orthodox Church were occasions for high drama, awe, and for many of the faithful, more than a little fear. Amid burning incense and staring icons, the presence of God was almost palpable—and at no time more so than during the celebration of the Eucharist.

The Eucharist was a ritual meal that established a physical and spiritual union of Christ and his worshipers. As in the West, the Byzantines held that the sacramental bread and wine became the body and blood of Christ and that by partaking of it (known as Communion), believers participated in his victory over death on the cross.

At the start of the service, a deacon processed down the nave of the church with a gospel like the one at far right. Scripture was read; a cantor sang a psalm; choruses of alleluias rang out. At the altar a priest consecrated the bread and wine. Then the clergyman stepped into the opening in the iconostasis, a screen separating the altar from the rest of the church, framed by an icon of Christ and an icon of the Virgin. "Approach with the fear of God and with faith," he called out, holding forth the chalice.

But for some congregants, fear was stronger than faith: Deeming themselves unworthy to approach the altar of God, they remained in their seats, unable to accept the proffered body and blood of Christ.

A mosaic of the Virgin and child links the dome of Greece's Hosios Loukas church with its icon-fronted sanctuary, focal point of the Eucharist.

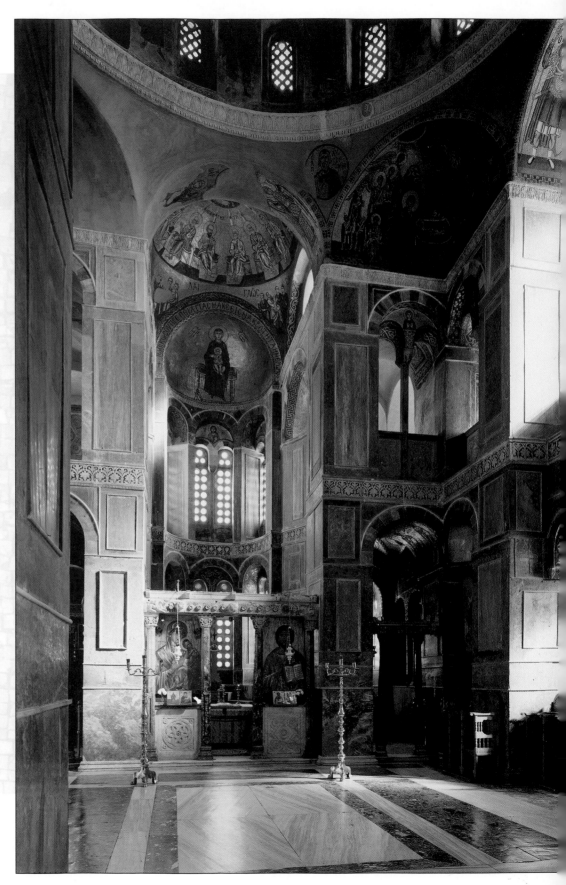

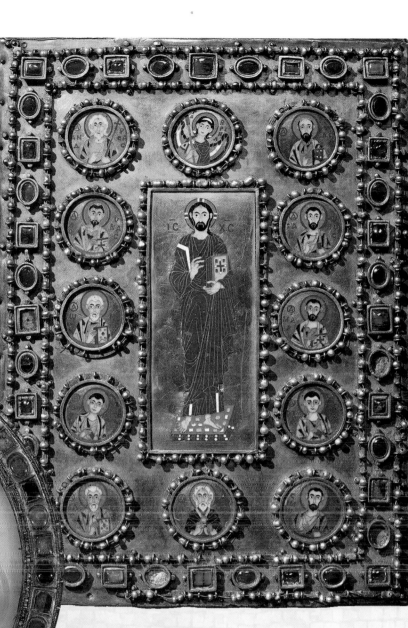

A bejeweled book cover designed to hold a sacred text portrays Christ, surrounded by enamel medallions of saints, bestowing a blessing while holding the Gospels in the crook of his left arm.

Used to hold communion bread during the Eucharist, this 11th-century alabaster paten has in its center a gold enamel medallion of Christ and his command, "Take, eat; this is my body."

The rim of this double-handled sardonyx chalice is inscribed with Christ's invocation, "Drink from it, all of you; for this is my blood of the new covenant."

85

history as Emperor Constantine X. By 1041, at the age of 23, Constantine Psellos had established himself as a lawyer.

Soon young Psellos advanced to the arena of real power, landing the position of secretary to the sickly emperor Michael IV. This ruler had attained the imperial office by marrying the empress Zoe on the very day that her first husband, Emperor Romanos III, was found dead in his bath under suspicious circumstances. Within months Michael IV was dead as well. His teenage nephew, also named Michael, was proclaimed his successor. Like his uncle, the younger Michael was not himself of royal birth, but he had been adopted by Zoe and was proclaimed her coruler, Michael V. Some four months after his uncle's death, Michael V successfully carried out a plot that placed Zoe in a nunnery and left him in sole control of the empire.

But Michael V had failed to anticipate the reaction of Constantinople's citizens. He soon found himself with an enraged mob on his hands, incensed at his treatment of Zoe, who was in their eyes the rightful heir to the throne. The city descended into chaos. The clash of arms and the clamor of roving bands of insurgents echoed along the knots of streets. With cries for retribution, the crowd looted the mansions of the imperial family. On the third day of rioting, the mob overran the palace, and the terrified emperor escaped to a monastery.

A posse was soon organized to capture Michael, and Constantine followed close behind. "Bold, resolute men were dispatched," with instructions to burn out the emperor's eyes with a branding iron, he wrote, hardly containing his own horror. It was over in minutes, the emperor twitching so violently that he had to be bound fast and held in place. But as swiftly as the deed was done, the fury of the moment abated, and the crowd, their passion spent, dispersed.

From observing the misfortunes of Michael V, Constantine learned to respect public opinion. The lesson would stand him in good stead over the course of his own long career as secretary,

minister, and chamberlain to nine different emperors. The reign of Michael V was followed by the return of Zoe, who entered into her third marriage—to the man who would be known as Constantine IX. His rule would result in a serious military decline and was marked by a lasting breach in 1054 between the eastern and western branches of the Christian church.

The fortunes of Constantine Psellos soared during the reign of the new emperor. He had become adept at the kind of bureaucratic infighting that characterized palace intrigue and, as he himself put it, he overcame "the jealous machinations of my rivals" to join the inner circle of the emperor's advisers. He was also appointed professor of philosophy at the University of Constantinople. Shortly before the death of Constantine IX, however, the faction of bureaucrats with which Psellos was allied lost favor with the emperor. Psellos left his high office and retired to a monastery, a fate that routinely befell politicians in 11th-century Byzantium.

Constantine Psellos was by nature no more a monk than his father had been. He professed to have long nurtured "a deep love for the meditative life" and went so far as to adopt a religious name—"Michael"—the name by which history remembers him. But he had a difficult time with the more ascetic aspects of his new life and found that the monastery seriously hampered his scholarly pursuits. Moreover, Brother Michael had little patience for his fellow monks, whom he described as "rustic and gross."

The death of Constantine IX in 1055 prompted the recall to the capital of several former officials, including Psellos. Eagerly shedding the woolen cowl, Psellos couldn't wait to get back to

A mosaic from the Chora Monastery church in Constantinople memorializes a prominent government official named Theodore Metochites, who is shown presenting a model of the church to Christ. In the manner of many affluent Byzantines, Metochites paid for the restoration of the monastery after it had fallen into decay during the 13th century. When he grew old, he became a monk at the monastery and upon his death was buried in its graveyard.

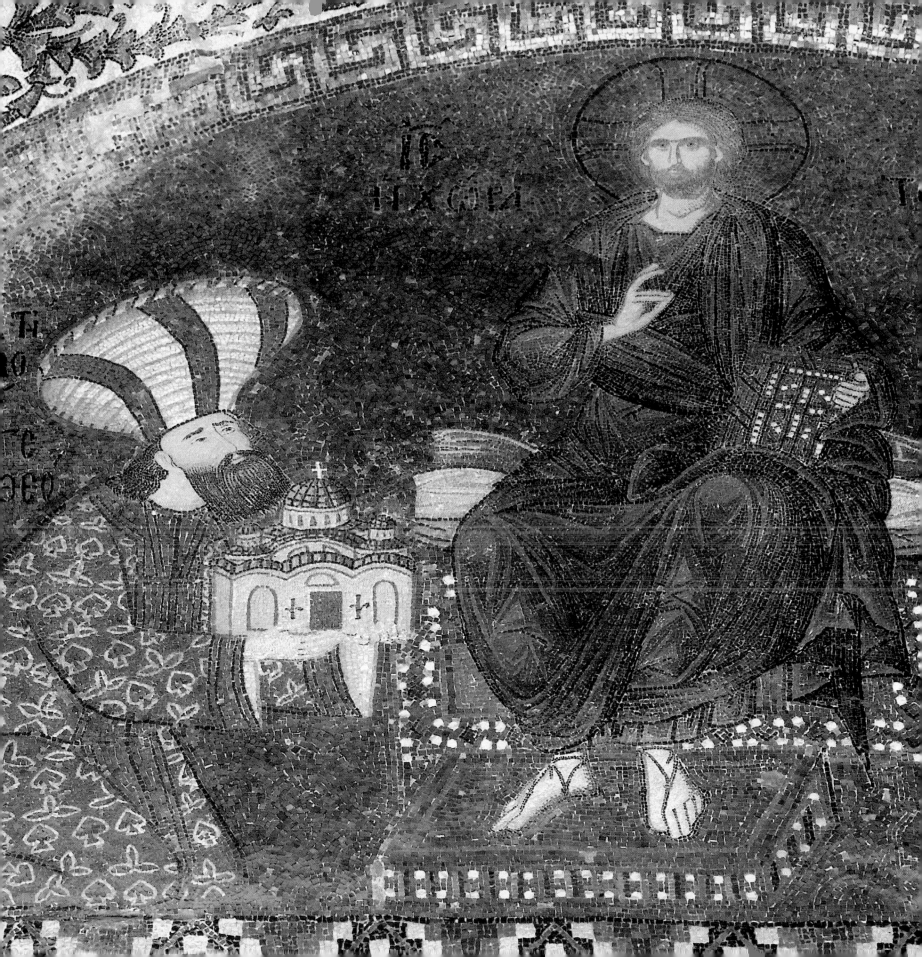

his old life in the civil service, with its familiar, military-style uniforms, its constant intrigues, and its predictable give-and-take of influence and bribery. Never again, he vowed to himself, would he inhabit a monastery, padding through a stone-cold oratory, fixing his eyes, like a woman, on the floor, the sandpaper weave of his woolen habit chafing his thighs at every step.

Once back in the corridors of power, Psellos counseled a string of emperors who rapidly succeeded one another. The first was Michael VI, an aging aristocrat whose weak leadership provoked a rebellion led by an army commander named Isaac Komnenos. Psellos was one of three officials sent by Michael VI to negotiate with Komnenos. The insurgent army chief listened graciously as Psellos made an eloquent appeal for a diplomatic resolution to the issues between the two contenders for the throne.

he liked to think that he was indispensable to his patrons, asserting that the emperor "hung on my lips and completely depended upon me for advice. If he did not see me several times a day, he complained and was annoyed."

For eight years, Psellos commanded an army of bureaucrats on behalf of his friend and emperor. In 1067, when Constantine X died, he served the widowed empress Eudokia, who ruled as regent for her three sons. He ran the empire in her name, boasting that she regarded him as a god. His achievements had clearly surpassed even his mother's aspirations for him.

Like many who aim high, Psellos finally overreached: Eudokia remarried in 1068, and her new husband was acclaimed as Romanos IV. Psellos had been tutor to the empress's eldest son, Michael, and was eager to see his pupil installed as emperor. When

"May you one day also experience all these blessings, my son."

Shortly afterward, however, Komnenos completed the coup and took the throne as the emperor Isaac. Instead of the exile or execution that might have followed, Psellos found his counsel being sought by the new ruler.

After two years Isaac became seriously ill, and Psellos persuaded him to abdicate and choose as his successor Constantine Doukas, the man who had been Psellos's former schoolmate and close friend. In praising the new ruler, Constantine X, Psellos wrote, "For me there is one overriding consideration: the fact that this man, as admirable in reality as he was in appearance, should place more confidence in my judgment than in the scheming of my rivals." As Constantine's chief minister, Psellos had reached the apex of bureaucratic power. In his more arrogant moments,

Romanos was captured by the Turks during a skirmish, Psellos took advantage of the opportunity. He sent Eudokia to a monastery and arranged for her son to be proclaimed the sole ruler, Michael VII. After Romanos was released from Turkish captivity, he was waylaid by Michael's adherents, who put out his eyes, and he subsequently died.

Having betrayed Michael's mother and stepfather, Psellos would feel the sting of a similar disloyalty: Michael VII drew close to one of Psellos's rivals and turned on his former tutor. Eventually Psellos was removed from power and lodged once again in a monastery, his last days haunted by the eerie prescience of his mother's last words to him: "May you one day also experience all these blessings, my son."

TRADING IN LUXURY

Anyone stepping into Constantinople's marketplace knew immediately that they were standing at the trading crossroads of East and West. By 1180, there were 60,000 foreigners, easily recognized by their native languages and dress, living and trading in the city's commercial districts. The warehouses and markets overflowed with sumptuous silks, fabulous jewelry, enameled metalwork, delicately carved ivory, perfumes, spices, and leather goods, as well as all the items of daily life. "One could not believe there was so rich a city in all the world," marveled the French chronicler Geoffroi de Villehardouin.

The official charged with the judicious administration of this huge apparatus was known as the city prefect, or eparch. Second in power only to the emperor, the eparch was the chief judge in the courts, as depicted here, and was the sole authority in matters of manufacture and trade. As described in *The Book of the Eparch,* published around 912, he set prices, interest rates, and

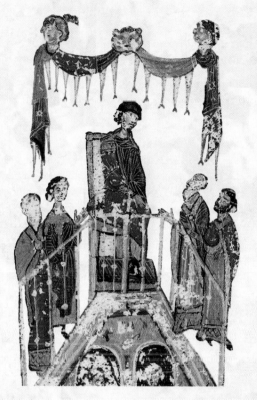

wages; certified weights and scales; levied duties on all goods passing into or out of the city; regulated the rate of exchange; and dictated terms of trade to all merchants.

His staff of thousands strictly enforced the commercial laws. A Spanish traveler, Ruy de Clavijo, described the punishment a violator could expect. "In a street," he wrote, "stand the Stocks, firmly built on the ground, where are set those convicted of heinous crime, and about to be imprisoned; or those who have contravened the laws and ordinances of the city authorities, namely, for instance those who sell bread and meat with false weight."

The Byzantine Empire flourished within this system: During the 12th century, the customs duties from Constantinople alone brought in an estimated $20 million worth of gold to the emperor's coffers. In fact, some historians believe that the decline of the empire can be traced to the liberalization of trade—and to the erosion of the power of the eparch.

SILK, AS PRECIOUS AS GOLD

When newly enthroned emperor Michael V processed through Constantinople on Easter Sunday 1042, there was great celebration: Crowds of well-wishers thronged the streets, and merchants unfurled bolts of purple silk in his path, covering the distance from Hagia Sophia to the Great Palace. The sovereign stepped upon the fabric knowing that, by law, only he and his family could enjoy the luxury of purple silk.

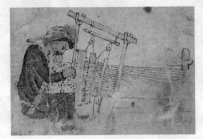

Byzantine silk was among the most precious commodities of the realm, valued on a par with gold, and its manufacture and sale were tightly controlled by the eparch. No fewer than five guilds were involved in the production of the fabric, including importers, merchants, finishers, weavers, and the makers of garments. It was unlawful to speculate on the price of silk at any step in the production process, to profit more than the amount set by law, and to market purple silk to anyone except the agents of the emperor. "The silk merchants are forbidden to sell to persons who are strangers to the city . . . purple of the distinctive dye [red or violet]," the law specified, "so as to prevent exportation of these out of the empire. Offenders will be flogged." The first silks were very plain, but around the sixth century, Byzantine weavers began developing more complex weaves, with multiple threads and repeating patterns. These weaves became possible through the use of horizontal looms, which originated in China. By the 14th century, further advances had led to the development of intricate brocades, richly woven with threads of silver and gold. These luxurious fabrics adorned upper-class homes and churches, where silk was made into curtains, slipcovers, altar cloths, and vestments. Silk even became an instrument of foreign policy: The emperor often made gifts of the best silks to foreign dignitaries.

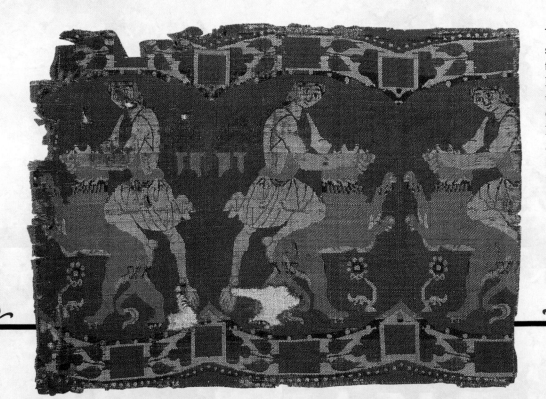

This ninth-century silk, with a scene from the Book of Daniel, was found in Switzerland's Cathédrale de Coire. Byzantine silks used as burial cloths in European cathedrals remain the best preserved today.

A 14th-century brocade belt woven with gold-and-silver threads displays a repeating pattern of a bear, a dragon, a falcon, and between them, panther masks.

Scenes of hunters attacking lions and leopards adorn this silk, which dates from the late seventh to early eighth century.

The emperor Charlemagne, who once received a gift of live elephants from the Byzantine court, was buried in this silk shroud made in Constantinople.

IVORY FOR ORNAMENT AND DEVOTION

Until 541, when Emperor Justinian I abolished the office, consuls to the empire often commissioned artisans like the one depicted in the 10th-century drawing at right to create two-part, hinged ivory tablets known as diptychs. The intricately carved pieces had on one face a likeness of the consul, and on the other a scene or inscription. The diptych was used as an elaborate calling card, announcing to a consul's friends his elevation to the exalted position.

From as early as 429, when the lawbook *Codex Theodosianus* was issued by Byzantine coemperors Theodosios II and Valentinian III, the use of ivory for religious artwork and secular wares was closely regulated. The codex exempted ivory carvers from all civic duties imposed on other workmen, so they might hone their skills and pass the trade along to their children.

Ivory from India and Africa was widely available in Constantinople and relatively inexpensive until the beginning of the seventh century. But when the port of Alexandria fell to the Persians in 619, the empire lost its access to merchants bringing caravans of ivory overland to the trading city, and Byzantine ivory carving all but ceased. It was not until the reign of Leo VI at the end of the ninth century that trade in ivory resumed, and by then it was so precious that it was usually only used for imperial emblems and religious works.

During the ascendancy of the Iconoclastic movement, the very wealthy Byzantines who could afford to purchase ivory delighted in the acquisition of intricately carved ivory book covers, panels, and boxes. The famous Veroli casket *(below)*, covered with images of the gods and creatures of Greek and Roman mythology, is a later example of ivory carved with such secular scenes. But with the revival of Christian imagery in art, the workshops of Constantinople once again began to produce their stock in trade, the small ivory three-paneled works of art known as triptychs, such as the one at right, for private devotional use.

The Veroli casket, 16 inches long and adorned with carved ivory-and-bone scenes from mythology, dates from the 900s.

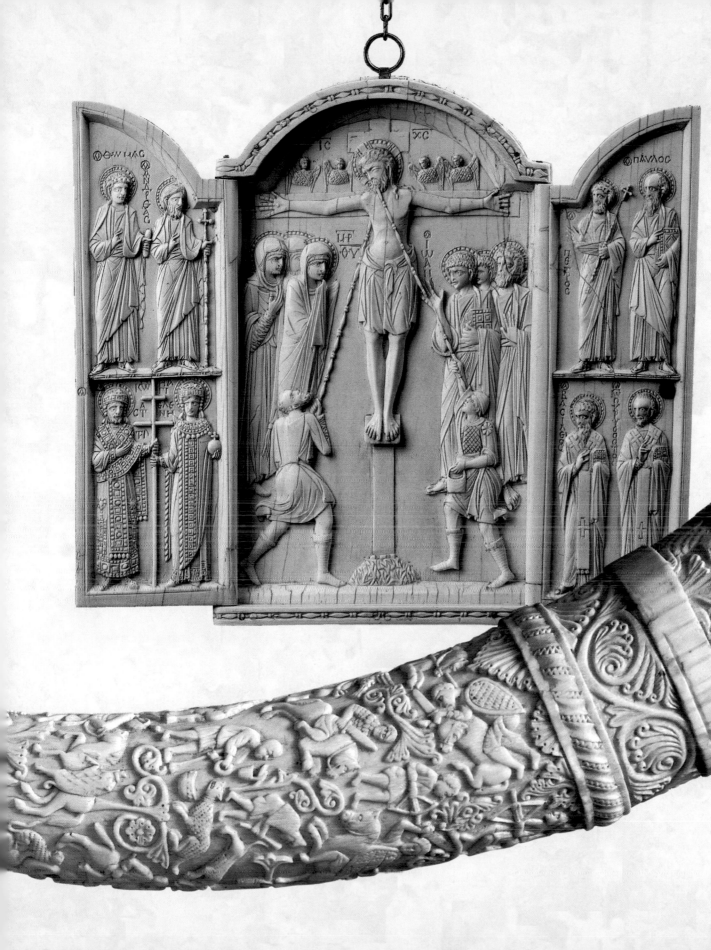

Constantine the Great and his mother, Saint Helena—holding the true cross in the panel at bottom left—are featured along with the apostles in this 11th-century ivory triptych depicting Christ's Crucifixion.

A hollowed-out elephant's tusk, or oliphant, is intricately carved with people, plants, and animals. Such tusks were used as signal horns in hunting and battle, and during the games at the hippodrome.

THE FINEST IN SILVER AND GOLD

Although Byzantine gold coins were the international standard medium of exchange for 1,000 years, objects created from precious metals also served as currency in the marketplace. Silver vessels such as bowls and pitchers were used in trade with Russia, Siberia, and Scandinavia, for example, and elsewhere as security for raising loans. Silver spoons, book covers, and furniture inlays were found in the homes of the well-to-do throughout the empire, and silver chalices, patens, and other liturgical implements stood upon the altars in Byzantine churches. Gold was used to create medallions, domestic plate, and liturgical vessels as well, and much gold was held solely for use by the emperor, who dined on golden dishes.

Indeed, so vital was the emperor's interest in guaranteeing the purity of the gold and silver that served as the exchange of the realm that one of the most severe punishments in *The Book of the Eparch* dealt with those who would melt down coinage to create other objects. Whoever "takes it upon himself to sell silver to be manufactured and sold shall have his hand cut off," reads the injunction. Silversmiths were required to work only in the workshops on the Mese—not at home—under the watchful eyes of the eparch's inspectors, and goldsmiths were prohibited from buying more than one pound of

uncoined gold bullion at a time. As a result of these restrictions, silver plate made in the empire between AD 300 and 700 was proclaimed to be 92 to 98 percent pure—a fact announced to all by the introduction of the stamping of silver products as early as the fourth century *(seventh-century stamp shown at left)*.

The Byzantines' most exquisite metalwork, however, was of gold and cloisonné. There is no more-stunning example of their workmanship than the famed Pala d'Oro altarpiece. It is a dazzling display of gold, enamel, pearls, and precious stones. The Venetian doge Pietro Orseolo commissioned the central panel from a Constantinople workshop in 976. In 1105, Doge Ordelafo Falier added more enamelwork, including his own portrait. Scenes of the life of Christ and the Virgin, which were looted from the Pantokrator Monastery in Constantinople by the troops of Doge Pietro Ziani in 1204, were then added to the top, and the altarpiece achieved its final form in a Gothic frame under the doge Andreas Dandolo in 1345.

These spoons were made in Constantinople and exported to Cyprus around 600. Animals decorate the hammered-silver bowls, which were soldered to the cast-silver handles.

This 12th-century gold-and-silver Byzantine-style incense burner resides in the cathedral of Saint Mark in Venice; it holds a relic of the 1204 Venetian crusade against Constantinople.

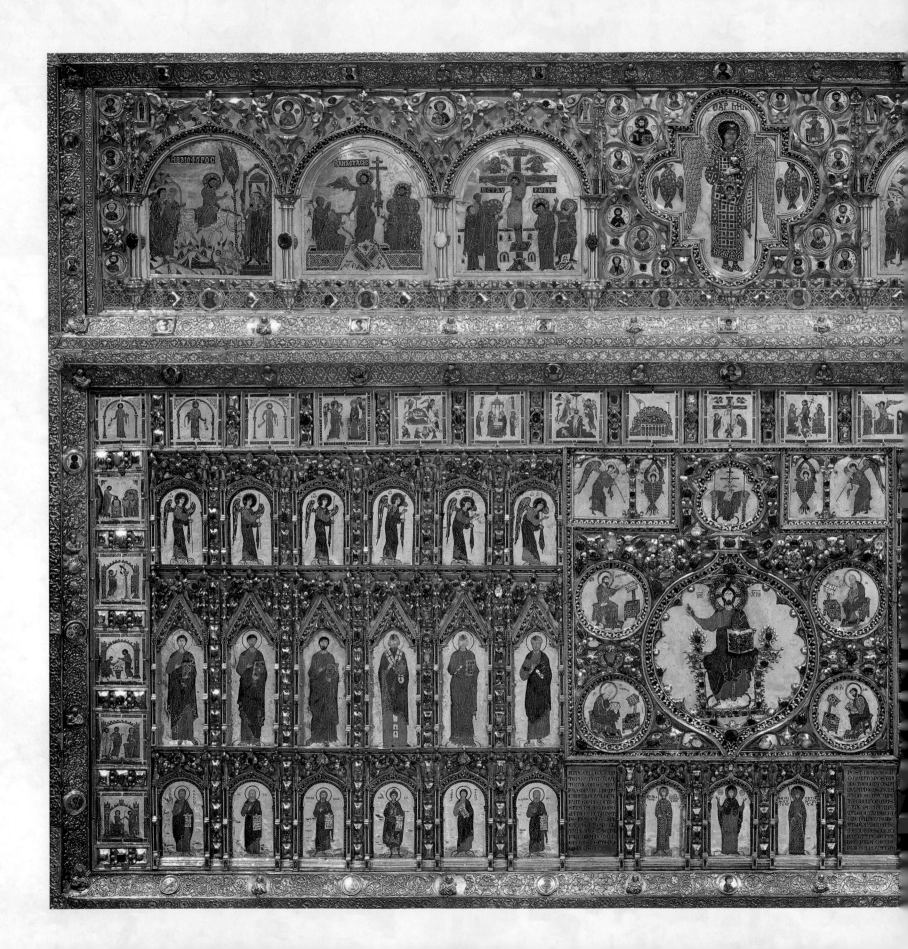

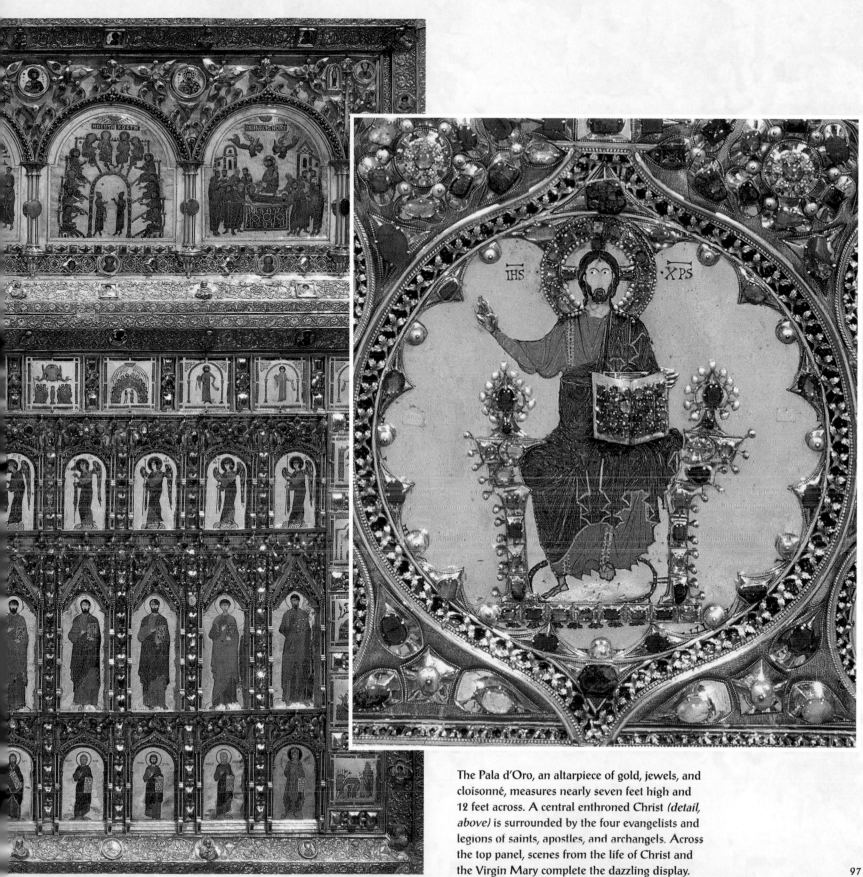

The Pala d'Oro, an altarpiece of gold, jewels, and cloisonné, measures nearly seven feet high and 12 feet across. A central enthroned Christ *(detail, above)* is surrounded by the four evangelists and legions of saints, apostles, and archangels. Across the top panel, scenes from the life of Christ and the Virgin Mary complete the dazzling display.

DEFENDING THE EMPIRE

Three Christian military saints stand ready to intercede on behalf of Byzantine warriors, who carried painted wooden icons such as this on campaign early in the 12th century. Prior to battle, soldiers knelt before their military icons—often prized family heirlooms—and prayed to their divine comrades in arms for protection and victory.

he dying horse lay in the tall grass, thrashing and foaming in its final agonies. Its owner, Mousoulios, watched helplessly. In his heart of hearts he almost wished he could trade places with his fallen mount. Its sickness had come on swiftly, without warning, and in a moment its torments would be over forever. But Mousoulios's woes were just beginning.

Mousoulios lived in the northern Anatolian province of Amneia during the late eighth century and served as a soldier in one of the provincial militias that guarded the Byzantine Empire's far-flung borders. For 300 years or more the realm had been divided into military districts, known as themes, each with its own locally based defense force. Unlike the crack troops of the emperor's own *tagmatic* army—Byzantium's military elite—thematic soldiers were essentially part-time warriors. These men belonged, as Mousoulios did, to families whose names were inscribed on the district's military rolls, recording their hereditary obligation to provide a soldier for the theme. Most sent their sons. But Mousoulios also served with peasant boys who had been hired as proxies by wealthy families that wished to keep their own offspring safely at home.

At a word from his superiors, a thematic soldier had to present himself, properly armed and mounted, for musters, drills, or active duty. As luck would have it, Mousoulios's horse had died on the very eve of a military inspection. Dragging away the carcass, Mousoulios felt sick with despair: He hadn't a hope of raising the money to buy himself another mount before the muster. He came from a poor family who could barely feed themselves from their small tract of land. So the loss of the horse came as a heavy blow, as bad as a failed crop or an implacable tax collector.

If Mousoulios turned up at the roll call on foot he would be guilty of dereliction of duty. He knew that any excuses would fall on stony ground. The inspecting officers were never impressed by sob stories; they'd heard them all before. The reports filed after every muster were routinely organized into four columns: Men present and correct, Sick men, Malingerers, and Absconders.

Mousoulios mused de-

jectedly upon heaven's tendency to distribute earthly blessings so unevenly. Here he was, facing ruin, crammed with all his relatives into a wretched two-room cottage. Meanwhile, only a short walk away, the wealthiest magnate in all Amneia, an elderly man named Philaretos, lived in a palatial villa surrounded by his own pleasant groves and gardens.

Mousoulios didn't own anything of value—except his horse.

Philaretos, on the other hand, possessed 800 mares, 80 mules and saddle horses, plus 600 head of cattle, 100 yoked pairs of oxen, and 12,000 sheep. He held the title to 48 large estates. All his lands were endowed with fertile, well-irrigated soil and worked by armies of laborers who probably praised God daily for allowing them to serve such a kindly master.

Philaretos was famous for his generosity. His grandson and biographer Niketas, who tells Mousoulios's story, recalls that "whenever a beggar solicited him, he would gladly feed him whatever he wished, and then turn over whatever the beggar desired, sending him away in peace, thus resembling Abraham and Jacob. And so over the years his great mercy became known to all in Anatolia and neighboring regions."

But these charitable deeds were gradually driving Philaretos to destitution. In the old days, said the gossipmongers at the village well, the family had lived a life of luxury, dining at a magnificent table made of ivory inlaid with gold, large enough to seat 36 guests in comfort. Now the family mansion was going to rack and ruin, and the magnate's coffers were almost empty.

As far as Mousoulios was concerned, however, no one else's troubles matched his own. Even if Philaretos could no longer afford to eat off golden platters, he might still part with one of his horses for a couple of hours to save a poor man's skin. So the soldier went to call upon the rich man and humbly requested the loan of a saddle horse. Philaretos didn't hesitate; he was happy to oblige a neighbor in need. But first he asked a question: "Once the day of inspection has passed and you have returned the horse to me, what then will you do?"

Mousoulios, who could only cope with the horrors of his plight one step at a time, sighed and shook his head. His lack of a horse wouldn't stay a secret for very long. His brigade commander was a firm believer in exercising horses regularly on rough terrain, to acclimate them to the conditions they might face in battle. In happier times, Mousoulios had enjoyed these training sessions, which often took the form of a day out hunting deer. But now he quailed at the thought of what would happen when the truth came out.

"Would that I survive this day escaping the whip!" he sighed to Philaretos. "Then I will run wherever my feet will take me, I will cross the sea and go to a foreign land. After all, what else can I do?"

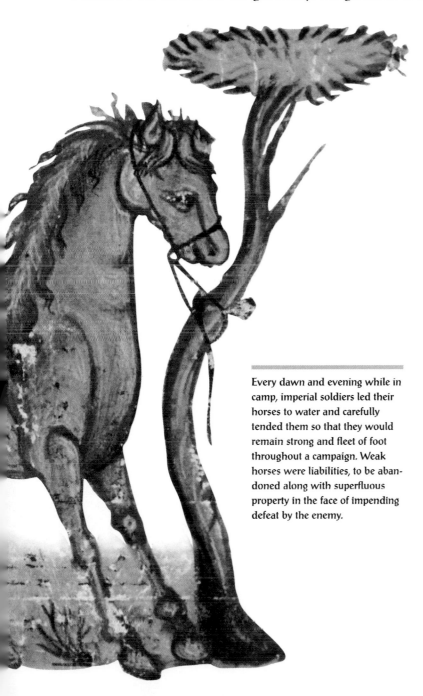

Every dawn and evening while in camp, imperial soldiers led their horses to water and carefully tended them so that they would remain strong and fleet of foot throughout a campaign. Weak horses were liabilities, to be abandoned along with superfluous property in the face of impending defeat by the enemy.

Philaretos knew that an absconding soldier, if caught, would be treated harshly. He might be branded as a criminal, expelled from the army, and handed over to the civilian authorities for sentencing. Or, if his commander was disposed to be merciful, the truant might find himself denied all future leave and placed on permanent garrison duty for the year. And even if Mousoulios did manage to escape, his family would suffer on his behalf: They would lose whatever pay the army owed him and would still be legally bound to provide a soldier for the theme. So Philaretos led Mousoulios to his stables and brought out a strong, handsome stallion. "Take him, brother," he urged Mousoulios. "I make him a gift to you. God will be with you wherever you go, and will protect you."

Mousoulios now realized why his neighbors called Philaretos a saint. Sending up prayers of gratitude, the soldier rode off to the muster with his faith restored.

Generations of soldiers like Mousoulios mustered, drilled, and patrolled the frontiers, waiting for the day when their distant emperor would summon them to war. For some the call came in the spring of 995.

In that year Emperor Basil II was wintering with his army in Bulgaria when messengers arrived at his headquarters with disturbing news. On the eastern edge of the Mediterranean, Arab forces were menacing the Syrian cities of Aleppo and Antioch. The region was a Byzantine protectorate, and any threat to its serenity represented a challenge to Basil himself. In Byzantium's history there had been emperors content to send off their armies

and sit comfortably in the capital, waiting for dispatches from the front. Among them had been Basil's own grandfather, a scholarly aesthete more interested in studying and writing history than in leading troops in battle. But the 37-year-old Basil, who cared little for such niceties as clean clothes or the company of women, was happiest among his fighting men. So when the distress call came out of the east, he rose swiftly to the occasion: He decided to mobilize the military strength of his entire empire, lead the march across Anatolia, and confront the enemy face to face.

As Basil hurried from Bulgaria to Constantinople, the mobilization orders went out to the thematic armies. They were directed to ready themselves for war and head into Syria, meeting up along the way with the emperor and his elite tagmatic troops, bulked up by foreign mercenaries from Russia and elsewhere.

To anyone watching from higher ground—shepherds tending their flocks on the Anatolian heights or desolate sweethearts climbing a hill for a last glimpse of the beloved—the mustering and departure of the great imperial force would have been an unforgettable sight. Light glinted off the steel helmets of the cavalrymen and the polished surfaces of shields, spears, and curving battle-axes. Each division had its own particular insignia and identifying color. Its officers wore shirts dyed in the same shade as the flags and banners their men would follow into battle. The companies of archers carried silk windsocks shaped like dragons; in combat they would fly these kites to monitor wind speed and direction, and adjust their bow shots accordingly.

The war wagons rolled out at the beginning of April. Like streams flowing into a river and rivers flowing into a sea, these units converged. By the end of the month 17,000 troops had traveled the entire breadth of Anatolia—a distance of some 600 miles—and stood at the gates of Aleppo, ready for the fray.

For most generals, such a rapid mobilization would have been impossible. But Basil II was a military genius who possessed one particularly potent secret weapon—his own organizational skill. He also enjoyed the support of a formidably efficient war machine. Intelligence, rather than brute force, was the guiding principle for Byzantine military operations. No detail

Like serfs, many field workers in the Byzantine Empire were tied to the soil. Here a group of hoe-carrying workers wearing short tunics over breeches wait in line outside of the local landowner's home to receive their wages.

went unnoticed; nothing was left to chance. As decreed by the military manual called the *Strategikon,* "A general should never have to say, 'I did not expect it.'"

Every top-ranking officer under Basil's command would have been familiar with the *Strategikon,* attributed to the sixth-century emperor Maurice. This compendium was only one of many ancient and contemporary texts on the arts of war studied by the literate men who led the Byzantine armies. It covered all aspects of forward planning, administration, weaponry, strategy, tactics, and the deployment of troops. Within its pages an ambitious young officer could study diagrams of camp layouts and battle formations. It set down the appropriate codes of conduct for an army in friendly territory or behind enemy lines. One chapter was devoted entirely to baggage trains, while another contained an analysis of the different fighting styles practiced by various enemy peoples. But the most important lessons the *Strategikon* taught were those concerning the management of men.

If he wanted to succeed, a Byzantine commander had to pick the right person for every job. He required senior officers who possessed "sound judgment and courage"; those leading the light infantry should not only be brave but be "good at hand-to-hand fighting, and, if possible, good shots with the bow." Heralds, on the other hand, "should be alert, intelligent, with vigorous, pleasant voices, able to speak Latin, Persian if possible, and Greek." Scouts "should be sober, alert, healthy."

Even the performance and abilities of the common soldier required shrewd assessment. An officer was advised to deploy his most able and experienced men at the front and rear of every marching column. Novices and known incompetents were to be tucked away into the middle

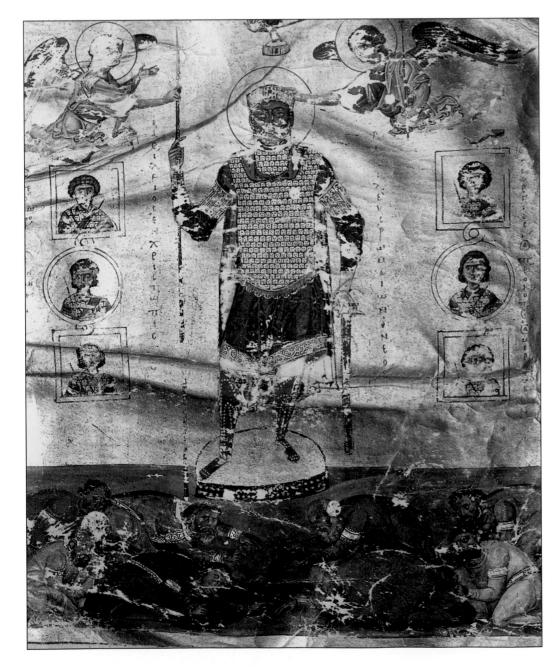

Surrounded by portraits of military saints, the emperor-general Basil II towers over his enemies while the archangels Michael and Gabriel place a spear in his hand and a crown on his head. Basil was described by a contemporary historian as a ruler who was "hard as steel," with a reputation "founded rather on terror than on loyalty."

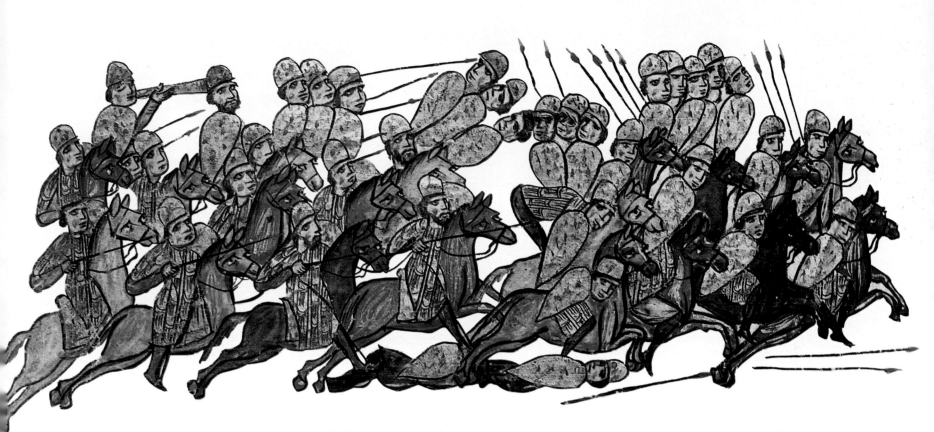

Byzantine cavalrymen wielding lances *(above, left)* rout Bulgarians in this 14th-century illustration. In 1014, during one of many campaigns against the Slavs of southeastern Europe, Basil II allegedly ordered 14,000 captives blinded, allowing a single man in every 100 to keep one eye. Such ruthlessness in battle earned him the name *Boulgaroktonos,* or "Bulgar Slayer."

of the line or relegated to the baggage train, where they would be less of a liability.

The good military manager had to know how to boost morale. To fight well a man had to feel good. "The more handsome the soldier is in his armament," advised Maurice, "the more confidence he gains in himself and the more fear he inspires in the enemy." To this end he gave meticulous instructions about the design and quality of weapons, tents, bridles, and garments, even specifying that cavalrymen's tunics should be cut "so they can be fastened to cover the knees while riding and give a neat appearance."

Maurice also provided helpful hints on manipulating soldiers' emotions. To bolster courage, for instance, enemy captives who looked hale and hearty were to be kept out of sight. More wretched and bedraggled prisoners of war could usefully be stripped naked and paraded before the men to prove just how pathetic the opposition really was.

But no amount of morale boosting could compensate if they lacked the supplies and support staff that made army life livable. Without them, so the *Strategikon* asserted, "the soldiers become distracted, hesitant, and dispirited in battle." A Byzantine fighting force, complete with servants, surgeons, priests, engineers, and camp followers, was virtually a city on the move. Each regiment had a baggage train of 350 ox-drawn wagons, with packhorses, to transport food, spare clothing, equipment, and cooking utensils.

DEFENSE AGAINST DEMONS

Among Byzantines of all social classes there was a widespread belief in the existence of demons, the fallen angels who roamed the earth, wreaking havoc. Demons were held responsible for a host of human miseries, from sickness and famines to storms and crop failures. One particular demon—the demon of midday—was even said to cause sluggishness and dejection.

To protect themselves, Byzantines called on an armory of Christian weapons, including incense, icons, holy water, the sign of the cross, Scripture, and prayer. A particularly favored way to ward off demons was the use of holy amulets, or enkolpia, a selection of which is shown at right.

Decorated with a variety of images—Christ, the Virgin, and the saints of the church eventually replacing earlier pagan subjects—enkolpia were worn on chains around the neck. Their protective value was tied to the value of the materials used in their manufacture, and many also functioned as expensive pieces of jewelry. Their magical power could be enhanced by placing small relics inside them; in cavities hidden within their amulets, the faithful often carried what they believed to be fragments of the true cross, the blood of martyrs, or healing dust from the tombs of the saints, all of which would safeguard them from the unseen evil loose in the world.

A mounted warrior, usually identified as Solomon, slays a demon with his lance on this oval medallion. Christians, Jews, and even pagans regarded Solomon as a power against evil spirits.

With Saint George on its cover and Saint Demetrios inside, this gold-and-enamel enkolpion carries the inscription, "[The wearer] prays that you will be his fiery defender in battles."

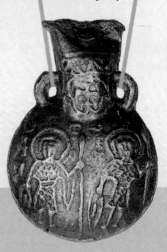

Two military saints wielding spears decorate a lead ampulla, or flask, that would have been carried for protection by a Christian pilgrim. It may have held oil from a lamp in Jerusalem's church of the Holy Sepulchre.

A jewel-studded reliquary box *(left)* opens to display three enameled panels *(below)*. The movable center panel, which depicts Mary and Saint John the Theologian at the Crucifixion, can be lowered to reveal a cross-lined cavity that may have contained a relic of the true cross. The two side panels portray Saints Peter and Paul.

A fertility amulet showing the Greek monster Medusa—her head writhing with snakes—is inscribed with a line from Isaiah, "Holy, holy, holy is the Lord of hosts; / The whole earth is full of [his glory]."

Two flowering shrubs flank the Virgin Mary in this pendant made of lapis lazuli and gold filigree. Less elaborate pendants might be crafted from bronze, pressed lead, or molded glass.

On this particular campaign the inventory was considerably more elaborate, thanks to the presence of the emperor himself. A treatise on military expeditions by Basil's grandfather, Constantine Porphyrogennetos, set out the proper packing list for a monarch on the march. Although Basil himself disdained the material comforts that Porphyrogennetos considered indispensable, the eunuchs who ran his household would probably have insisted that everything be done by the book.

Porphyrogennetos decreed that an imperial baggage train required 582 packhorses—backed up by another 400 reserves—to convey the emperor's belongings. Clothing, utensils, and portable furniture were stowed in purple leather cases secured with polished iron bands.

At every overnight stop, only half the

assortment of fresh towels. When he needed to relieve himself, a bronze lamp illuminated his private latrine, with the chamber pot concealed inside a gilded chair.

Should boredom strike, the emperor could browse in his mobile library of military manuals, theological works, histories, handbooks for interpreting dreams and omens, seismological charts, and texts on meteorology and navigation. But Basil, soldier that he was, had better things to do than bury his nose in a book. Crushing the last of the spring wildflowers underfoot, his armies had survived nearly four weeks of forced marches. Now they converged at the designated rendezvous. The emperor's heart beat faster as he watched the crack troops from Constantinople, the militiamen from the Anatolian themes, and the burly merce-

"Dancing and handclapping should be forbidden, . . . they are a waste of energy for the soldiers."

equipment was unpacked. The remainder was immediately sent ahead to the next day's destination. Meanwhile, servants hurried to set up the tents of the portable palace. Cooks took possession of any fresh fish or fowl that had been hooked or snared in the course of the day, and considered how best to combine it with the stores they had brought along: olive oil, cooking fats, almonds and pistachio nuts, cheese, rice, beans and lentils, lamb and beef preserved in milk.

On arrival, Basil would find everything ready and waiting. At home in Constantinople he was notorious for dressing shabbily and paying little attention to personal hygiene. But if he felt inclined to scrub off the grime of the journey a traveling steam bath would be made ready—complete with a red leather water container, bronze cauldrons, small braziers, warming pans, and an

naries from beyond his empire's borders all coalesce into a single, formidable invasion force.

Their first task was the construction of a fortified camp. Around its perimeter, hundreds of travel-weary men put their backs into digging the first line of defense—a trench eight feet deep and five or six feet wide. Their superiors stood above them, barking orders. Every shovelful of dirt had to be banked up on the inner rim of the ditch to form a protective earthwork. Meanwhile, outside this ring, other soldiers prepared small pits filled with sharp stakes. These man-traps would give a painful welcome to any enemy raiders or lurking spies; as a safety measure their locations were recorded and passed on to everyone in camp.

Inside this boundary the army wagoners drew their vehicles into a circle, forming a second protective barrier. Four large gates

and several smaller doorways, all carefully guarded, gave access to the camp itself.

Once constructed, this city of tents launched into its own distinctive routines and rituals. During the day the infantry drilled intensively: They practiced instantaneous responses to verbal and silent signals, perfected their repertoire of battle formations, and fought mock duels with staffs or actual swords. Heralds moved constantly between the commanders' headquarters and the tents of lesser officers, passing on messages and orders.

Scouts slipped in and out of the gates, bringing back whatever information they could about the enemy's readiness for the coming fight. Only the sharpest and brightest soldiers were deemed fit for these delicate missions; they had to be discreet, able to melt into the landscape, and quick to assess any signs of an imminent surprise attack. Even the chaplains were busy. They had to bless each unit's flag, one by one, and dispatch it to the appropriate standard-bearer, who would raise the sanctified banner to lead his comrades into battle.

But suddenly this cacophony of clashing swords, parade ground commands, and priestly benedictions fell silent. The emperor was about to make his ceremonial entrance, with an entourage of glittering dignitaries in his wake.

His soldiers, from both the thematic and tagmatic armies, were drawn up in ranks to receive him. Basil greeted each unit individually, as a father to his sons, as prescribed by Constantine Porphyrogennetos. "Well met! How are you?" he would ask. "How are my daughters-in-law, your wives, and your children? How did you fare during the march?" Without pausing for an answer, the emperor then hailed them all as "Soldiers of Christ" and urged them to fight hard, to display their courage, and to show their loyalty not only to God but to his own imperial self.

A shrewd emperor knew that soldiers needed more than a motivational speech to spur them on, of course. He encouraged them to do their utmost "so that our majesty, displaying good

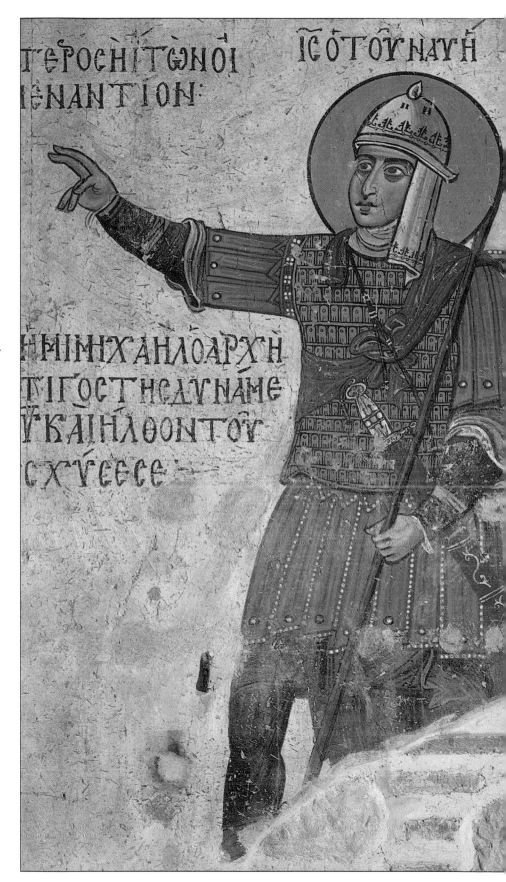

Weapons at the ready, a Byzantine soldier of the 10th century enters battle wearing a Roman "fighting skirt," breastplate, and iron helmet.

will, may worthily repay and reward your courage and nobility and true faith and love; and honour you with various honours; and award dignities to those who previously had none, and distinguish you with countless benefits."

That these benefits would come in the form of cash was a moot point. Even the lowliest mule driver knew that imperial baggage trains usually carried considerable sums of money, much of it intended as tips and sweeteners for the troops. But Basil's biographers would make no bones about it: This particular emperor was a miser. Nevertheless, his soldiers stayed fiercely loyal; they sensed their emperor was one of their own kind, happier in a tent than a marble palace.

Basil ruled them with an iron hand. Though he was shorter than most of his soldiers, he still cut a terrifying figure, and when it came to military matters he was a perfectionist. At any sign of sloppiness or lack of discipline, his round, ruddy face grew even redder and his bushy whiskers rippled with rage. He demanded total obedience. Heroics had no place in Basil's army: Anyone who acted on impulse, broke ranks, and pitched into the foe

without following orders was inevitably punished—even if the daring act had saved the day.

And on this particular day Basil was even more vigilant than usual as he moved through the ranks of the infantry. He inspected each man with a cold-eyed thoroughness that made even the toughest veteran squirm. He had not flogged his forces at top speed across the whole of Asia Minor only to be let down by a rusty piece of chain mail or a frayed leather strap.

In the evening, after the officers delivered the next day's marching orders, the trumpeters blew three times on their horns. The triple blast marked the end of the day's activities. Soon the aroma of 17,000 army dinners hung like a greasy cloud above the camp. After eating, and just before being dismissed for the night, the troops sang the hymn known as the Trisagion—"Holy God, holy strong one, holy immortal one, have mercy on us."

Then, by official order, silence fell.

When the army wasn't on a war footing—and the dour Basil hundreds of miles away—camp life probably was a noisy and convivial affair, with dancing, raucous music, and voices sending

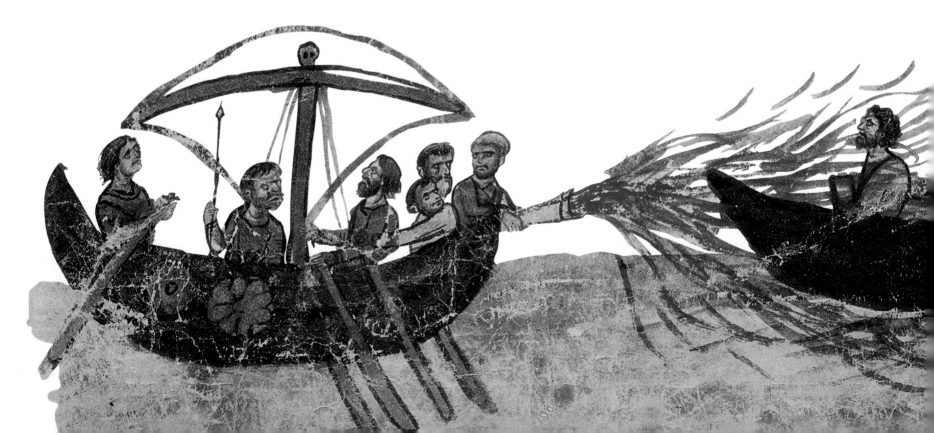

jokes and insults from tent to tent. But on this night the most solemn discipline was maintained. "Noise," as Basil would know from his *Strategikon,* "can lead to a great deal of trouble. Dancing and handclapping should be forbidden, especially after the evening dismissal, not only because they are disorderly and annoying, but they are a waste of energy for the soldiers."

To an exhausted infantryman, it seemed as if the night lasted only a moment. No sooner had he closed his eyes and drifted into a dream of soft beds and dark-eyed women than the order came to rise. In the chill before dawn, the men put on their armor, picked up their weapons, and took their places in the line. The heavy infantry stood ready to move out first, followed by

the war wagons. At first light the trumpets blew three times and Basil's army marched to battle.

In this case, however, the battle never happened. Shocked by the sudden appearance of such a massive force, with the emperor himself at its head, the Arabs had simply folded their tents and fled. But now Basil's blood was up: He whirled his armies into Arab territory in pursuit of the retreating foe, raiding and pillaging the Mediterranean coast as far as Tripolis, some 150 miles to the south. Then, with honor satisfied and the threat defused, the emperor ordered his armies back into Anatolia and disbanded the invasion force. Thematic and tagmatic armies took their leave of each other and headed home.

Basil himself didn't hurry back to Constantinople. He had not traveled to the eastern frontiers of his empire since boyhood, and a leisurely trip back through Anatolia would give him a chance to visit with some of its affluent provincial landowners. He was glad he took the time. His visit to a fabulously wealthy grandee named Eustathios Maleinos proved particularly enlightening.

When the imperial entourage arrived at his gleaming white marble palace in Cappadocia in central Anatolia, Maleinos came out to greet Basil with a fulsome speech of welcome. Together the two men made a strange picture. The emperor, still in his travel-stained tunic of coarse cloth, rank with the smell of his own sweat, showed little emotion as he contemplated the perfumed and carefully barbered nobleman. Basil's stony gaze swept from the lavender-scented silk scarf to the gold-edged scarlet tunic with its pearl buttons to the leggings embroidered with mythical beasts to the butter-soft leather boots to the ruby rings upon the landowner's fingers.

Maleinos escorted his visitor across a colonnaded courtyard as broad as an army parade ground, through halls floored with polished onyx and lined with a rainbow of glittering tiles, into a suite of cool marble chambers. Within them, the walls told sto-

FIGHTING WITH FIRE

Of all the weapons the Byzantines used in time of war, none was more deadly—or terrifying—than a mysterious, napalm-like liquid known as Greek fire. Invented during the seventh century, Greek fire was squirted from tubes or thrown in clay pots and would ignite spontaneously and burn, even on water. It was manufactured in Constantinople, and its main ingredients are believed to have been sulfur, saltpeter, and naphtha, but the exact proportions were never written down and remained, in Byzantine fashion, a state secret.

Although the fiery liquid was employed for warfare on land and at sea, its extreme volatility made it safer to use in naval engagements, as shown at left. The Byzantine navy had spectacular successes with it. In the year 941, for example, Greek fire was turned against an invasion force of 10,000 Russian ships bound for Constantinople; all, it was reported, burst into flames and sank.

ries. Mosaics, composed of brilliant gemstones and small squares of gold, depicted scenes from Holy Scripture and the old but still beloved tales of pagan heroes—Amazons in battle, Odysseus and his adventures, the triumphs of Alexander the Great.

That evening, at the banquet arranged for his welcome, Basil showed little appetite for the delicacies set before him. Seemingly the flesh of every creature that had sailed in Noah's Ark had been roasted for his pleasure. Under the gilded ceiling of Maleinos's dining hall, he waved away the maidservants bearing silver washbasins of rose water, refused the wine, yawned at the undulations of the dancing girls, and stopped up his ears against the drums and flutes.

Maleinos took the emperor's indifference in his stride. Perhaps a hunting trip would provide some entertainment. And to keep things simple, he would probably bring along only a few hundred retainers instead of the thousands who formed his private army.

It took many hours, if not days, to travel through the rich farmlands, vineyards, pastures, and settlements under Maleinos's control. The territory he called his own extended as far as the horizon in every direction. Thousands of laborers paused in the fields to watch the hunting party go by. In the villages, women weaving vividly patterned linens and silks—for Maleinos's own use, or for his agents to sell at a profit—stopped their looms to admire the horses' silver saddles and the grooms' golden belts. All, without exception, saluted Maleinos as if he, not Basil, were the master of all Byzantium.

Once they reached the hunting grounds, there was plenty of sport to be savored. Maleinos's bird handlers released eagles, hawks, peregrines, and the very large birds of prey known as gyrfalcons; hounds and trained leopards scoured the forests, obeying the calls of the huntsmen's ivory horns. The kill was enormous, and the mules soon staggered under the weight of slaughtered bears, gazelles, stags, does, hares, and partridges.

But throughout these blood-spattered diversions, Basil remained pensive. And only when he returned to the capital did he reveal what had been on his mind. On the first day of January 996 Basil issued an edict, duly marked with his own imperial seal. Its title was "New Constitution of the pious Emperor Basil the Young, by which are Condemned those Rich Men who Amass their Wealth at the Expense of the Poor." It pointed an accusing finger at the very Anatolians who had entertained Basil so royally on his homeward journey, charging them with taking illegal title to crown territory and expropriating lands from the common folk around them. Maleinos was the guiltiest of the lot: He and his family had, said the edict, "enjoyed for a hundred years, perhaps 120, the uncontested possession of property unlawfully acquired by them." And like the other nobles,

he would have to prove the legitimacy of his land claims or be stripped of his holdings.

Basil was not necessarily a Robin Hood in royal purple. He may or may not have lost sleep over the sufferings of poor peasants bullied out of their little plots of ground. But he believed that the great magnates who lived like kings in remote frontier districts, indifferent to the imperial will, posed a definite threat to his power. Basil knew, too, that few Anatolian nobles could produce the documentary evidence he required. As a result, some aristocratic families found themselves reduced to the level of the peasants who had once tilled their fields and had bowed to them as they passed; others were rendered homeless and turned into beggars. But Basil reserved his harshest punishment for the man who had entertained him in Cappadocia: Maleinos was not only stripped of all his property but sentenced to imprisonment—for life.

Basil II died on December 15, 1025. He left behind an empire seemingly at the peak of its power and glory. It stretched from the mountains of Armenia to the west-facing shores of the Adriatic Sea, from the banks of the Euphrates, deep in Mesopotamia, to

A hunter thrusts his spear into the side of a wild boar trapped by the man's eager hounds in this scene on a painted ivory chest from the late 10th century. Hunting, enjoyed by Byzantines of all social classes, was thought to sharpen the skills required in battle and conferred honor similar to that attained in victory over a wartime enemy.

the Danube, flowing through Europe's heart. The capital city of Constantinople was a living symbol of the empire's might: It lay at the point where two continents met, and the golden domes of its massive churches mirrored the dome of heaven itself. But this brilliance soon began to fade like the dyes of an ancient carpet left too long in the desert sun. Basil II had dreaded danger on two fronts—attacks by foreign foes and erosion of imperial power by enemies within. Over the next 400 years both of his nightmares came true.

In 1071, barely half a century after Basil's death, the first Turkish warriors to emerge out of western Asia took most of Anatolia. In 1204, Western crusaders inflicted an even more crushing defeat, sacking Constantinople itself. And by the 1400s the Byzantine realm consisted only of the Peloponnesos in southern Greece and the region immediately surrounding the capital. Like carrion crows wheeling above the soldier Mousoulios's dying horse, foreign powers circled the moribund hulk of the empire—Serbs, Bulgarians, Normans, Turks, and the rising maritime states of Catalonia, Genoa, and Venice. Trade still flourished, but the profits went elsewhere, into the hands of prosperous Italian merchants in particular.

As the physical dimensions of Byzantium shrank and its political influence diminished, the very structures of the state began to rot away. Riots, class conflicts, civil war, state coffers drained by endless military expenditure, a countryside devastated by heavy taxation—all caused the once smooth-running machinery of the Byzantine state to grind to an ignominious halt. The army, a pale and sickly shadow of Basil II's mighty war machine, depended entirely on foreign mercenaries. The navy no longer had enough ships or men to guard the seaways; even the local pirates went about their work unchallenged.

On March 12, 1449, the chosen successor to this shrunken and splintered realm sailed into the Golden Horn to claim his throne. It was a mark of just how bad things were that Constantine XI arrived on a Catalan ship; his own Byzantine fleet was too depleted to provide a suitable vessel to bring him to the capital from his home in the Peloponnesos.

As Constantine made his way from quay to palace, he could hardly avoid the visible signs of Byzantium's decay. At the waterside, the ramshackle state of the once-magnificent imperial dockyards was a shameful sight. Ships still sheltered there, but the noise of industry, the hammering and sawing and shouting, was missing. Dust coated the old ropewalks, birds nested in sailmakers' lofts, and slipways stood empty.

Behind them rose a townscape pockmarked with ruins. The church at Blachernai, which had housed the community's most precious relic, the veil of the Virgin Mary, seemed little better than a burned-out shell. At the highest point of the city, the Church of the Holy Apostles—resting place of Constantine the Great—threatened to collapse into a heap of rubble. Ghosts flitted through the echoing cloisters of abandoned monasteries. In the wreckage of ancient mansions, the smoke from squatters' campfires besmirched the remnants of mosaic panels and marble walls.

Of course, the crowds turned out to greet their new ruler. But the native inhabitants of Constantine XI's capital seemed a far cry from those glossy, elegantly dressed subjects who had lined the streets to hail his predecessors in the empire's golden age. A Spanish visitor expressed his surprise that this city, once the throbbing heart of the Christian world, now seemed so "sparsely populated." He reported that "the inhabitants are not well clad, but sad and poor, showing the hardship of their lot." Once Constantine arrived at his palace, he would find it shorn of its ancient glories. The building was in a sorry state. The gold and silver goblets from which members of earlier dynasties once sipped their excellent wines had been replaced by cups of pewter or clay. The treasures had long since been ransacked. The jewels were fakes.

For generations, the court had struggled vainly to keep up

appearances. A Byzantine chronicler describing the wedding of Constantine's grandfather, John V, had lamented that "most of the imperial diadems and garb showed only the semblance of gold and jewels; they were of leather and were but gilded, as tanners do sometimes, or of glass which reflected in different colors. To such a degree the ancient prosperity and brilliance of the Roman Empire had fallen, entirely gone out and perished."

Even the ceremony—or rather the lack of it—that commemorated Constantine XI's own accession to the throne was a painful reminder of the empire's disarray. He had been proclaimed emperor in a civil ceremony at Mistra, in Greece, but never crowned. He wasn't the first emperor to be invested in a provincial city: Michael VIII, the founder of the current dynasty, had been crowned at Nicaea when Constantinople was in the crusaders' hands; John VI was crowned in Thrace. But both rulers had made certain to repeat the rite when they entered the imperial capital.

This option was not open to Constantine, however. He arrived in the cap-

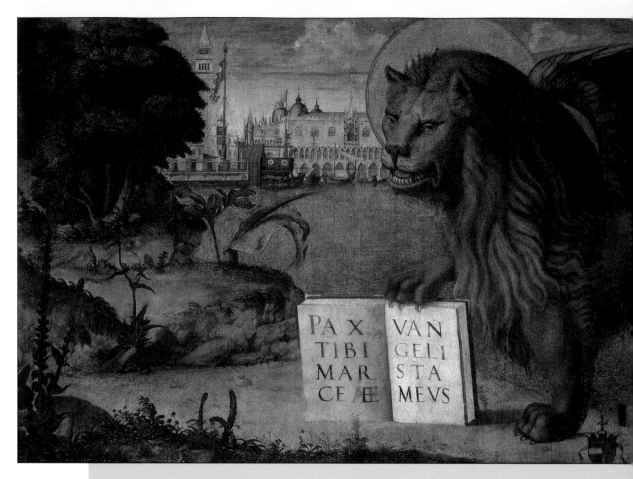

THE RAPE OF CONSTANTINOPLE

To the residents of Constantinople, the sight of foreign invaders crashing against the well-fortified walls of their city was nothing new. Arabs, Goths, Persians, and Slavs—infidels or pagans all—had attacked the Byzantine capital before, without success. But in 1203 a new threat appeared outside the walls: Spurred by religious zeal as well as sim-

ple greed, the forces of Western Christendom had come to besiege the greatest Christian city of the day.

The impetus for this latest assault on Constantinople began in 1198. That year Pope Innocent III called for a Fourth Crusade to liberate the Holy Land from Muslim control. Lacking funds to support the venture, Innocent

Enrico Dandolo wears the traditional hat and vestment of his office, doge of Venice. The opportunistic Dandolo viewed the Fourth Crusade as a means of promoting Venetian interests at the expense of Byzantium.

The winged lion of Saint Mark, patron saint of Venice, displays the Latin motto of the maritime republic, "Peace be unto you, Mark, my Evangelist."

turned to the wealthy city-state of Venice, whose doge, or duke, Enrico Dandolo, agreed to lead the crusade and provide transportation for the 10,000 volunteers—mostly French, German, and Flemish—who responded to the pope's call.

For years the doge had sought ways of asserting Venetian trading dominance in the eastern Mediterranean, only to be frustrated by the Byzantines. Now, though, he saw his chance. He had at his command a great many men, and in the summer of 1202 a Byzantine dynastic dispute gave Dandolo the pretext for diverting his fleet to Constantinople: The crusaders would intervene on behalf of a pro-Western aspirant to the throne, Prince Alexios, who had

Although Pope Innocent III intended to start a holy war to free Jerusalem from the infidels, his crusade ravaged Constantinople and never reached the Holy Land.

promised the Eastern Church's submission to Rome as well as military and financial support for the crusade.

So it was that the crusaders dropped anchor in the Golden Horn in July 1203. After a short struggle—in which crusader knights attacked the land walls and Venetian sailors the weaker harbor walls—the city fell, and Alexios was crowned emperor. The people of Constantinople, however, were incensed that their new ruler had allied himself so openly with the West, and in January 1204 Alexios was strangled, and the gates shut on the crusader army, which had remained in camp outside the city.

Dandolo was furious. On the morning of April 9 he launched a second assault, and before long the troops were back in the city. For three days, bands of treasure-hungry Venetians prowled its great churches and tombs while crusader mobs pillaged with abandon. "They seized gold and silver, precious stones and tableware of precious metals, silks and satins, coats of fur," recalled one

Frenchman of his fellow crusaders. "I stake my word that never had any army gained so much plunder in the whole history of the world."

But the invaders did more than just loot: While an imperial Byzantine court was set up in exile at Nicaea, the westerners installed their own emperor in Constantinople and a Venetian as patriarch. Only in 1261—after almost 60 years of Latin rule—was a Byzantine emperor restored to the throne and a new dynasty established. Though it would enjoy a brief renaissance, Byzantium had been fatally weakened by the Fourth Crusade, and in the years ahead the empire could do little to resist the encroachments of its final enemy, the Ottoman Turks.

ital at a time when the whole Orthodox Church was racked by schism. Gregory III, the patriarch of Constantinople, whose sacred duty it would have been to place the crown on the new emperor's head, now stood on the far side of a religious divide. Some Orthodox Christians—Gregory among them—believed that the time had come to unite with the Church of Rome. Most of the Byzantine populace violently disagreed and condemned the patriarch as a traitor to the faith. It would have been anathema—and politically disastrous—for Constantine to receive his crown from such tainted hands. In 1451 Gregory resigned, leaving the Byzantine Church without a leader.

The patriarch's defection to Rome was only one of the worries that Constantine inherited along with his crown; another was his own lack of an heir. He had outlived two young wives; both died childless. His envoys visited princely houses everywhere—from Portugal to Venice to the Black Sea port of Trebizond—in search of a new bride. Many delicate negotiations were undertaken; none succeeded.

But of all the fears that beset Constantine in the small hours of the night, the one that pressed most heavily upon him was the

Venetians assault Constantinople's walls using flying bridges—planks lashed to ship mastheads—and scaling ladders. It was the first time the city's formidable walls had ever been breached.

The four bronze horses of Saint Mark's cathedral in Venice were among the many treasures plundered from Constantinople in 1204.

ever increasing power of the Ottoman Turks. Already they had overrun most of Anatolia and eastern Europe, and their capital of Adrianople lay just over 100 miles from Constantinople. When the wind blew from the right direction, the wakeful Constantine could almost imagine that he heard the Turkish muezzins calling the faithful to early morning prayer.

The Ottomans had a new ruler too. In February 1451 Sultan Murad II died suddenly, in his prime, struck down at the dinner table by an apoplectic fit. His son Mehmed II was only 19. At first the Byzantines had breathed a collective sigh of relief. Murad had been a great military leader who forged the Turkish army into an efficient fighting force. But the green youth who succeeded him was unlikely to pose an immediate threat. Some members of the imperial court even suggested that Mehmed's newly widowed stepmother might make an ideal candidate for Constantine's own empty marriage bed.

At first the new sultan had lulled the Western powers into a false sense of security, sending off goodwill messages in all directions, swearing to live in peace and signing treaties with the Hungarians, the Venetians, and the Serbs. Mehmed was an intellectual, interested in experimental science, astrology, and military strategy. He was also an avid student of the classical empire builders, Alexander the Great and Julius Caesar.

Constantine himself seems to have been less charmed than most of his contemporaries. And the young man was certainly ruthless. It was rumored, at least by Byzantine propagandists, that when his stepmother came to congratulate him on his accession, Mehmed had greeted her affectionately and engaged her in a lengthy conversation. But when she returned to her own infant son, she found he'd been murdered in his bath.

Barely a year after coming to power, Mehmed dropped his mask. He revealed his all-consuming obsession: the conquest of Byzantium. He was said to pace the halls of his palace at night mulling over attack plans. He pored over maps and filled reams of paper with his own sketches of the city's fortifications and their weak points.

Mehmed's first aggressive act was to build a fortress on the European side of the Bosporos, just a few miles north of Constantinople. His chosen site dominated the nar-

To penetrate enemy fortresses, imperial troops employed a variety of siege tactics, such as bashing through walls with a mobile battering ram *(top)* or launching Greek fire over the ramparts *(bottom)*.

rowest part of the strait, and stood directly opposite another Turkish castle, Anadolu Hisar, built by the sultan's great-grandfather in 1397. The two together would give him a total stranglehold on the Bosporos.

In preparation, Mehmed consulted architects, recruited stonemasons, and drafted a work force. His laborers began dismantling every monastery and church in the area and carting off their stones to the construction site. Constantine sent a delegation to Adrianople, bearing gifts and asking only that the sultan take pity on certain nearby villages and spare them from his wrecking crews. Mehmed replied by killing the messengers.

On April 15, 1452, the actual building work began. And the Byzantines could do little more than look on helplessly, watching the likely engine of their own destruction rise on the skyline. Less than five months later, on August 31, the citadel known as Rumeli Hisar stood proud above the Bosporos, and the naval blockade of Byzantium began.

Constantine, desperate to win support from the Western powers, ventured to suggest that perhaps the time had come for a union of the two Christian churches after all. But even in the face of their own extinction at the hands of the Turks, the people of his city folded their arms and refused to recognize the union. At the imperial court, a senior official would speak for many when he declared, "I would rather see the Muslim turban in the midst of the city than the Latin mitre."

No one doubted that the siege was coming. Constantinople began to prepare. Every able-bodied man and woman contributed to the effort. They set to work strengthening the city's defenses, collecting weapons, stockpiling supplies. Old enemies forgave each other, rivals toiled side by side, political factions reconciled their differences and directed their energies to the common cause. The colonies of resident foreigners—Catalans, Venetians, Genoese—all threw themselves into the struggle. A massive floating boom was chained across the opening to the Golden Horn to bar the entrance of enemy ships from the Bosporos.

On the western, landward side, the city was protected by massive walls. Three layers of fortifications had formed a seemingly unbreachable four-mile-long barricade that extended from the Sea of Marmara to the northern tip of the Golden Horn. The first line of defense was a ditch 60 feet wide and some 30 feet deep. Behind it an embankment, guarded by a parapet, stood before a 30-foot-high exterior wall punctuated by 96 towers. Within this enclosure lay the final rampart, a 40-foot-high wall defended by another 96 towers, each one climbing about 60 feet into the sky.

Any enemy who had ever succeeded in entering Constantinople had had to find another way in. For a thousand years the land walls had resisted all attackers, impervious to wheeled towers, catapults, and every other form of siege engine. Now, though, the Ottomans had a new and terrible form of artillery at their disposal—a cannon strong enough to shatter stone. The emperor was painfully aware of its potential, because its inventor, a Hungarian engineer named Urban, had first offered to build the gun for him. But Constantine, perhaps pleading poverty, could not or would not meet his price. In the manner of arms dealers throughout history, Urban merely shrugged and went off to sell his product to the opposition.

Mehmed was delighted by Urban's cannon and offered him four times the salary he'd asked for. Installing the weapon atop the ramparts of Rumeli Hisar, the sultan promptly ordered another, twice the size. This second gun was almost 27 feet long with bronze walls eight inches thick, and its gaping mouth, two and one-half feet in diameter, spat stone cannonballs weighing 1,340 pounds apiece. During a test run at Adrianople, Mehmed rejoiced to see one of these missiles fly more than a mile through the air before plunging six feet into the earth. It was the biggest gun the world had ever seen.

The sultan had his minions prepare the route for the can-

Encamped outside Constantinople, the Ottoman Turks prepare to besiege the Byzantine capital, which is portrayed in this 15th-century French painting as a fortified Gothic city. In the foreground Turkish soldiers train their cannons on the land walls, while others, above and to the left, drag their ships overland to position themselves in the Golden Horn.

non's journey from his own capital to Constantine's. A gang of 200 men labored with all speed to improve the road surfaces and reinforce the bridges. At the beginning of March 1453 the wagoners cracked their whips, and a team of 60 oxen began to pull the great gun across Thrace. Another 200 men escorted the metal monster, holding it steady as the convoy rolled inexorably toward its destination. Three weeks later, following in the wake of his 70,000- to 100,000-strong army, Mehmed made his own, much swifter, journey. He arrived outside the walls of Constantinople on Thursday, April 5. On the next day, the Muslim Sabbath, he unleashed his cannon. The final struggle had begun.

In the weeks that followed, the people fighting for the life of their city and the people manning the cannons encircling it became the protagonists in one of history's most decisive confrontations. To defend Constantinople's walls, the emperor could call on fewer than 7,000 troops. Initially he continued to nurse hopes that the Christian West would come to the rescue. On April 20, four Genoese ships, though hugely outnumbered, engaged the Turkish fleet in battle and beat them back. The city rejoiced. But two days later the inhabitants woke to a sight that beggared all belief: Turkish warships were lying in the upper reaches of the Golden Horn.

Mehmed had conceived of a bold stroke to defy the Byzantines' floating boom and get his ships into the channel—an overland portage. He had laid a road across the neck of land between the Bosporos and the Golden Horn, mounted some 70 ships on wheeled wooden cradles, and used the combined muscle power of thousands of men and oxen to haul the vessels over the 200-foot-high ridges. As dawn broke on April 22, a procession of enemy vessels could be seen jerking and shuddering their way down the hills beyond the city and sliding into the waters of the Golden Horn. The bombardment began.

Deafened by the explosions and blinded by the blasts, the people of the now surrounded city—nuns and noblemen, kitchenmaids and priests, street urchins and courtiers—worked together to mend every fresh breach in the battered walls. They struggled on from the end of April until the third week of May, fighting for their faith, their world, and their way of life. They grew hungry and tired and sick with the sense that nothing they could do would save them.

The earth and the heavens seemed fraught with evil omens. On May 22 the night sky confirmed their worst fears as the moon entered a total eclipse. At the emperor's urging the whole community took to the streets, bearing a sacred icon of the Virgin Mary, praying for her to intercede and save them. Suddenly, the procession was halted by screams of horror. The holy image had slipped and fallen. The onlookers rushed to lift it back into place but found it unaccountably heavy, as if it had been made of solid iron. Eventually the icon was secured again, and the march moved off. Then the sky exploded: Thunder, lightning, sheets of rain, and a torrent of hailstones flooded the streets and forced the worshipers to run for shelter. The next morning brought an impenetrable and completely unseasonable fog, turning May into gray November. At the day's end another frightening phenomenon assailed the eyes: The great dome of Hagia Sophia glowed red as if suffused by a rising tide of blood, and then went dark.

Constantine ignored the pleas of his courtiers, who encouraged him to flee the city. Escape was still possible. If he managed to reach some place of safety, perhaps in the Peloponnesos, he might someday have hopes of rescuing the fallen empire from the Turks. But Constantine, laboring under no illusions, refused to leave. His capital's fate, and his empire's, would be his own. His friends and officials stood by him. When messengers came from Mehmed offering terms of surrender that would spare both the city and its people, Emperor Constantine shook his head and sent the envoys away.

In the early morning hours of May 28, a sense of foreboding filled the air. The Turkish army rested in its camp outside the

land walls, marshaling its energies for the final attack. Everyone, on both sides, knew it would come sometime in the darkness before dawn. Inside the city the authorities distributed weapons. Priests, carrying icons, made a circuit of the walls. A huge procession filled the streets, singing, "O Lord have mercy on us." One last time the emperor addressed his people. The enemy, he said, "are supported by guns, cavalry, infantry, and their numerical superiority, but we rely on the name of the Lord our God and Sav-

first Turkish soldier, bursting through the door with a shriek of triumph. His comrades flooded in behind him, and then the blood began to flow.

Some lucky enough to survive what followed claimed that there had, indeed, been a miracle at the very moment when the doors were broken down. A pair of priests, resolutely conducting Mass even as the screams rang out, grasped the most precious objects on the altar and simply melted into the southern wall.

"The spider weaves the curtains in the palace of the Caesars."

ior, and secondly, on our hands and the strength which has been granted us by the power of God."

Traveling to the palace at Blachernai, where the land walls met the Golden Horn, Constantine thanked the staff for all their labors on his behalf. No one pretended that the disruptions to the palace's stately routines were only temporary. Constantine asked their forgiveness for any offense he might have caused them, any discourtesy caused by his distractions during this terrible time. Then he bade each one good-bye and went out to the walls, to face the Turks alongside his people.

At an hour or two after midnight on May 29 the Turkish forces began their final assault on the city. Soon after dawn it was theirs. Those civilians who could muster the strength made their way into Hagia Sophia, all notions of schism between Latin and Orthodox believers forgotten. Surely a place so sacred would protect them from the enemy's fire and sword. There were those among the faithful convinced that an angel would descend from heaven during this ultimate hour of need and fight off the foe. But their hopes were futile. The only visitation that day was the

For centuries after, believers would maintain that on the day that Constantinople became a Christian city once again, the priests would reappear and resume the service at precisely the point where it was broken off.

In the evening of that longest of days, Hagia Sophia received another visitor. Sultan Mehmed II had waited while his warriors received their customary reward—an opportunity for an orgy of murder, rape, and pillage. Within a matter of hours the city's treasures had been carted off, the spoils divided, the prisoners put to whatever uses their captors wished. Chroniclers would differ over the numbers dead or enslaved, but it was likely that 4,000 Byzantines perished and 50,000 more were taken prisoner. Now the city was quiet at last.

Kneeling outside the ransacked church, the 21-year-old Mehmed picked up a handful of dirt from the ground and sprinkled it onto his turban. He might have conquered an ancient empire, ended a millennium of Christian rule in the East, and set his stamp upon the course of history, but he knew his place. He was a lowly mortal creature, as humble as dust. Then he entered

the church and declared that it would henceforth serve God as a mosque.

Constantine never witnessed this ultimate proof of his empire's demise. He had died defending the walls, and now lay among a heap of corpses. Although the sultan ordered that the city be scoured until Constantine's body was found, the search proved fruitless. The emperor's final resting place remained unknown. But his death confirmed an ancient Byzantine prophecy that the empire would end as it had begun, with a ruler named Constantine on the throne.

The sultan mused that he, too, had fulfilled a promise made, so said the sages, by the prophet Mohammed himself: "Have ye heard of a city of which one side is land and the two others sea? The Hour of Judgment shall not sound until 70,000 sons of Isaac shall capture it."

Then the founder of the great Islamic empire that would rise from Byzantium's ashes made his way into the ruined palace of the ancient emperors. He contemplated what remained of the colonnaded courts and lustrous mosaics and, it was later claimed, quoted the words of a Persian poet whose name is now forgotten: "The spider weaves the curtains in the palace of the Caesars."

And from a high place that had once been a church, Mehmed heard the muezzin summon the city's new masters to prayer, praising God, but in a different tongue.

The roses were in bloom when Sultan Mehmed II captured a run-down Constantinople on May 29, 1453. In the centuries ahead, the city would undergo a renaissance, though not as a center of Christianity but as the imperial capital of the Muslim Turks.

LEAVING THE WORLD BEHIND

Though the Byzantine Empire died with the conquest of Constantinople by the Ottomans in 1453, its religion lives on. Today Eastern Orthodoxy is the faith of many millions of people around the globe and is still practiced with fervor in the ancient monasteries throughout the empire's former realm. There, surrounded by some of the glorious treasures of the Byzantine past, like the icon below, monks and nuns keep alive a way of life that once made Constantinople the most devout place on earth. At their zenith, the city's monasteries numbered in the hundreds, and they provided sanctuary for thousands of individuals from all walks of life.

Monastic life offered a variety of benefits to those who chose to leave the world behind. It represented a career opportunity for some—monks from the educated aristocratic and ruling classes helped make the monasteries centers of cultivation and learning, with high-ranking clergy often called upon to give their opinions on matters of state. Many, called to a religious vocation, spent their lives in contemplation, preparing for life after death. Still others took advantage of the monastery's community and security. Even emperors—some under duress—sought the escape that monasteries offered; of the 88 who ruled over the course of the 1,123-year-old empire, 13 secluded themselves.

Five centuries after the Ottomans seized Constantinople, the city, renamed Istanbul, remains the seat of the spiritual leader of Orthodoxy, the ecumenical patriarch. And although the city where Eastern Orthodoxy began is now overwhelmingly Muslim, the patriarch continues to exert his influence on all the Eastern Orthodox churches, wherever they may be.

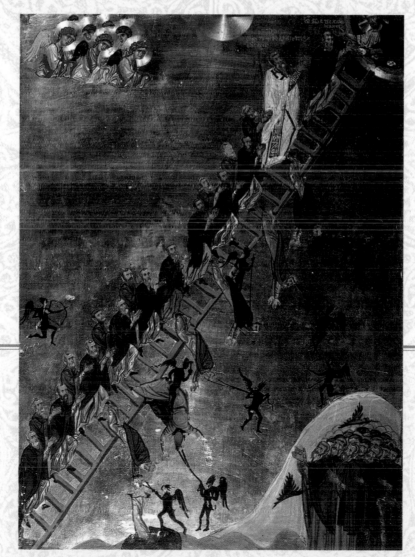

Nestled at the foot of Mount Sinai, the Monastery of Saint Catherine occupies the site where Moses beheld the burning bush. Active to this day, it was built by Justinian I in the sixth century.

In this 12th-century icon preserved in the Monastery of Saint Catherine, monks climb to heaven though some, having succumbed to temptation, fall from the ladder and are dragged away by devils.

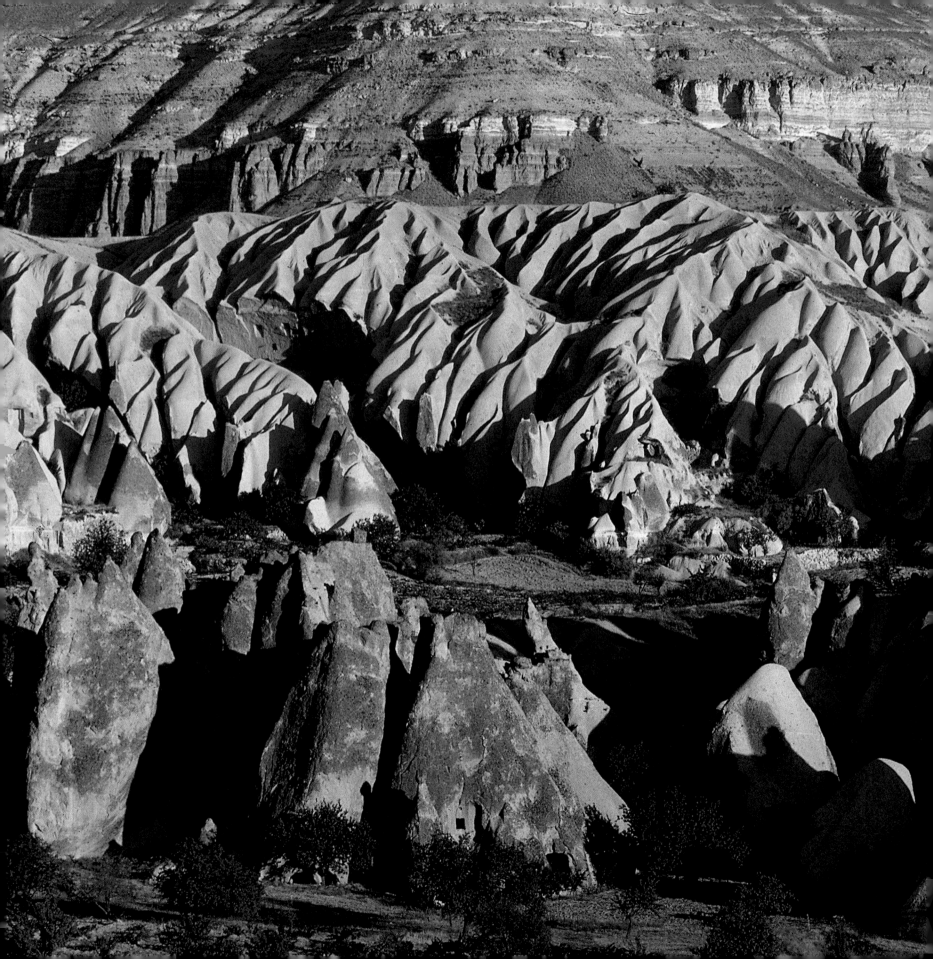

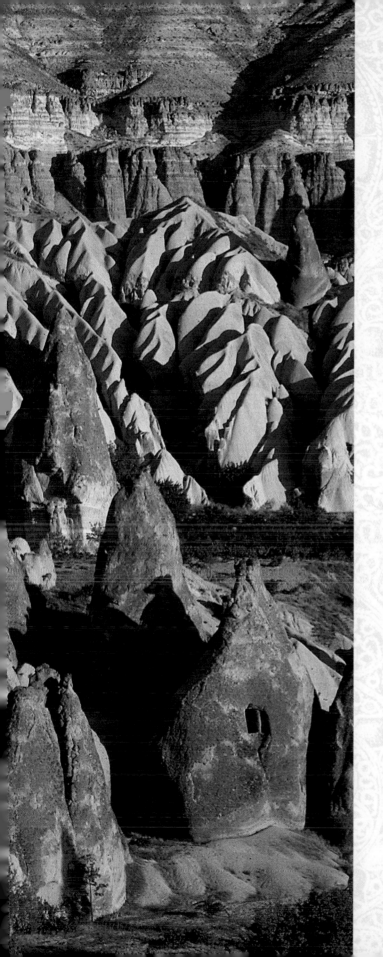

A HAVEN FOR ASCETICS

Eastern Orthodoxy took root in Greece, the Balkans, and Russia and thrived, yet there is no more haunting proof of the power it held over human lives in Byzantine times than in Cappadocia, a region of central Turkey. Here, in an austere landscape that appealed to ascetics, religious orders hollowed churches and monasteries out of the soft volcanic tuff. Many are simply modified natural caves; others have carved domes and columns that serve no structural purpose but mimic freestanding churches.

"There is scarcely a place in the entire world," wrote the fourth-century saint Gregory of Nyssa, "that can boast of as many churches as there are in Cappadocia." Today there are hundreds. Most were abandoned in the 11th century when the area was overrun by Turks, but many still have Byzantine frescoes ornamenting their walls. Saint Gregory marveled over the artists' ability to show "the feats of the martyr, the sufferings, the pain, the savage faces of his tormentors, the insults, and the blessed end of this spiritual athlete—all these pictured for us in paint as if written in a book."

Laid down by volcanoes ages ago, compacted ash has weathered into hills and cones in Cappadocia's Göreme Valley *(left)*. The Mary Chapel *(above)* is one of many churches cut from the stone and decorated by monks.

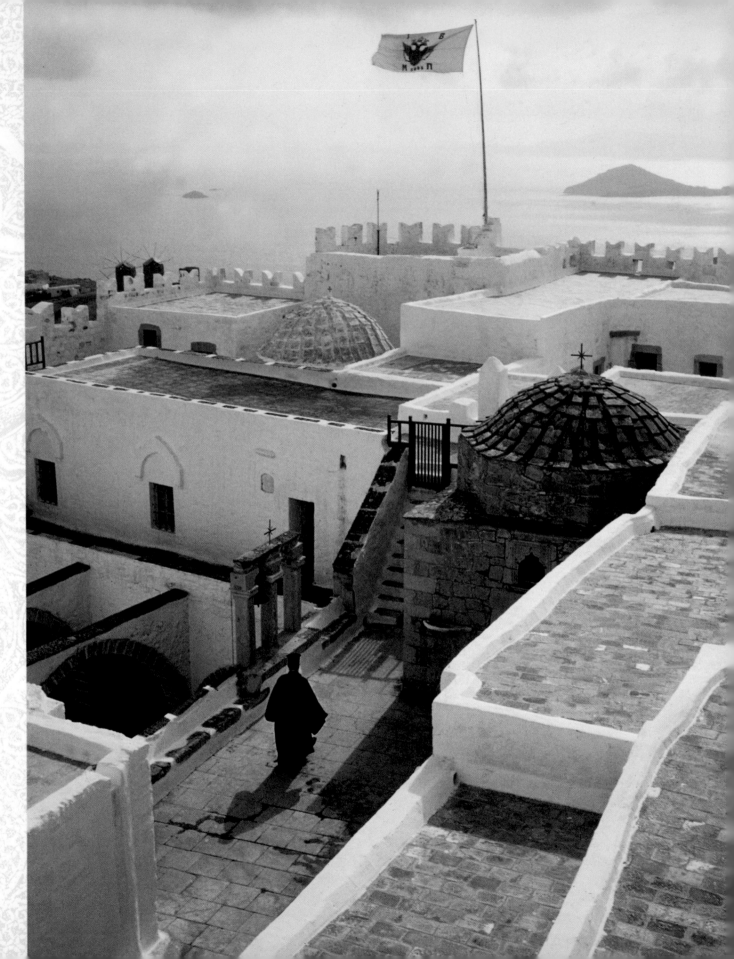

Built like a fortress, the crenelated monastery of Saint John the Theologian sits on a mountain slope overlooking the Aegean. Its location helped it to withstand attack. As a vestige of Byzantium seemingly immune to change, the monastery flies the imperial flag.

AN ISLAND RETREAT

Few places in the Byzantine Empire could have held less promise for settlement than the island of Patmos, which lies off Turkey's Aegean coast and is now part of Greece. Purportedly the refuge where the apostle Saint John penned Revelation, it was uninhabited and waterless, possessing little arable land. Yet the churchman Christodoulos gladly accepted it as a gift from Emperor Alexios I in 1088 and proceeded to found a monastery there.

Thanks to the tenacity and devotion of succeeding generations of monks, the monastery grew wealthy, earning revenues both from a booming sea trade and from the pilgrims who came to venerate the miracle-working relics of its founder Christodoulos, who had been made a saint. Subject over the years to many attacks by Arabs, Turks, pirates, and others attracted by its riches, the monastery never succumbed, and as a result its monastic archive and collections of rare manuscripts, icons, and other ecclesiastical treasures are intact today, offering a window on the Byzantine past.

In this early-12th-century manuscript illumination, Saint John prepares to set down his thoughts on the scroll unfurled before him. Tradition identifies a cave-shelter down-hill from the Patmos Monastery as the spot where John wrote his Holy Scripture.

THE HOLY MOUNTAIN

A small pocket of Byzantium still survives in north-eastern Greece on an isolated peninsula jutting into the Aegean. Dominated by Mount Athos, deemed a holy mountain by the church fathers, 20 monasteries scattered in the hills and along the shore preserve the old order. Indeed, they constitute the spiritual center of Eastern Orthodoxy today.

Drawn by its isolation, monks first began coming to the unpopulated peninsula in the ninth century. Living alone or in small groups, they devoted themselves to prayer and fasting. But their population began to grow and prosper, especially after the emperor Nikephoros II Phokas endowed a large monastery there, bestowing enough cash and properties to support some 80 monks.

Because the Arabs had been driven from their base in Crete, new monasteries could be built right on the water. Thus blessed by direct access to the sea, the monasteries became the beneficiaries of a lucrative maritime trade. Their good fortune lasted through the occupation of the Ottomans; the monks won the protection of the sultan and they became self-governing, which they still are today.

More than 7,000 strong at the dawn of the 20th century, their numbers had dwindled to only 1,145 by 1971. But thanks to a resurgence of interest in monasticism, young men from around the world have begun to enter the monasteries, and the number of brethren has already climbed to 2,000.

The 14th-century Simonopetra Monastery rises from a cliff above the Aegean, with snowcapped Mount Athos in the background. According to ancient edict, no beardless youths, eunuchs, or females could enter Athos's sacred precincts.

GLOSSARY

Alabaster: a fine-textured mineral that is usually white and translucent, often carved into ornamental objects.

Apollo: the Greek and Roman god of music, poetry, drama, and prophecy.

Apse: a semicylindrical vaulted space that in a Byzantine church traditionally held a statue of the Virgin Mary.

Augustaion: a public square in Constantinople that contained Justinian's column and many statues, including one of Constantine the Great's mother, Helena.

Basileus: the main title of the Byzantine emperor.

Bishop: a clergyman ranking above a priest with authority to ordain and confirm, usually governing a diocese.

Brocade: a silk fabric with raised designs, often in gold and silver.

Bulla: a round seal attached to an official document.

Bullion: uncoined gold or silver in bars or ingots.

Canonize: to declare a person, after his or her death, an officially recognized saint by ecclesiastical authority.

Cantor: a church official who sings and chants liturgical music and leads the congregation in prayer.

Cappadocia: ancient name for a hilly and mountainous region of central Asia Minor, now part of modern-day Turkey, with many churches and monasteries, some dating back to the 10th century.

Chamberlain: an officer in the household of a lord or sovereign.

Chlamys: a long cloak fastened on the right shoulder to leave the right arm free; worn by soldiers, it became part of the military insignia of the emperor.

Chrysobulls: documents bearing the emperor's gold bulla, or seal.

Cloisonné: a style of enamel decoration in which the enamel is raised on a metal background and is surrounded by gold wire.

Codex Justinianus: a compilation of imperial law commissioned by Justinian I, arranged according to subject and intended to be free of contradictions and repetitions.

Codex Theodosianus: a Latin lawbook commissioned by Emperor Theodosios II, compiled in 429. Superseded by the *Codex Justinianus.*

Codification: to classify and systematize; usually relates to law.

Constantinople: capital of the Byzantine Empire, founded by Constantine the Great in 330 on the site of the Greek city of Byzantium.

Consul: a chief magistrate.

Courtier: an attendant at a royal court.

Covenant: a formal and binding agreement.

Deacon: an official in the Orthodox Church whose duties were ministerial, ranging from assisting at baptism to supervising charities performed by the church.

Deo coronatus: the state of being "crowned by god"; in Byzantium, this meant that the ruler possessed God's approval.

Diocese: a territorial unit administered by ecclesiastical authorities.

Diptych: a laterally connected pair of panels made of wood, ivory, or precious metal.

Doge: the chief magistrate of Venice.

Edict of Milan: the first decree granting tolerance of Christianity, issued by Constantine the Great in 313.

Enkolpia: an object with Christian imagery, such as an amulet, worn around the neck.

Epanagoge: a lawbook dating from 886, compiled partially by the patriarch Photios.

Eparch: second only to the emperor, the eparch of Constantinople acted as governor, supreme judge, and chief of police, and controlled all commercial and industrial activity in the city.

Eunuchs: castrated men who often played important roles in the church and civil administration.

Filigree: intricate ornamental work of gold, silver, or copper wire applied to gold and silver surfaces.

Fresco: a painting on freshly spread lime plaster with water-based pigments.

Gakos: a pungent Greek sauce used with fish dishes.

Greek fire: an incendiary agent discharged in liquid form, first used in siege and naval warfare by the Byzantines in the seventh century; its composition was kept a secret from outsiders.

Guilds: organizations of craftsmen and merchants that promote the economic interests and welfare of their members.

Gynaikeion: the part of a Byzantine house or palace reserved for women.

Hagia Sophia: cathedral of Holy Wisdom in Constantinople built by Constantius II in 360. It was destroyed by fire in 404 by supporters of John Chrysostom, and was rebuilt in 415 by Theodosios II. Destroyed again during the Nika Revolt in 532, Justinian rebuilt it almost immediately, completing it in 537. In 1453 it was converted into a mosque and renamed Ayasofya Camii.

Hippodrome: arena for horse and chariot events built by Septimus Severus around 196 and completed by Constantine the Great. It served as an arena for sports, the proclamation of emperors, and the celebration of triumphs, and as a center of public life in Constantinople.

Icon: a religious image usually painted on a wooden panel, used in the devotions of Byzantine Christians.

Iconoclasm: a religious movement of the eighth and ninth centuries that rejected icons as idolatrous.

Iliad: an ancient Greek epic poem attributed to Homer.

Koilas klaphthmonos: the Byzantine slave market; literally, the "valley of weeping."

Lapis lazuli: a semiprecious stone, usually azure blue.

Liturgy: a rite or collection of rites prescribed for public worship.

Logothete: a high official usually serving in a department with a fiscal function.

Magistrate: an official who executes administrative and judicial tasks.

Mese: the central avenue of Constantinople that connected the major public squares of the city.

Milion: the milestone in the Augustaion from which the distance to any point in the empire was measured.

Mosaic: an elaborate and expensive form of mural decoration using small pieces of vari-

ously colored material to form pictures or patterns.

Mount Athos: an important center of Eastern Orthodox monasticism in Greece.

Muezzin: a Muslim crier who calls the hour of daily prayers.

Nave: the long narrow central hall in a church.

Oliphant: an ivory horn used sometimes as a signaling horn or, if sealed at one end, as a drinking vessel.

Omophorion: a long scarf made of wool, linen, or silk that served as a vestment; worn only by a bishop.

Paleologue: a member of a noble family thought to possess ancient ancestors; name of the last dynasty to rule in Constantinople, from 1259 to 1453.

Papyrus: the pith of a reed plant, cut into strips and pressed into a material to write on; the principal writing material of the ancient world and late antiquity.

Paten: a plate or shallow dish, usually made of precious metal, used to hold communion bread at the Eucharist.

Patmos: island in the Aegean near the coast of Asia Minor, now a part of Greece, where the exiled Saint John purportedly penned the Book of Revelation; site of an important Byzantine monastery.

Patriarch: any of the bishops of the five ancient Christian sees, or seats of a bishop's jurisdiction: Alexandria, Antioch, Constantinople, Jerusalem, and Rome.

Patrician: a person of high birth; aristocrat.

Pontiff: the pope, the bishop of Rome.

Porphyry: a hard rock ranging in color from red to purple and reserved for imperial decorative use.

Postulant: a candidate for membership in a religious order.

Procheiron: a law textbook for practical use dating from 870-879.

Proskynesis: in Byzantine ceremonies, a gesture or posture of supplication or homage performed by pressing the head to the floor.

Proxy: a person authorized to act for another.

Quadrivium: term applied to four disciplines—arithmetic, geometry, music, and astronomy—that supplemented the main curriculum of grammar, rhetoric, and dialectic in Byzantine education.

Regent: one who governs a kingdom in the absence of the rightful sovereign or during the reign of a minor.

Reliquary: a receptacle for relics.

Repoussé: an object, typically metal, shaped or ornamented with relief patterns made by hammering or pressing on its reverse side.

Rumeli Hisar: a citadel constructed by Sultan Mehmed II on the Bosporos that served as part of an Ottoman naval blockade of Byzantium in the 15th century.

Sage: one distinguished for sound judgment and wisdom.

Sardonyx: an ornamental stone consisting of onyx with layers of sard, or carnelian.

Strategikon: a late-sixth- to early-seventh-century Byzantine military treatise that stressed mobile, flexible cavalry tactics rather than the classical use of infantry; ascribed to the emperor Maurice.

Stylites: ascetic monks who stood or sat on platforms atop pillars equipped with ladders to the ground. The practice was meant to disengage the monk from the world and its sins.

Sultan: a Muslim leader with military and administrative authority conferred by the caliph, the spiritual leader of the Islamic world.

Tagmatic army: a professional military regiment under direct command of the emperor, generally stationed at or near Constantinople.

Theme: both a military division and a territorial unit administered by a commander possessing both military and civil power.

Triptych: a picture, carving, or altarpiece with a central panel and two flanking panels, used in public or private devotions.

Trisagion: "thrice holy"; Byzantine name for the biblical *Sanctus*, a hymn containing the verse "Holy God, holy strong one, holy immortal one, have mercy on us."

PRONUNCIATION GUIDE

Amneia AM-nee-uh
Antigonos an-TIG-uh-nohs
Basiliskianos BAY-zuhl-isk-ee-AH-nohs
Blachernai blak-EHR-neye
Boulgaroktonos BOHL-guhr-AWK-tuh-nuhs
Chalkoprateia KAL-koh-pruh-TEE-uh
chlamys KLAM-is
Chrysostom kris-OHS-tohm
Dekapolitissa DEHK-uh-pohl-IH-tis-suh
deo coronatus DAY-oh cohr-uh-NAW-tuhs
Diomedes deye-AW-muh-deez
enkolpia ehn-KOHL-pee-uh
Epanagoge EH-PAHN-ah-goh-hay
Eudokia Ingerina you-DOH-kee-uh ing-gehr-EEN-uh
Eusebios you-SEE-bee-ohs
Eustathios Maleinos you-STAY-thee-ohs muh-LEYE-nohs
gynaikeion gin-uh-KAY-uhn
Hagia Sophia HAY-juh soh-PHEE-uh
Hosios Loukas hoh-SEE-ohs LOO-kahs
Kantakouszenos kan-tuh-koo-ZEN-ohs
koilas klaphthmonos KOY-lahs KLAPTH-moh-nohs
Mamas MAH-mahs
Metochites MEHT-oh-keyets
Mousoulios MOH-SOH-lee-ohs
Nicaise neye-SAYS
Nikephoros Phokas NIK-uh-FOHR-ohs FOH-kahs
Niketas NIK-uh-tahs
Panteleemon pan-tuh-LAY-mohn
Paphlagonian PA-fluh-GOHN-ee-uhn
Philaretos fil-uh-RAY-tohs
Porphyogennetos POHR-FEE-oh-JEN-neh-tohs
Procheiron PRO-KEYE-ron
proskynesis PROHS-kuh-NEE-sis
Roch ROK
Romanus Argyrus ROH-muh-nuhs ahr-GEYE-ruhs
Ruy de Clavijo ROO-ee deh clah-VEE-yoh
Strategikon struh-TEJ-eh-kon
Symbatios sim-BAH-tee-ohs
themes THEEMS
Theophilitzes thee-oh-FIL-itz-ehs
Tzimiskes TZIM-eh-seez
Villehardouin vee-hahr-DWAH

ACKNOWLEDGMENTS AND PICTURE CREDITS

ACKNOWLEDGMENTS

The editors wish to thank the following individuals and institutions for their valuable assistance in the preparation of this volume:

Helen C. Evans, Metropolitan Museum of Art, New York; Heidrun Klein, Bildarchiv Preussischer Kulturbesitz, Berlin; Georgi Majstorski, Archaeological Museum, Preslav, Bulgaria; Georg Minkenberg, Domkapitel, Aachen; Marie Montembault, Département des Antiquités Grecques et Romaines, Musée du Louvre, Paris; Yuri Piatnitsky, State Hermitage Museum, St. Petersburg, Russia.

ciana, Venice (ms. gr. 479, fol. 12v). **102, 103:** Bibliothèque nationale de France. **104:** AKG, Paris/Werner Forman/Biblioteca Marciana, Venice (ms. gr. z17, fol. IIIr). **105:** Artephot /René Percheron, Paris. **106:** Copyright The British Museum, London, except top right, Kelsey Museum of Archaeology, University of Michigan. **107:** Photo RMN, Paris/D. Arnaudet (2); By concession of the Superintendency for BB.AA.AA.AA.SS of Puglia-Bari, Italy (2). **109:** From Ekdotike Athenon S.A. *Greek Art: Byzantine Wall-Paintings.* **110, 111:** Artephot, Paris/Biblioteca Nacional, Madrid. **112:** © Erich Lessing, Culture and Fine Arts Archive/Hora Church (Kariye Camii Museum), Istanbul. **114:** Trésor de la Cathédrale de Troyes, Corinne, photo Chevallier. **116-119:** Border by John Drummond, © Time Life Inc. **116:** © Erich Lessing, Culture and Fine Arts Archive, Vienna/Palazzo Ducale, Venice, Italy; Anderson/Alinari, Florence—INDEX/Cantarelli, Florence. **118:** Archiv für Kunst und Geschichte, Berlin/Palace of the Doges, Venice. **119:** Scala, Florence. **120:** Vatican Library, Rome (Vat. gr. 1605, fol. 20r)—Vatican Library, Rome (Vat. gr. 1605, fol. 36r). **122:** Photo Hubert Josse/Bibliothèque nationale de France. **125:** Werner Forman Archive, London/Topkapi Palace Library, Istanbul. **126:** Photograph © The Metropolitan Museum of Art. Photograph by Bruce White. **127:** Photo Dominique Genet/*L'Art de Byzance,* Editions Citadelles et Mazenod, Paris. **128, 129:** VISUM/Gebhard Krewitt, Hamburg; Europa-Farbbildarchiv Waltraud Klammet, Ohlstadt, Germany. **130:** Dimitri Kessel for *Life.* **131:** Werner Forman Archive, London/National Library, Athens. **132, 133:** © James L. Stanfield/National Geographic Image Collection.

Design Elements: John Drummond, © Time Life Inc.

BIBLIOGRAPHY

BOOKS

Acheimastou-Potamianou, Myrtali. *Greek Art: Byzantine Wall-Paintings.* Athens: Ekdotike Athenon, 1994.

Beckwith, John:
The Art of Constantinople: An Introduction to Byzantine Art, 330-1453. Greenwich, Conn.: Phaidon, 1961.
Early Christian and Byzantine Art. Baltimore: Penguin Books, 1970.

Brand, Charles M. *Byzantium Confronts the West, 1180-1204.* Cambridge, Mass.: Harvard University Press, 1968.

Buckton, David, ed. *Byzantium: Treasures of Byzantine Art and Culture from British Collections.* London: British Museum Press, 1994.

Byzance. Paris: Bibliothèque Nationale, 1992.

Byzantine Magic. Ed. by Henry Maguire. Washington, D.C.: Dumbarton Oaks, 1995.

The Byzantines. Ed. by Guglielmo Cavallo. Trans. by Thomas Dunlap, Teresa Lavender Fagan, Charles Lambert. Chicago: University of Chicago Press, 1997.

Byzantium: Church, Society, and Civilization Seen through Contemporary Eyes. Chicago: University of Chicago Press, 1984.

The Cambridge Medieval History (Vol. 4). Cambridge: University Press, 1966.

Chatzidakis, Nano. *Greek Art: Byzantine Mosaics.* Athens: Ekdotike Athenon, 1994.

Choniates, Nicetas. *O City of Byzantium: Annals of Niketas Choniatēs.* Trans. by Harry J. Magoulias. Detroit: Wayne State University Press, 1984.

Constantine Porphyrogenitus de Administrado Imperio. Ed. by Gy. Moravcsik, trans. by R. J. H. Jenkins. Washington, D.C.: Dumbarton Oaks, 1967.

de Combray, Richard. *Venice: Frail Barrier.* Garden City, N.Y.: Doubleday & Co., 1975.

Diener, Bertha. *Imperial Byzantium.* Boston: Little, Brown and Co., 1938.

Fury of the Northmen: TimeFrame AD 800-1000 (TimeFrame series). Alexandria, Va.: Time-Life Books, 1988.

The Glory of Byzantium: Art and Culture of the Middle Byzantine Era, A.D. 843-1261. Ed. by Helen C. Evans and William D. Wixom. New York: Metropolitan Museum of Art, 1997.

Godfrey, John. *1204: The Unholy Crusade.* Oxford: Oxford University Press, 1980.

Grabar, André. *Byzantine Painting.* Trans. by Stuart Gilbert. Geneva: Skira, 1953.

Grabar, André, and M. Manoussacas. *L'illustration du Manuscrit de Skylitzès de la Bibliothèque Nationale de Madrid.* Venice: Bibliothèque de l'institut Hellénique d'etudes, 1979.

Grierson, Philip. *Byzantine Coinage.* Washington, D.C.: Dumbarton Oaks, 1982.

Hallam, Elizabeth, ed. *Chronicles of the Crusades: Nine Crusades and Two Hundred Years of Bitter Conflict for the Holy Land Brought to Life through the Words of Those Who Were Actually There.* New York: Weidenfeld & Nicolson, 1989.

Hammond, Inc.:
Historical Atlas of the World. Maplewood, N.J.: Hammond, 1974.
The Times Atlas of World History. Ed. by Geoffrey Barraclough. Maplewood, N.J.: Hammond, 1993.

Handbook of the Byzantine Collection. Washington, D.C.: Dumbarton Oaks, 1967.

Hellier, Chris. *Monasteries of Greece.* London: Tauris Parke Books, 1996.

Hetherington, Paul. *Byzantium: City of Gold, City of Faith.* London: Orbis, 1983.

The Holy Bible. New York: Thomas Nelson & Sons, 1952.

Hull, Denison B. *Digenis Akritas: The Two-Blood Border Lord.* Athens, Ohio: Ohio

University Press, 1972.

Istanbul: Et la Turquie du Nord-Ouest. Paris: Guides Gallimard, 1993.

Kaplan, Michel. *Tout l'Or de Byzance.* Paris: Découvertes Gallimard Histoire, 1991.

Kucharek, Casimir. *The Byzantine-Slav Liturgy of St. John Chrysostom: Its Origin and Evolution.* Allendale, N.J.: Alleluia Press, 1971.

MacCormack, Sabine G. *Art and Ceremony in Late Antiquity.* Berkeley: University of California Press, 1981.

McEvedy, Colin. *The Penguin Atlas of Medieval History.* Harmondsworth, Middlesex, England: Penguin Books, 1961.

Maguire, Eunice Dauterman. *Art and Holy Powers in the Early Christian House.* Urbana: University of Illinois Press, 1989.

Mainstone, Rowland J. *Hagia Sophia: Architecture, Structure and Liturgy of Justinian's Great Church.* New York: Thames and Hudson, 1988.

Mango, Cyril A.:
The Art of the Byzantine Empire: 312-1453. Englewood Cliffs, N.J.: Prentice-Hall, 1972.
Byzantium: The Empire of New Rome. New York: Charles Scribner's Sons, 1980.

Matthew, Donald. *Atlas of Medieval Europe.* New York: Facts On File, 1983.

Menen, Aubrey, and the Editors of Time-Life Books. *Venice.* Amsterdam: Time-Life International, 1978.

Milton, Joyce, Rafael Steinberg, and Sarah Lewis. *Religion at the Crossroads: Byzantium, The Turks* (Imperial Visions: The Rise and Fall of Empires series). New York: HBJ Press, 1980.

Morris, James. *The World of Venice.* New York: Pantheon Books, 1960.

Morris, Jan. *The Venetian Empire: A Sea Voyage.* New York: Helen and Kurt Wolff, 1980.

Natanson, Joseph. *Early Christian Ivories.* London: Alec Tiranti, 1953.

National Geographic Atlas of the World. Washington, D.C.: National Geographic Society, 1970.

Nicol, Donald M. *Byzantium and Venice.* Cambridge: Cambridge University Press, 1988.

Norwich, John Julius. *Byzantium: The Decline and Fall.* London: Viking, 1995.

Ostrogorsky, George. *History of the Byzantine State.* Trans. by Joan Hussey. New Brunswick, N.J.: Rutgers University Press, 1957.

The Oxford Dictionary of Byzantium (Vols. 1 and 2). New York: Oxford University Press, 1991.

Oxford Illustrated History of the Crusades. Ed. by Jonathan Riley-Smith. Oxford: Oxford University Press, 1995.

Psellus, Michael. *The Chrono Graphia.* Trans. by E. R. A. Sewter. New Haven, Conn.: Yale University Press, 1953.

Queller, Donald E. *Medieval Diplomacy and the Fourth Crusade.* London: Variorum Reprints, 1980.

Queller, Donald E., ed. *The Latin Conquest of Constantinople.* New York: John Wiley and Sons, 1971.

Queller, Donald E., and Thomas F. Madden. *The Fourth Crusade: The Conquest of Constantinople.* Philadelphia: University of Pennsylvania Press, 1997.

Rice, David Talbot:
Art of the Byzantine Era. London: Thames and Hudson, 1963.
Constantinople: From Byzantium to Istanbul. New York: Stein and Day, 1965.

Rice, Tamara Talbot. *Everyday Life in Byzantium.* New York: Barnes & Noble, 1967.

Riley-Smith, Jonathan, ed. *Atlas of the Crusades.* New York: Facts On File, 1990.

Runciman, Steven. *Byzantine Style and Civilization.* Harmondsworth, Middlesex, England: Penguin Books, 1975.

Sherrard, Philip, and the Editors of Time-Life Books. *Byzantium* (Great Ages of Man series). Alexandria, Va.: Time-Life Books, 1966.

Shtereva, Irina, et al. *Bulgarian Medieval Town Technologies.* Sofia: Soros Center for Arts, n.d.

Spatharakis, Iohannis. *The Portrait in Byzantine Illuminated Manuscripts.* Leiden, Netherlands: E. J. Brill, 1976.

Strategikon. *Maurice's Strategikon.* Philadelphia: University of Pennsylvania Press, 1984.

Thubron, Colin, and the Editors of Time-Life Books. *The Venetians* (The Seafarers series). Alexandria, Va.: Time-Life Books, 1980.

Tillmann, Helene. *Pope Innocent III.* Trans. by Walter Sax. Amsterdam: North-Holland, 1980.

Toynbee, Arnold. *Constantine Porphyrogenitus and His World.* London: Oxford University Press, 1973.

Treasures of Mount Athos. N.p.: Holy Community of Mount Athos, 1997.

Vasiliev, A. A. *History of the Byzantine Empire: 324-1453* (Vol. 1). Madison: University of Wisconsin Press, 1952.

Veyne, Paul, ed. *A History of Private Life: From Pagan Rome to Byzantium* (Vol. 1). Trans. by Arthur Goldhammer. Cambridge, Mass.: Belknap Press of Harvard University Press, 1987.

Vikan, Gary, and John Nesbitt. *Security in Byzantium: Locking, Stealing, and Weighing.* Washington, D.C.: Dumbarton Oaks, 1980.

Villehardouin, Geoffroi de. *Memoirs of the Crusades.* Trans. by Frank Marzials. Westport, Conn.: Greenwood Press, 1983 (reprint of 1908 edition).

Weitzmann, Kurt, Manolis Chatzidakis, and Svetozar Radojcic. *Icons.* New York: Alpine Fine Arts, 1993.

Whitting, Philip, ed. *Byzantium: An Introduction.* New York: New York University Press, 1971.

Whittow, Mark. *The Making of Byzantium: 600-1025.* Berkeley: University of California Press, 1996.

PERIODICALS

Brown, Dale Mackenzie. "Shelter in the Rock." *House Beautiful,* March 1997.

Dumbarton Oaks Papers, 1962, no. 16.

National Geographic, December 1983.

Vikan, Gary. "Art, Medicine, and Magic in Early Byzantium." *Dumbarton Oaks Papers,* 1984, no. 38.

OTHER SOURCES

Early Christian and Byzantine Art. Exhibition catalog, April 25-June 22, 1947. Baltimore: Walters Art Gallery, 1947.

INDEX

Numerals in italics indicate an illustration of the subject mentioned.

Time-Life Books is a division of Time Life Inc.

TIME LIFE INC.
PRESIDENT and CEO: George Artandi

TIME-LIFE BOOKS
PRESIDENT: Stephen R. Frary
PUBLISHER/MANAGING EDITOR: Neil Kagan

What Life Was Like
AMID SPLENDOR AND INTRIGUE

EDITOR: Denise Dersin
DIRECTOR, NEW PRODUCT DEVELOPMENT:
Elizabeth D. Ward
DIRECTORS OF MARKETING: Joseph A. Kuna,
Pamela R. Farrell

Deputy Editor: Paula York-Soderlund
Design Director: Cynthia T. Richardson
Text Editor: Robin Currie
Associate Editor/Research and Writing:
Trudy W. Pearson
Senior Copyeditors: Mary Beth Oelkers-Keegan (principal),
Anne Farr
Technical Art Specialist: John Drummond
Picture Coordinator: David Herod
Editorial Assistant: Christine Higgins

Special Contributors: Charlotte Anker, Ellen Galford,
Dónal Kevin Gordon (chapter text); Sarah L. Evans,
Jessica K. Ferrell, Christina Huth, Marilyn Murphy Terrell,
Elizabeth Thompson (research-writing); Beth Levin
(research); Charlotte Anker, Dale Brown, Janet Cave
(editing); Barbara L. Klein (index and overread).

Correspondents: Maria Vincenza Aloisi (Paris), Christine
Hinze (London), Christina Lieberman (New York). Valuable assistance was also provided by Kalypso Gordon
(Athens), Angelika Lemmer (Bonn), Nihal Tamraz
(Cairo), Barbara Gevene Hertz (Copenhagen),
Trini Bandres (Madrid), Ann Natanson (Rome).

Director of Finance: Christopher Hearing
Directors of Book Production: Marjann Caldwell,
Patricia Pascale
Director of Publishing Technology: Betsi McGrath
Director of Photography and Research: John Conrad Weiser
Director of Editorial Administration: Barbara Levitt
Production Manager: Gertraude Schaefer
Quality Assurance Manager: James King
Chief Librarian: Louise D. Forstall

Consultant:
David Olster is an associate professor at the University of
Kentucky, where he teaches early Christian and Byzantine
history. He has published two books on the early to
medieval Byzantine Empire and is currently working on
several research projects, including a reexamination of
the origins of Iconoclasm and the diplomatic friction
between Constantinople and the court of Charlemagne.

Library of Congress Cataloging-in-Publication Data
What life was like amid splendor and intrigue :
Byzantine Empire, AD 330-1453 / by the editors of
Time-Life Books.
 p. cm.
 Includes bibliographical references and index.
 ISBN 0-7835-5457-5
 1. Byzantine Empire—Civilization.
2. Istanbul (Turkey)—History—To 1453. 3. Orthodox
Eastern Church. 4. Christian art and symbolism—
Medieval, 500-1500—Mediterranean Region.
I. Time-Life Books.
DF521.W48 1998 98-12916
949.5'02—dc21 CIP

Other Publications:
HISTORY
The American Story
Voices of the Civil War
The American Indians
Lost Civilizations
Mysteries of the Unknown
Time Frame
The Civil War
Cultural Atlas

COOKING
Weight Watchers® Smart Choice Recipe Collection
Great Taste~Low Fat
Williams-Sonoma Kitchen Library

SCIENCE/NATURE
Voyage Through the Universe

DO IT YOURSELF
The Time-Life Complete Gardener
Home Repair and Improvement
The Art of Woodworking
Fix It Yourself

TIME-LIFE KIDS
Library of First Questions and Answers
A Child's First Library of Learning
I Love Math
Nature Company Discoveries
Understanding Science & Nature

For information on and a full description of any of the
Time-Life Books series listed above, please call 1-800-
621-7026 or write:

Reader Information
Time-Life Customer Service
P.O. Box C-32068
Richmond, Virginia 23261-2068

This volume is one in a series on world history that
uses contemporary art, artifacts, and personal accounts
to create an intimate portrait of daily life in the past.

Other volumes included in the
What Life Was Like series:

On the Banks of the Nile: Egypt, 3050-30 BC
In the Age of Chivalry: Medieval Europe, AD 800-1500
When Rome Ruled the World: The Roman Empire, 100 BC-AD 200
At the Dawn of Democracy: Classical Athens, 525-322 BC
When Longships Sailed: Vikings, AD 800-1100
Among Druids and High Kings: Celtic Ireland, AD 400-1200
In the Realm of Elizabeth: England, AD 1533-1603